Digital
Photography
for 3D Imaging
and Animation

Digital Photography
for 3D Imaging
and Animation

Dan Ablan

Wiley Publishing, Inc.

Acquisitions and Development Editor: Pete Gaughan

Technical Editor: Keith Reicher

Production Editor: Martine Dardignac

Copy Editor: Kim Wimpsett

Production Manager: Tim Tate

Vice President and Executive Group Publisher: Richard Swadley

Vice President and Executive Publisher: Joseph B. Wikert

Vice President and Publisher: Neil Edde

Media Project Supervisor: Laura Atkinson

Media Development Specialist: Kate Jenkins

Book Designers: Franz Baumhackl and Lori Barra

Compositor: Franz Baumhackl

Proofreader: Nancy Riddiough

Indexer: Ted Laux

Anniversary Logo Design: Richard Pacifico

Cover Designer: Ryan Sneed

Cover Image: Dan Ablan

For general information on our other products and services or to obtain techni-
cal support, please contact our Customer Care Department within the U.S. at
(800) 762-2974, outside the U.S. at (317) 572-3993, or fax (317) 572-4002.

Wiley also publishes its books in a variety of electronic formats. Some content
that appears in print may not be available in electronic books.

Library of Congress Cataloging-in-Publication Data

Ablan, Dan.
 Digital photography for 3D imaging and animation / Dan Ablan.
 p. cm.
 ISBN-13: 978-0-470-09583-6 (paper/dvd)
 ISBN-10: 0-470-09583-0 (paper/dvd)
 1. Photography—Digital techniques. 2. Three-dimensional imaging.
 3. Computer animation. I. Title.
 TR267.A242 2007
 006.6′86—dc22
 2006037902

Dear Reader

Thank you for choosing *Digital Photography* for *3D Imaging and Animation*. This book is part of a family of premium quality Sybex graphics books, all written by outstanding authors who combine practical experience with a gift for teaching.

Sybex was founded in 1976. More than thirty years later, we're still committed to producing consistently exceptional books. With each of our graphics titles we're working hard to set a new standard for the industry. From the writers and artists we work with to the paper we print on, our goal is to bring you the best graphics books available.

I hope you see all that reflected in these pages. I'd be very interested to hear your comments and get your feedback on how we're doing. To let us know what you think about this or any other Sybex book, please send me an email at: sybex_publisher @wiley.com. Please also visit us at www.sybex.com to learn more about the rest of our growing graphics line.

Best regards,

NEIL EDDE
Vice President and Publisher
Sybex, an Imprint of Wiley

For my parents

Acknowledgments

At some point, I need to figure out a way to write acknowledgments without having them all sound the same. But even then, there might be a familiar ring to the sentences. Regardless, I need to first thank Pete Gaughan for getting this book off the ground. For years now, Pete and I have discussed doing a book like this, and it was his persistence that got it done. Thanks, Pete! Thank you to the team of editors who've helped turn my messy text into something presentable: the production editor, Martine Dardignac; the copy editor, Kim Wimpsett; and the proofreader, Nancy Riddiough. Thanks to Keith Reicher, my technical editor. Your questions helped to further tighten the text. When it came to including media, the work of Laura Atkinson helped get it done—thanks, Laura. And thank you to Sybex for the opportunity to do this book. Although we got off slowly, it's great to see this tome finally come together.

I want to thank my parents. Without their support of my endeavors over the years, I would not be where I am today. My Dad could have forced me into a profession I wasn't crazy about, like selling nuts and bolts, but he saw something in me as early as grade school. In the eighth grade, he lent me his Canon AE-1. He never got it back. Through high school, college, and beyond, he has been there supporting me with film, food, and the well-needed words of encouragement every son is entitled to.

I must give heartfelt thanks to my super-wife, Maria. Your support of my work and photography is what makes books like this possible. How you do it, I'll never know! And I promise, I'll clean out my gear from that extra bedroom! Finally, to Amelia: I challenge you to find a luckier dad anywhere! Thanks for being my daughter.

About the Author

Today, computer books are written by just about anyone. Some are good, some are not. I always tell people that my books can be found in the bookstore right near the real books! In most cases, it doesn't matter who's writing the book—what matters is the content.

Before I entered the glamorous and fascinating world of 3D animation, I worked in a not-as-much-fun world of video production. After graduating college with a bachelor's degree in broadcast journalism, I promptly went to work for a very small CBS affiliate. If your idea of experience is standing in the center of Indiana with a 70-pound camera on your shoulder in the 20-degree Midwest cold, then I've got the referral!

I wanted more and moved up to a program manager position for a large cable television outfit. There, I discovered 3D animation via NewTek's LightWave 3D and an Amiga computer. Now, you have to remember that today 3D is everywhere; in 1989, 3D was prevalent only in hugely expensive systems in the top video production studios, and mostly in an experimental state. Either way, one look at a small red apple rendering one pixel at a time (I think it took an hour or so) and I was hooked. From there I produced corporate video for a couple of years and along the way submerged myself into 3D.

In 1994, I went to work for an Amiga dealership, selling and training Video Toaster and LightWave systems. Also in 1994, I was fired from the Amiga dealership because Commodore stopped making Amigas. However, I had started doing 3D work on the side, and with the help of unemployment checks from the state of Illinois, I was able to forge ahead with my own business, AGA Digital Studios.

While creating 3D animations for corporate accounts like Bosch and Kraft Foods, I also began submitting articles to the only LightWave publication at the time, *LightWave Pro*. From there, I wrote tutorials every month and also contributed to its sister publication, *Video Toaster User*. I was "Dr. Toaster" and would answer questions for readers (I did not choose the name of the column, by the way). Avid Media Group, publishers of *Video Toaster User* and *LightWave Pro,* were acquired by Miller Freeman Publishing, and so I started writing for a new magazine called *3D Design*. Around 1995, I met with a representative from Macmillan Publishing and we discussed the idea of a LightWave book. They knew who I was through my articles in the trade magazines, and in 1996, the first book about LightWave was published: *LightWave Power Guide* from New Riders Publishing.

Now, more than a decade later, AGA Digital Studios, Inc., is located in the Chicago area; we create animations for corporate and industrial clients such as United Airlines, NASA, Lockheed Martin, the FAA, Blue Cross and Blue Shield, AllState, McDonald's, and many others. In addition to daily animation work, in 2003 I founded a new division of AGA Digital dedicated to 3D learning courses. 3D Garage.com is a training source with material that is presented as project based courses. Visit www.3dgarage.com for more information.

The book you are reading represents my tenth book. For more information on my other books and photography, visit my website, www.danablan.com.

Contents

"When you think about it, photography is everywhere.

It's our window to the world..."

Introduction

Who doesn't like a nice photo? When you think about it, photography is everywhere. It's our window to the world, as they say. Photography is memories in our shoe boxes, on our nightstands, and on our walls. It provides history, news, and information through newspapers, magazines, and books. When you consider all the places it exists, you might think photography is used to its fullest extent. But as the emerging world of 3D animation becomes more commonplace, the technologies of digital photography and 3D can be merged to further enhance the digital artist's creative spirit. This is what Digital Photography for 3D Imaging and Animation is all about.

Today, more 3D work appears in television, movies, and even the Internet than you probably realize. Filmmakers use 3D imagery to add digital sets, open windows on buildings, add leaves to trees, or simply add birds to a scene. Much of this work is created with the help of digital photography. With the advances in technology and improvements in software performance, digital content creators have been able to visualize their dreams while controlling budgets. For a small boutique studio, the combination of digital photography and 3D is wide ranging, and the results are never ending.

Getting the Most from This Book

Digital Photography for 3D Imaging and Animation was created to introduce you to the possibilities of two growing mediums. This book is about ideas. It begins with an introduction to digital photography and how it relates to 3D. To get the most from this book, you don't need much—just a desire to learn and experiment and the willingness to try a few new projects through software programs you may or may not already be using.

This book is non-platform-specific, meaning you don't need to have any one particular piece of software. It also means that you can be using the Mac OS or Windows to follow the projects. Although I use many different software applications, you can perform the projects in any comparable program you like. I've included trial versions of many programs on the book's DVD.

Experiment and Practice

Talk with anyone who has worked in the field of photography or 3D animation for a while, and one thing they'll tell you is that they experiment. That is, they take some time and click a few buttons, try a few new settings, or simply create something with "what if?" in mind. This is what you should always do, no matter how big your career is or how busy you are. You see, it's those late-night experiments in 3D or the afternoon unscheduled photography shoot that will help take you to the next level.

Both 3D animation and photography are creative fields of study. If you've worked in either, you know that isolating time to work and "be creative" is not so easy. You can't always just turn it on and pump out a masterpiece that will please your client or yourself. It takes time. What helps is experimenting with new ideas and practicing different techniques whenever you can. This book was designed to help you do just that.

Why This Book?

3D animators who've been in the field for a while come from a few varying backgrounds. Some come from engineering, some come from art and drawing, and others come from video and photography. All of these areas of study play a role in 3D modeling and animation. Today, students can learn about 3D in colleges; some even start learning about it as early as middle or junior-high school. The theories taught in schools for animation often begin with the basics of color, art, and design. But if you look at the available training materials and books on the market, few, if any, bridge the gap between any of these arts and 3D. *Digital Photography for 3D Imaging and Animation* is the first of its kind to introduce new and existing users of both mediums to the various techniques and processes available.

What's on the DVD?

The companion DVD is home to 115 image files that I've provided to you completely royalty free. These are in addition to the images provided for the projects throughout the book. You have my license to use them as practice files in your digital-imaging and 3D applications. Please do not sell, distribute, or donate these images in any way. They are for your personal work.

Also included are two hours of video training on various 3D applications and techniques, from creating a seamless texture to stitching together stills to make a panoramic environment. And of course, the DVD provides all the supporting files you'll need to follow along with the tutorials found throughout the book.

On top of this, I've assembled an excellent collection of third-party software to help you with your 3D work and education:

- **LightWave 3D®,** from NewTek, Inc.: Demo version. This Emmy®-winning 3D modeling, animation, and rendering software provides solutions for tasks ranging from TV, film, and games development to architectural visualization.

- **Maya® 7 Personal Learning Edition,** from Autodesk, Inc. This special version of the Academy Award®-winning integrated 3D modeling, animation, effects, and rendering solution is designed for noncommercial use.

- **3ds Max® 9,** from Autodesk, Inc.: Evaluation version. This 3D animation, rendering, and modeling software lets game developers, design visualization professionals, and visual effects artists maximize their productivity and tackle challenging animation projects.

- **Silo,** from Nevercenter LTD: Trial version. Silo is a next-generation production-quality 3D modeling program, employing advanced polygonal modeling tools and completely integrated subdivision surfaces.

- **Adobe® Photoshop® CS2,** from Adobe Systems, Inc.: Tryout version of the professional standard in desktop digital imaging.
- **Image Modeler,** from REALVIZ: Trial version. ImageModeler lets you measure and create photo-textured 3D objects from multiple photographs taken all around the objects.
- **Stitcher,** from REALVIZ: Trial version. Stitcher enables the creation of high-quality, professional-level panoramas in just a few clicks.

System Considerations

This book was written on a MacBook Pro, with Intel Core 2 Duo, 2GB of RAM, and an ATI x1600 video card. Some portions were tested on a Sony Vaio Pentium 4 running Windows XP Media Center. The majority of applications used throughout the book are compatible with the Mac OS and with Windows. The digital photos used throughout the book are in JPEG format and will be easily accessible on any current computer system. When it comes to the projects, the only differences you'll experience will be based on the processor, RAM, and video graphics card you have installed on your system. You'll also run into a few keyboard variances, which will be noted.

Worried about what computer to use? People are always asking what's the best computer to get. Do you need to buy the latest and greatest machine to handle your soon-to-be-massive library of digital photos? Should you spend $10,000 on a custom-built 3D workstation? How about those fancy new quad processors? In the end, it comes down to your wallet and what works for you.

But what is crucial, and often is a mistake made by many, is this: don't overdo the processor and forget the memory. You're better off getting a 2.5GHz Pentium 4 or a 1.67 Mac G5 with 2–3GB of RAM rather than the latest Xeon processors with only 512MB or 1GB of RAM. Here's why: RAM (memory) is like money—you can never have too much. (Well, you can have too much, but you can cross that bridge when you come to it.) Do you need to go out and spend $5,000 on a top-of-the-line computer? No, not at all. If you have it, by all means go for it. For the rest of us, a tight little system with good RAM and hard drive space is often all that is needed.

For the Mac vs. PC thing, we're not going there. That's for you to decide!

Words to Work By

It's rare that you find anyone working in the world of 3D or photography who does it because they "have" to do it. Sure, some projects and jobs are not ideal, but you'll be hard-pressed to find anyone who just can't wait to get out of these industries. When you merge digital photography and 3D, you are expanding the creative possibilities available to you. This book was designed to help get you started.

Whether you're a photographer just getting into 3D or an animator who wants to expand their personal or professional resume, *Digital Photography for 3D Imaging and Animation* is your guide to that next level. You have a passion for creating. And although you may have a job or a client along the way who makes you want to quit the whole thing, deep down you know you can't. You know that your best work is yet to come.

> **Note:** Sybex strives to keep you supplied with the latest tools and information you need for your work. Please check the Sybex website at www.sybex.com, where I'll post additional content and updates that supplement this book if the need arises. Enter Ablan in the Search box (or type the book's ISBN—0470095830), and click Go to find the book's update page.

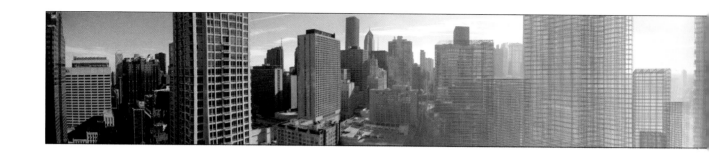

Photography and 3D

1

It wasn't too long ago that film, television, computers, and animation were completely separate entities. Each of these is an art form in its own right. Today, as you look to professional production companies, or even the home computer, all of these entities are wrapped up into one, thanks to the advances in computer technology.

Chapter Contents

Early Imaging

People have been trying to understand and record light for more than 2000 years. As early as the fourth and fifth centuries B.C., Greek and Chinese philosophers discussed the basic principles of optics. Today we still apply the principles they learned.

In the early ninth century, the Muslim astronomer and mathematician Ibn Alhaytham invented the camera. In fact, the word *camera* as we know it comes from the Arabic word *kamra*, which translates to the word *room*. After being adopted into Latin, the word became *camera* and then *camera obscura*, which means *dark room*.

A camera works on two basic principles, a positive process and a negative process. And although this had been known for hundreds of years prior, it wasn't until William Talbot pioneered the process in the mid-1800s in England that photography as we know it today began to take shape. Initially, a pinhole opening let a specific amount of light into a dark box; this was the first part of the process. The second part involved materials inside the box that changed when exposed to light. In the twentieth century, lenses replaced pinholes, and film was manufactured to permanently record the exposed image. Along the way, the art of photography has evolved, but the basic principles have remained the same. Light enters through a glass lens and is recorded onto a material, coated with specific light-sensitive chemicals, also known as *film*. And although many variations of film exist—from black-and-white to color to infrared—photographers have been rapidly migrating to the new, digital age, leaving all film behind.

Today, the chemical process has in most respects given way to a digital world. That's not to say traditional processes are completely a thing of the past, but in terms of general consumers, prosumers, and professional shooters, a good majority are going fully digital. In addition, a growing segment of Hollywood is leaning toward digital filmmaking. The differences of digital over film are as follows:

- Although film is nearly a 100-year-old process and digital is still in its infancy, film is more costly and more work.

- Film has a slightly different look than digital.

- Digital provides instant feedback.

- With film, photographers are limited to a relatively small number of shots before having to change film rolls. With digital, photographers can shoot thousands of images on one memory card, and changing memory cards is even easier than changing rolls of film.

- Film has a risk of being destroyed if not handled properly, both in the camera and in the lab. Digital shots are less likely to be destroyed. (However, the media that digital shots are stored on are susceptible to data loss, just like any computer hard drive.)

Clearly, choosing whether to shoot film or digital is a subjective choice for each individual. Not too long ago, film produced a much higher resolution than digital, except for a few top-end cameras costing as much as a small car. But today, when you

compare film resolution to digital resolution, even inexpensive digital cameras are now able to match film resolution. Therefore, even hobbyists can enter the digital photography market and shoot images with full-frame sensors.

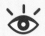

Note: A *full-frame sensor* is a digital chip in cameras such as the Canon 5D that is equivalent to a 35mm frame.

3D Animation

So as the film world transitions to the digital world, how does three-dimensional (3D) imaging and animation fit in? Aren't the two completely different? Yes and no.

3D animation has truly come of age in the past 10 years, but most people don't realize this amazing technology began as early as 1974. 3D technology then was not what we know today, with graphical user interfaces. And I won't even discuss what computer power was then, but let's just say your current wristwatch can do more. 3D in its infancy was nothing more than a series of numbers and code. The result was three-dimensional wireframes.

In the beginning, computer scientists (yes, computer scientists, not artists) digitized data by hand or sketched on graph paper and typed the numbers into a computer manually. But what did they create? One of the most common objects, still used today, was the teapot (see Figure 1.1). While simple in design and not too complex for systems to draw, the teapot is useful for testing because it has complex geometry, has self-shadows, and has convex and concave surfaces. Many 3D systems today come with a default teapot that you can use for testing scenes, reflections, shadows, bump maps, and of course image mapping.

Figure 1.1
Used primarily for testing 3D elements, the teapot has become an industry standard.

In the 1980s, computer graphics technology matured as the personal computer (PC) revolution began. Yet, this budding technology was available only to massive computer systems and those with massive budgets. In the 1990s, everything changed as computer power became faster and cheaper. Emerging 3D software companies perfected and released better graphical user interfaces and offered much sought after tools such as ray tracing, bump mapping, refraction, and caustics. Today, these features are commonplace in 3D applications, and you rarely see rendered images without them.

By the mid-2000s, video cards in computer systems were able to process millions of bits of data. This is mostly thanks in part to the ever-growing PC video-game industry. The demand for high-end graphics in games led to a demand for high-end graphic cards for computers. 3D animators were the beneficiaries of this demand because the video card that was once more than $2,000 could now be purchased for less than $200 at the local computer store.

Merging Technologies

You might be asking yourself how these two technologies, one very old, one just kind of old, can come together in this modern-day technoplasmic world we live in. Good question! This book will help you explore all the possibilities of digital photography and its uses in 3D imaging and animation. Specifically, this book will guide you through the following:

- Digital photography methods such as megapixels, f-stops, apertures, and lenses, as well as how they all relate to 3D applications
- How and what to shoot with your digital camera for use in 3D
- How you can apply your everyday photographic composition in 3D
- How to use 3D technology to apply digital photographic quality to your rendered 3D images
- How to apply digital photography to your 3D workflow and thought process
- How to use digital photographs as 3D textures and image maps
- How to create image-based modeling from digital photos
- How to create compositions with 3D objects and digital photos
- How to use digital photography to light your 3D scenes through high-dynamic range (HDR) imagery

You'll find when you discuss the idea of digital photography to someone and also mention 3D animation that most people do not consider these to be related fields. Go a step further, and talk to anyone in the 3D business who has been doing it since the early 1990s. You'll find they come from one of three backgrounds, if not all of them: photo/video/film, art, or engineering. Today, 3D animation is studied widely across the world in not only colleges and universities but even in high schools. When the medium was just beginning to emerge as a business and entertainment resource in

the early 1990s, those in the video business jumped on board to enhance their products. Engineers and draftspeople realized the potential of 3D imaging to bring their ideas to life. And artists who wanted to add that "something extra" to their drawings and paintings found 3D to be the perfect solution. So when you think about digital photography and how you can use it in 3D imaging and animation, the possibilities are truly endless.

For example, Figure 1.2 shows a photo of a traffic light. The original high-resolution photo was taken in midday sun in downtown Chicago. Figure 1.3 shows a 3D model created in Luxology's modo. The 3D image does not use any image maps or textures from the real photo, and it's not used for lighting the scene, which leads to the question, what's the use of the image?

Figure 1.2

A photograph of an everyday traffic light. Although seemingly ordinary at first, it has many details upon closer inspection, all of which are important when re-creating images in 3D.

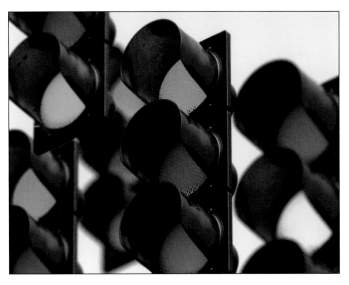

Figure 1.3
Based on the photograph in Figure 1.2, this 3D-generated image uses details from the real model, such as the grid pattern on the lenses, as well as lighting and reflections.

The use of Figure 1.2 for creating the 3D image in Figure 1.3 is simple: reference. On its simplest level, digital photography serves as an open door to real-world references. For example, pretend your client comes to you and says they need a model of a traffic light for an illustration in an upcoming meeting. They want to go 3D so they can control the angles and time of day and also can make the traffic light look newer. But at the same time, they want it to look like the current models they're using. Unbeknownst to you, many companies manufacture traffic lights, and the lights come in many shapes and sizes. There's a lot more to them than just red, yellow, and green.

Often when 3D artists think of digital photos as reference, they think only in terms of X, Y, and Z. That is to say, to them, a reference photo should be of an item in three forms: front, side, and top. Then in their 3D program, they use these reference photos as a background template from which to model. Consider a filmmaker who is rebuilding old New York for their next hairy-gorilla movie. They too use photos as reference; granted, the photos might be 50 or 60 years old, but to them, the more reference they have, the better. How the filmmakers use these references is also how the 3D artist can use them. Rather than using an image to "trace over" the reference, they can use images to call out fine details such as the design of a building, the height of a bridge, or the shape of a street.

3D models created today are open to artistic interpretation. That's not to say the result shouldn't resemble the original or that a client should not get what they're paying for. The point is, a digital photo can go a long way when it comes to 3D modeling when used as a reference. For example, Figure 1.4 shows a shot of a city street, which was used as inspiration for the 3D image in Figure 1.5.

Figure 1.4 A photograph of a city street is a top-notch reference for creating details in 3D.

Figure 1.5
Based on the image in Figure 1.4, this 3D image was generated using only a few photographs as reference. Fine details found their way into the El tracks thanks to the photo reference.

Digital photos are not only good as model references but as lighting references as well. When you talk about lighting in 3D, however, you should assume you're considering the environment as well. As many photographs know, light is everything. The same applies to 3D. Well, not exactly! In fact, 3D is so much more. Light is almost everything, as are the quality of your 3D models, the details in your texturing, the balance of reflection vs. shadows, and so on.

For instance, Figures 1.6 and 1.7 have a similar lighting situation. Figure 1.6 relies on reflections and indirect illumination with an overcast sky to create an outdoor courtyard. Figure 1.7 also uses reflections and indirect illumination but to create a studio look. Both 3D images have minor differences when it comes to lighting, but because the models are so diverse in their size and surfacing, they have entirely different looks.

Figure 1.6
Lit with the environment around it, these buildings rely on global illumination and reflection for their result.

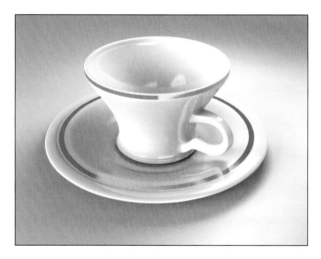

Figure 1.7
Also lit with the environment around it, this teacup relies on reflections and soft shadows for a studio look.

Digital Incorporation

It's clear that digital photography plays a strong role in 3D imaging and animation. It's used on so many levels, and as you've seen here, just as reference alone, digital photos can greatly enhance the detail and realism of your 3D work. But how can you incorporate a digital workflow beyond just reference images? Where do you begin, and where do you go once you've started?

The following chapters in the book will take you on a step-by-step journey of not only understanding digital photography but of specifically using even the simplest digital camera to take excellent photos. Beyond that, you'll learn what to shoot, learn how to shoot, and learn to differentiate good light from bad light. Later, you'll go far beyond just photo references and learn how the right series of photographs can become a beautiful 3D environment in your scenes. You'll learn how to create your own HDR images using Adobe Photoshop. You can use the HDR images you create to light your 3D scenes for the ultimate in rendering realism. From there, you'll learn how powerful digital photographs can be not only for texture mapping in 3D but also for image modeling. Complex images on simple 3D objects can yield high-end results.

If you're ready, get out your camera, turn the page, and read on to learn about digital photography methods—from megapixels to lens types to f-stops to apertures—and to learn how they all play an important role in 3D applications.

Digital Photography Methods

To fully use digital photography in your every-day 3D workflow, you first need to understand the basic principles of photography. These principles include megapixels, f-stops, lenses, and apertures. Although you might not think these topics relate to computer imaging, they in fact have more of an impact on your digital work than you might realize. And although this book is not so much an instructional digital photography book as it is a digital imaging book, it's good to educate yourself about a few key factors of photographic principles in the digital world in which we live.

2

Chapter Contents
Working with Megapixels
Working with Lenses

Working with Megapixels

When you go shopping for a digital camera, the kid at the electronic store will most likely try to sell you the camera with the greatest amount of megapixels. You of course think more is better, and in most cases, it is. However, more goes into a digital camera than megapixels, just as more goes into a computer than a processor. Other factors play a large role in the final photograph. If you buy a camera with a tiny lens and it is mostly automatic, the pictures it takes even with higher megapixels will not be as good as a camera with better optics, more control, and fewer megapixels.

A *megapixel* is one million pixels. Typically, camera makers refer to the megapixels as the number of sensor elements in digital cameras. The sensor is essentially digital film that records your image. Many types of digital sensors exist, all varying in size; there has yet to be an industry standard. Currently, 35mm film is a standard, and the digital photography world is quickly moving toward full-frame sensors, which are the digital equivalent of 35mm film. Professional photographers appreciate a full-frame sensor for many reasons. When shooting digitally with a smaller sensor, you encounter the "multiplication factor." That is, a 24mm lens on a 35mm film camera gives about the same field of view as a 38mm lens on a digital camera. The reason for this is because non-full-frame sensors are smaller and have smaller pixels; therefore, the sensor compensates with a multiplication factor.

It is important to understand the multiplication factor used by certain digital single lens reflex (dSLR) cameras when you plan to use those images in 3D. Generally, most digital cameras employ a 1.5 multiplication factor. This is true if you're comparing digital camera settings to 35mm camera settings because lenses, for the most part, are still manufactured as 35mm lenses. As the digital age progresses, the lenses for dSLRs will be manufactured specifically for dSLR cameras, and comparisons to 35mm shooting will be a thing of the past. At this point, however, it's important to be aware of the size of the final image; see Table 2.1 to learn how megapixels translate to image resolutions.

 Note: Later in the book, I'll discuss compensation and the calculation of digital photos from camera to 3D.

Table 2.1 Typical Image Resolutions

File Size	Typical Dimensions
0.3 megapixels	640×480, or VGA
0.5 megapixels	800×600, or SVGA
0.8 megapixels	1024×768, or XVGA
1.3 megapixels	1280×1024, or SXGA
1.9 megapixels	1600×1200, or UXGA
3.1 megapixels	2048×1536, or QXGA
5.2 megapixels	2560×2048, or QSXGA
6.3 megapixels	3504×2336
12.8 megapixels	4368×2912 (full-frame)
16.7 megapixels	4992×3328

You can see from this table that, although the camera store clerk might be selling you on an 8-megapixel camera, even a 1.9-megapixel camera equals a high resolution. Taking this a step further, National Television Systems Committee (NTSC) television is 720×486, and high-definition television (HDTV) is 1920×1080!

Shooting with a full-frame sensor, which usually houses 12.8 megapixels or more, has many benefits; in fact, this can impact your 3D imaging. For example, let's say you have a 3.1-megapixel camera and need to photograph textures for image mapping a large building. Even at 2048×1536 resolution, these images might not be sufficient for your 3D model. Most cameras with a smaller resolution like 3.1 megapixels are tiny and compact. And although this is perfect for snapshots of cousin Jim's wedding, it's not ideal for 3D. That's not to say you can't use a 3.1-megapixel camera in your work, but it does mean you have to be careful how much you do with those images. If you're taking images from a 3.1-megapixel camera and using them to map onto a building and your client wants you to animate a walk-through of the building, you'll find that the images even at 2048×1536 resolution will be come blurry or pixelated. This is because as you animate the 3D camera in a program such as Autodesk's Maya, NewTek's LightWave, Softimage's XSI, or Maxon's Cinema4D, you're essentially enlarging the photograph as you move closer to it. You'll learn more about this later in the book. Furthermore, this doesn't mean you can't use a simple point-and-shoot camera. Quite the opposite is true actually! The type of camera you use, the optics the camera employs, and the control you have over the aperture are the factors you need to consider depending on the project at hand. Point-and-shoot cameras are a must-have for any 3D animator. Even though a small "pocket" camera might not provide enough resolution for an aerial photograph for mapping 3D spheres, it can provide useful for texture grabs, reference shots, and simple backdrops.

For example, let's say you've been contracted to model and texture the inside of an aircraft. Your client is at the airport and has a small window of time to photograph the textures for the seats you need to build in 3D. The client has a small 3.1-megapixel camera. Will this suffice? Of course it will—mostly because you have no other option at the moment but also because the animation project does not call for a close-up of the seats in 3D. The animation requires only a fly-through of the airplane. Therefore, the 3.1-megapixel camera is more than enough because the 2048-resolution images will fill only 20 percent of the screen at any one time. Figure 2.1 shows the photograph of the fabric, and Figure 2.2 shows the 3D-rendered image using the image for the fabric on the airline seats. Those seats are then replicated and placed inside the 3D aircraft model, as shown in Figure 2.3.

Figure 2.1

A picture of fabric from a 3.1-megapixel camera is suitable for texture mapping in 3D when the shot is not a close-up.

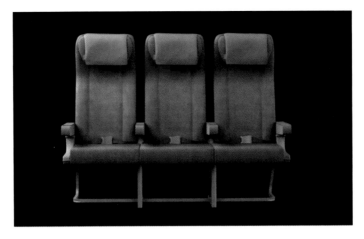

Figure 2.2
The fabric was mapped across airline seats in 3D.

Figure 2.3 The textured seats were replicated to fill an airline. A final shot like this does not need high-resolution textures.

As you can see in Figure 2.3, you don't need a high-resolution image to texture map the seats. In fact, a high-resolution image in this scenario is not smart because it will slow down your production time. Larger images take more memory and, in 3D, longer time to process, especially if you're using bump maps.

Now, on the flip side, sometimes in your digital work you'll need your photographs to be high resolution, and in these situations you need as large an image as you can get. Figure 2.4 shows an aerial shot of a landscape. The background image was originally a 4368×2912 image. Figure 2.5 shows a 3D aircraft composited over the aerial photo.

Figure 2.4 Certain aspects of 3D imaging will require a high-resolution image. Here, the background sky and ground were originally a 4368×2912 image.

Figure 2.5 A large image allows flexibility for movement in 3D.

In Figure 2.5, the 3D United Airlines aircraft is composited over the aerial photograph. The large photograph is partially mapped onto a sphere in 3D, which allows the 3D camera to turn and rotate around the scene, while still seeing an atmosphere. Without a high-resolution image, the image would appear pixelated and blurry. You need enough resolution so you can move around the scene, just as you would with an animated building walk-through or a close-up of an image-mapped object. As you can see from the examples, megapixel sizes do make a difference in your 3D world.

When shooting with a camera that has a smaller sensor, you might find more noise in the image. Specifically, although the picture might be clear and sharp, if you study the image, especially in the distance, you'll see it just doesn't have as much fine detail. Figure 2.6 shows a photo taken with a point-and-shoot Nikon S3 digital camera. This is a 6-megapixel camera and takes large, bright, clear images, but its small lens and fully automatic controls do not allow as much detail to be captured. Notice the concrete or the street lamps. The edges are soft. Figure 2.7, on the other hand, was taken with a Canon 5D dSLR camera. This 12.8-megapixel camera uses interchangeable lenses with full automatic and manual controls. In this image, look at the street and at buildings in the distance. The image is sharp, and fine details are very noticeable.

Figure 2.6
Point-and-shoot cameras such as the Nikon S3 are convenient and take clear images, but they lack detail because of small optics.

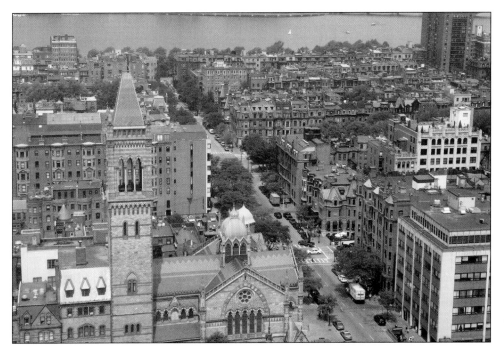

Figure 2.7 Digital SLR cameras such as the Canon 5D allow for the use of large lenses and offer the shooter more control than a point-and-shoot camera. The result is more detail in the image

Comparing a small point-and-shoot camera to a full-frame dSLR is almost like comparing apples to oranges. However, when it comes to 3D animation and imaging, you may be using one or the other (or both) in your work. Both cameras are useful in 3D, but where you use the images from these cameras makes all the difference. If you'll be working with a point-and-shoot camera, you'll be shooting in automatic mode. Assuming you're using a dSLR such as a Canon Rebel, you'll have more control and access to different lenses.

From this point on, this book will be using a dSLR for its examples and projects. You should know that dSLR cameras provide better accuracy, faster shooting, sharper images, and more control over light. And just as with film, in digital photography, light is everything.

Working with Lenses

As big a part of photography as the camera itself, the lens is where all the excitement happens. You see, the lens is your window to the world, so to speak. It is what controls the light entering the camera and determines the focus, of course. More important, the lens you choose gives you access to light control via apertures and f-stops.

Lenses are primarily designed the same for both film and digital cameras, but the lens you choose may work differently with the digital camera sensor. Although many lenses, such as those from Nikon, can work on both their film and digital cameras, the digital sensors react differently to light than film does. One of the biggest differences is

the lens multiplication issue. Since most sensors are smaller than film frames, your camera will crop the image you see through the lens, anywhere from 1.3, 1.5, or 1.6 times larger. Some cameras crop as much as two times. This is something to take into consideration when shooting digitally.

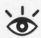

Note: Digital SLR photography is fun and complex at the same time. Lenses, sensors, multiplication factors, and more, are all part of this amazing field of study. This book is designed to instruct you on some of the basics and then move you into using your images in 3D animation and imaging. To learn more specifics about lenses and digital cameras, check out the *Digital Photography Digital Field Guide* by Harold Davis (Wiley, 2005) or *Digital Photography Visual Quick Tips* by Gregory Georges (Wiley, 2006).

Apertures and f-Stops

Understanding apertures and f-stops is even more important to using digital photography in 3D imaging than megapixels. Simply put, more megapixels will produce larger images, and how you use those images will impact your final 3D render. But the aperture will directly affect the digital image itself. Basically, the lens *aperture* is what determines how much light enters the camera and hits the sensor. A narrow aperture limits the light to the sensor, useful for brightly lit situations, such as in Figure 2.8.

Figure 2.8 Using a narrow, or small aperture, you limit the amount of light affecting a digital camera's sensor. This is useful for brightly lit situations.

Using a wide aperture, you'll be able to shoot in low-light situations. A wide aperture emits more light to the digital camera's sensor. Figure 2.9 shows an indoor photo taken with a very wide aperture.

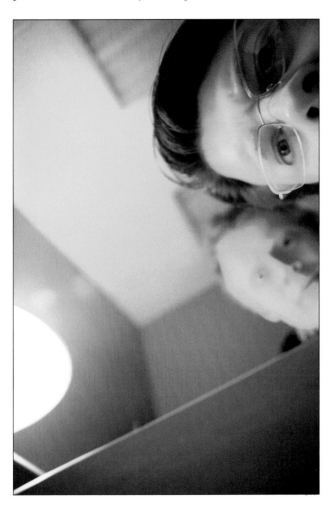

Figure 2.9
By shooting with a wide aperture, you're able to photograph low-light situations.

When working with point-and-shoot cameras, you really don't have too much control over aperture settings. But if you're shooting with a dSLR such as a Nikon D70 or a Canon 30D, you have complete control over aperture through the use of lens *f-stops*. A lens with a minimum aperture setting of, say, f2.8 is always considered a fast lens. These lenses are more expensive in most cases, but they offer the most flexibility when shooting. A lens with a minimum aperture setting of f8 is considered a slow lens. This is a more affordable lens but lacks usability in some shooting situations.

If you're like many shooters, you might have a general lens you use in most shooting situations. This is a nonprime lens that usually ranges from a wide angle to medium telephoto. A lens like this, perhaps a 24mm to 70mm, is a great "walking" lens because you have a range to work with when focusing on a subject. A zoom lens is often slower

than nonzooming lenses, because zoom lenses have smaller minimum apertures. However, the zoom lens is convenient for setting up the perfect shot, which could save you a lot of time later on the computer, especially when using the images in 3D applications. Let's say you're hanging off a 29th-floor balcony and need to get a shot of the patio on the ground floor. Without knowing the exact height and having the perfect-sized lens, you'd have to make do with your regular lenses. However, using a zoom lens, your range is now expanded, and you can choose to frame your shot as you like. Now, the benefit of this is that even though you can crop and enlarge images later in the computer, the end result is that you're cropping the image and losing resolution. By having the ability to zoom, you can keep the images large as well as save yourself time post-processing your shots. Figure 2.10 shows a shot taken with the 24mm end of a Canon lens. Figure 2.11 shows a shot taken with the 70mm end of the same Canon lens.

With a dSLR camera, you can choose between a wide range of zoom lenses, so be sure to check your manufacturer's website for availability. If you're specifically shooting for 3D imaging, you can get away with one or two good lenses. A general walk-around lens that ranges from a wide angle to a medium telephoto, something such as 24mm to 70mm, will serve you well. Beyond that, you might want to get a longer-range zoom lens, perhaps a 70mm to 200mm.

Figure 2.10 Using a zoom lens is ideal in many situations. Here you have a wide shot looking down at a patio.

Figure 2.11 Using the same zoom lens, the patio is now full frame, and no cropping is needed in the computer.

A longer-range zoom lens is great to use when you want to incorporate a lot of depth. Figure 2.12 shows an image taken with a 200mm Canon lens. Here, you can see the tennis player in focus, and the backdrop has a good amount of blur. With the subject cheated to the right, the image will work perfectly for the cover of a magazine or an opening title page of a DVD. Adding text over the blurred background will really make it pop.

Figure 2.12
A longer-range zoom lens will create more depth in the image, perfect for digital titling.

Before I get too far ahead of myself and discuss uses for your images, read on to learn a little more about f-stops and how they relate to depth of field.

Depth of Field

As something that has been part of photography since the beginning, depth of field might be something new to you when working in 3D animation and imaging. Relatively new to the 3D scene, depth of field was often not applied to rendered images but has been rearing its head more recently in animated movies. Depth of field is one of the most important aspects of photography. It is something you are familiar with, even if you don't know the term. Basically, *depth of field* is when objects in front of and behind the photographic subject become out of focus. No matter what lens you're using, the lens can focus on only one set distance. Anything else out of that range will be subject to an out-of-focus range, determined by the lens's f-stop. Figure 2.13 shows a digital photo with narrow, or shallow, depth of field. This shot was achieved by setting the f-stop wide open (a large aperture) to f2.8. Figure 2.14 shows an image with a slightly wider depth of field because the f-stop was set to f7.1. The lens was "opened up" a bit. Figure 2.15 shows an image with a wide depth of field taken at f11. f11 is a small aperture.

Generally, lenses on most cameras range from an f3.5 to f22. Some however have a wider range, and of course, are more expensive.

Figure 2.13 Using a lens "wide open" at an f-stop of 2.8 will create a shallow depth of field.

Figure 2.14
With a large lens opening (a large aperture), you have a narrower depth of field.

Figure 2.15 Moving away from the subject and using a smaller lens opening (aperture) of say, f11, you increase the depth of field.

With the three examples shown, you can see how changing the f-stop can greatly affect the perceived focus—the depth of field of the image. Figure 2.15 showed yet another situation where the camera position, in addition to the f-stop, plays a role in the depth of field. This is called the *focal length*, and I will discuss it in a moment.

Depth of field is part of photography, but it's not usually part of 3D imaging and animation. As with most aspects of 3D, you, the artist, need to instruct the computer to use depth of field. This is not something that's applied automatically in any application and, therefore, is not something most artists think about using. But you should! You see, depth of field in 3D adds realism to your scenes, and when added to an image that uses real-world lighting, reflections, and ray tracing, you're on your way to re-creating reality. Figure 2.16 shows a 3D image that uses a wide depth of field. Figure 2.17 originally shown in Chapter 1 is a 3D image that uses a very narrow depth of field.

Figure 2.16
To add realism to your 3D scenes, you can employ even a little depth of field.

Figure 2.17
As you can see in digital photography, you can use a narrow depth of field in your 3D renders for a more dramatic look.

Focal Length and f-Stop

The focal length you choose in digital photography, as well as in your 3D application, can have a dramatic affect on your final image. The *focal length* is the distance between the front of your lens and the image focal plane, either film or the digital sensor. The focal length of the lens is related to the focusing distance: longer focal lengths can focus on, and even magnify, subjects that are farther away. As shown in Figure 2.15, moving the camera away from the subject slightly to increase the focal length also increases the depth of field. Figure 2.18 shows a photo using a severe wide-angle lens, with a wide aperture. The result is that the boy and his mower appear strong and powerful. The same shot if taken from above with less of a wide-angle lens would not have the same impact.

Figure 2.18

Changing your focal length will not only affect the depth of field but also the impact of the image, both in the real world and in 3D.

The f-stop of an exposure is the focal length of the lens divided by its diameter. A good example of this is a 200mm lens set to f4. The lens diameter is 50mm—that is, 200mm divided by 50mm = 4. This is why the term f-stop is typically written as f4, meaning "focal length over 4" or "focal length divided by 4." You see, camera lenses have a series of f-stops, and each one is a "half stop" greater than the previous, which means each one lets in half as much light as the previous one. So, greater numbers in the f-stop actually represent less light; f22 is a small opening in any lens, and f2 is very large.

As you take photos, either for reference or fun, you might find yourself moving around and changing positions in addition to adjusting the f-stops. Without knowing it, you're setting the focal length. So it goes without question that you should also perform the same camera positioning in 3D. As you'll see later in Chapter 4, "How to Shoot the Shot," you'll incorporate focal length and depth of field in 3D applications.

When shooting, the first goal to establishing a good focal length is to assess the subject as well as its surroundings. If you're shooting portraits, you need to be careful not to shoot too wide because you'll start to see some distortion. However, this exaggerated look that comes with wide-angle lenses might be something you're after, both in digital photography and in 3D. Figure 2.19 shows a 3D scene with a 14mm lens. Notice how the body appears dwarfed by the head? You can apply this exaggeration in most 3D programs as a creative effect.

Figure 2.19 You can achieve the exaggerated effects of a severe wide-angle lens in 3D applications.

Other scenes might require focal lengths much longer, such as action scenes or sports. For these, you can never be too close to the action. Using a zoom lens to increase focal length is also possible in 3D.

Your Next Shot

This chapter gave you a brief overview of the basic camera functions. Certainly, your local bookstore has books available on lens optics, apertures, focal lengths, and more technical information than you would probably ever want to read. But with the basic information presented here, you will soon see that you can apply this knowledge to 3D. It's important to understand these basic principles before you go out and shoot.

Chapter 3 will guide you on a photographic journey of what to photograph for use in 3D. This includes background plates for compositing, texture maps for image mapping, and even environment shots for spherical mapping. It will also instruct you on noticing details and paying attention to different lighting conditions and how each will affect an image later in the 3D environment.

What to Shoot

3

This chapter will guide you through the first steps in photographing for 3D work. You'll learn about composing your shot, noticing details, and paying attention to good light and, more important, to bad light.

Chapter Contents

Composing Your Shot

Digital photography often works its way into unlikely places. With the flexibility of shooting thousands of images and no worry of running out of film or having to deal with developing, uses for digital photography have expanded to many situations. The obvious is of course everyday snapshots of family, friends, events, and so on. But with digital photography now being used for medical imaging, references for land surveyors, court evidence, and architectural renovations, its use in 3D is more common than ever. Perhaps at this point, you've decided, yes, you can use digital photography in your 3D work. But where do you begin? In the previous chapter, I briefly discussed megapixels, depth of field, and focal lengths—all basic principles you need to consider. But this book focuses more on the uses of digital photography in 3D, not on the mechanics. You might think what you're shooting is part of the mechanical operation, but that's not the case at all. Knowing what to shoot is your first task when photographing anything for use in 3D imaging and animation.

Figure 3.1 shows a typical digital photo that in many respects is not too useful in 3D.

Figure 3.1 This digital photo is not useful for 3D because of shadows, poor angle, and uneven light.

Take a closer look at Figure 3.1; the image might serve well as a photo reference of a big tree (taken at Muir Woods just outside San Francisco). But it won't work well as a texture element for use in 3D. Figure 3.2, on the other hand, is an image of tree bark that will work well as an image map on a 3D model.

Figure 3.2
A digital photo of tree bark
evenly lit and properly
framed works well in 3D.

In Figure 3.2, you can see that the bark fills the entire image. But more than that, the angle of the shot is straight on, and the light is even. Looking at Figure 3.1, it's good for nothing more than a reference or desktop wallpaper! The light bleeds over the bark at the top left. The angle is severe, making the bark at the bottom wider than at the top. Even cropping this image wouldn't allow you to map it convincingly in a 3D environment. And even if you wanted to use this image entirely for 3D, perhaps as a backdrop, its angle will limit what you can place in or on the photo. By the same token, even cutting out the tree and using it as an image map wouldn't work because of the heavy light from behind the tree that bleeds into the textures. Figure 3.2, conversely, is a shot taken from directly in front of the tree. It was also taken with the light behind the camera, rather than to the left, right, or behind. This is important because the bark is evenly lit, and the shadows are significantly reduced. In referencing the two images, you should ask yourself, what do I need to look for when shooting for 3D?

When shooting images for use in 3D, no matter what the final use is, such as compositing, texture mapping, HDR imaging, or even just reference, you need to study the composition. They say that in photography "light is everything" when in fact, light, composition, and subject are everything. The first fact you should know about composition in photography is that there is no right or wrong way to frame your shot. Photography is an art, and it should reflect not only what you see but also how you see it. The ideas presented in this chapter are merely suggested guidelines you can use when shooting. With that said, you need to be aware of a few issues when shooting for use in a 3D animation or imaging program compared to when taking family snapshots. For example, some photographs are simple remembrances of a family vacation or snapshots of the family pet, as in Figure 3.3.

Figure 3.3

In most cases, you're not always thinking about where the shot will eventually end up. You're concentrating on just "getting the shot."

The thought process behind photos like these is simply to capture the moment and nothing more. In most cases, you're not thinking about printing the photo on holiday cards or using it for a backdrop in a 3D animation—you're simply taking a picture. In fact, with a shot like this, you're not even thinking about the composition but rather having the dog look into the lens. That is your goal, and it's a good one. But taking your shots to the next level requires a little more thought, and sometimes more planning, when you will use the end result in your 3D program. It's essential, if you plan to take digital photos for use in 3D, that you remember this task.

Figure 3.4 shows a shot of a building courtyard. It's framed well and could be useful in 3D for compositing characters or perhaps adding elements to the shot digitally. So, what's wrong with this shot? If you consider that your animation will be rendered in either 4:3 or 6:9 format, this photograph will not fit your final rendered frame, or at least it will need to be severely cropped. Not thinking ahead to how the picture will be used when taking the shots can cause problems later. Figure 3.5, on the other hand, shows the same location but with the camera turned horizontally, matching the frame aspect of the final render more closely.

Figure 3.4
This is a nice photograph for compositing 3D elements, but since the camera is turned vertically, it can lead to problems later.

Figure 3.5 This is the same shot as Figure 3.4 but with the camera turned horizontally to better match the final 3D-rendered frame.

On the flip side, you may need vertical images in your 3D work. Perhaps your client calls and tells you she needs to see smoke rising up in an alleyway. Figure 3.6 shows a photo of an alleyway that works well for compositing characters, vehicles, and so on. It was taken horizontally. By contrast, Figure 3.7 was taken vertically and can be used for the traveling smoke shot your client requires.

Figure 3.6
Although the render frame of your animation might be 4:3 or 6:9, the animation needs to pan up to see the fire escape in the alley.

Figure 3.7
Here, a vertical image works better for the specific project.

Because these images were photographed at a high resolution of 4300×2900 pixels and your render frame will be, at the most, 1280×720 for high definition, you still have a lot of image to use. In other words, you can move your 3D camera around the scene without losing detail in the image. Figure 3.8 shows the image of the alley mapped onto a flat polygon in a 3D application. You can do this in any 3D package as a simple planar image map. But because the image is 2912×4368 in size and the final render is set to D1 NTSC (720×486) standard definition, the 3D camera can easily move around the image without quality loss.

Figure 3.8
With the right composition and resolution, you have a lot of flexibility in 3D on certain photos. Here, the vertical photo is mapped onto a flat 3D plane.

Figures 3.9 through 3.12 show a series of images of a 3D linear move on the y-axis. This is a 300-frame, 10-second animation traveling from the base of the image to the top. You can view the final render of this from the book's DVD. It's called Alley.mov.

Figure 3.9
Because the image is vertical, you can place the 3D camera at the bottom of the image, starting the animation.

Figure 3.10
The 3D camera slowly pans up on the y-axis.

Figure 3.11
The 3D camera continues traveling up toward the top of the image.

Figure 3.12
The 3D camera comes to rest at the end of the animation, at the top of the tall, high-resolution image.

As you can see, certain shots lend themselves well to 3D, especially high-resolution images. The sequence shown here is also an example of motion control. You'll be guided through more examples of motion control in Chapter 7, "Image Mapping with Digital Photos." The composition you choose when shooting for 3D is almost as important as what you shoot. Perhaps you're creating image maps for a 3D kitchen. Digital photos for this project should be evenly lit and composed in such a way that they'll map correctly in your 3D application.

The way to first start understanding the composition of a shot is to use the simple *rule of thirds*, which helps you frame your shot. Figure 3.13 shows a digital photo shot well within the rule of thirds. How is that? you say. Take a look at Figure 3.14, which has four lines drawn over the image.

Figure 3.13
This interior photograph seems well balanced. And there's a reason for it.

Figure 3.14
If you break down the image into thirds, both vertically and horizontally, you can see how elements of the image fall into place.

Using the rule of thirds, you simply place elements of your image into the areas where the thirds cross. This is merely a guideline, and as you can see in Figure 3.14, you don't need to have each key element reside within a third. But if you use the rule of thirds as a rough approximation, you'll have an easier time composing your shot. And although you can't see thirds through your camera's viewfinder, if you picture (pun intended) the lines across your image as you frame up a shot, before long, you'll train your eye.

The bottom line is that you don't want to place your main subject smack-dab in the middle of your frame. Consider the entire frame, and pay attention to not only what's in the field of view but also what's not. Figure 3.15 shows a cool shot of a lightbulb. Ordinarily, this is not very exciting, but by adhering to the rule of thirds the bulb is cheated over to the right of the frame, and the shot takes on much more interest. And some other details here make the image more interesting.

Figure 3.15 By offsetting the lightbulb to the right third of the frame, the picture has a lot more interest, even though the subject matter is basic.

Noticing Details in Subject Matter and Light

It has always been my belief that the smartest people are not those who are aware of what they know but those who are aware of what they don't know. You can apply my philosophy to photography quite easily. Using Figure 3.15, it's really nothing more than a lightbulb hanging from an old ceiling. But take a closer look, paying attention to the electrical piping and the lines they create, illuminated by the single bulb. Notice the crossing beams of wood and how they carry your eye forward and back. But some of the key elements in this image are the darkness and the shadows. The lightbulb is casting interesting shadows, above and around the general area. But the photograph was taken with enough distance that the area the light doesn't reach becomes a subject all its own. So although you might think on initial viewing that this shot is just a lightbulb and some old wood, it's really a lot more.

Light itself, or the lack of it as you've seen, can be the subject matter in your digital photography. So what? you ask. As you study and learn how to shoot interesting subjects, also study the light and details, because you can use every bit in 3D, including the lighting, the shadows, and of course the composition. Figure 3.16 shows a drummer, but what's really the subject here? Right! The blue spotlight and how it fills the frame with color. You can achieve this same dimension in 3D by using spotlights and volumetric tools.

Figure 3.16
At first glance this is a shot of a drummer, but really the subject is the light. Light can also be a subject in 3D.

Light, as I've mentioned, is everything. It's a phrase that's said often, but what does it mean? Light is also part of your composition, and it can be your subject matter, as shown in Figure 3.16. Light does not have to directly illuminate your scene. In fact, some of the most dramatic shots are those that are indirectly lit. Figure 3.17 and Figure 3.18 show two examples of how using silhouettes changes the mood of the image.

Figure 3.17
With a person sitting center in the photo, he is not as prominent as a silhouette. The dramatic backlight creates a solemn mood.

Figure 3.18
Similar to Figure 3.17, light from a lone window illuminates the shot. The result is that the window becomes the subject, not the person.

Light can be the main subject without being blatant. Light works well in Figure 3.16 with a strong, vivid presence. However, light in your digital photography can be strong without being overpowering. Figure 3.19 shows a close-up of a few summer roses. They are lit with a bright morning sunlight, yet the illumination is not overpowering.

Figure 3.19 Light can be strong and powerful in your shots without taking over the entire image.

Clearly I could show pages upon pages of lighting examples, with different composition scenarios and the various combinations. Pick up any photographic magazine or book, and you'll see how the study of subject and light is a constant. The same element applies in your 3D work. In fact, your work as a 3D content creator using digital photography is more work than a typical photographer. You see, you need to pay attention to detail, study subject composition, and work with the light to make your photographs work in 3D. Then, if that weren't enough, you have to use your knowledge of practical shooting in the computer environment. But don't worry, digital photography and 3D can blend together easier than you think, and before long you'll be shooting all your shots with 3D in mind. If the best photographers are editors, then the best editors are photographers.

Shooting for 3D

Up until now, I've primarily discussed basic photographic principles that you should be studying and using not only for using images in 3D but simply to improve your photography. This section will get you going in how to shoot for 3D. And guess what the two main ingredients are? You guessed it, composition and light! Figure 3.20 shows what might be a good shot for use in re-creating an old cement staircase. But upon further examination, the composition is poor, and the light is uneven.

Figure 3.20
Initially, the cement on the stairs looks like a good use of digital photography for image mapping. But the angle of this shot is not useful for 3D, and the shadows are harsh.

The goal of shooting an image like this is to be able to take just the cement texture from the stairway and map them onto a 3D object. Figure 3.21 shows a much better angle; it not only makes your life easier editing the image for use in 3D, but the light is more even as well. Another bonus of shooting the shot like Figure 3.21 is that it fills the frame, giving you more resolution so when moving the 3D camera, you are not locked into a fixed distance to avoid pixelation or a blurry image map. The closer, high-resolution image will give you more flexibility, just as the tall, high-resolution vertical alley picture shown in Figure 3.7.

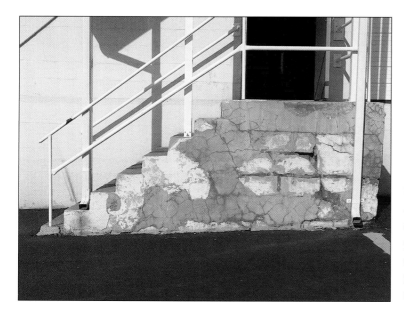

Figure 3.21 By changing your point of view and photographing the stairway straight on, you eliminate harsh shadows and obtain an image better for texture mapping.

Thinking ahead to a 3D modeling project of rebuilding a cement staircase, the image shown in Figure 3.21 will work well. Figure 3.22 shows the image with the cement on the front edge of the stairs isolated.

Figure 3.22
With a small bit of editing in Adobe Photoshop, the image is ready for use in 3D.

Once this image is cropped and the gutter is painted out, it's ready for use in 3D. It's saved as a 32-bit TIFF file so that the alpha channel is saved along with it. This allows the cropped image to be easily mapped in any 3D program because there is no background for the stairs. Taking it a step further, Figure 3.23 shows the same image mapped onto simple geometry in 3D, applied as an image map, and rendered.

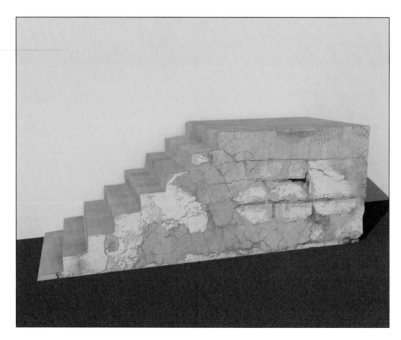

Figure 3.23
Going one step further with the cropped photograph, it's easily mapped onto geometry in a 3D program.

And as you can see from Figure 3.24 and Figure 3.25, you have complete flexibility to where you place the 3D camera. The image doesn't have any harsh shadows, and the image map doesn't have any odd angles because the shot was taken straight on.

Figure 3.24
Because the image was photographed directly head-on and heavy shadows have been eliminated, you can position the 3D camera on either side of the staircase.

Figure 3.25
Here, the 3D camera is on the other side of the staircase. Because the digital photo is composed and lit properly, the 3D camera can go wherever you want it.

You'll realize the importance of your digital shots when you start working with them in a 3D environment. After using only a few poorly composed, unevenly lit images, you'll realize how following basic digital photography principles is key to your workflow. When working with digital photos of textures, as shown in Figure 3.24 and Figure 3.25, pay attention to all the details. Notice that at the base of the stairs, the surface is uneven. Will this cause problems later when image mapping? If you crop out this section, will that negate the use of the image?

You might have heard people say, "fix it in post!"—that is, fix a poorly lit photograph or poorly shot video in post-production. Correcting errors for bad images is not only a headache, but it's a backward way to work. Garbage in equals garbage out, as they also say, and you should almost never rely on post-production processes. Compose your shot as best you can with the resources available to you. Figure 3.24 and Figure 3.25 are good examples of this. Perhaps you could have twisted and duplicated the stairway texture from Figure 3.24 to make a decent image map, but it is easier to walk around to the front of the subject, align your camera, and take a decent photo. Then, you can concentrate on your 3D work, not on cleaning it up.

That's not to say every image you shoot will be perfect. In fact, you'll balance and straighten most images before using them in 3D. This is prepping the photo for use in 3D, not fixing it, though. The point is, you should shoot every image as if you're going to use it directly in your 3D program for image mapping, compositing, or reference. Figure 3.26 shows a shot taken of a street. At the time, this was the only angle possible. The light was even enough, except for some shadows on the pavement.

Figure 3.26 As much as you plan on taking a good photo for use in 3D, sometimes you can't quite make it 100 percent usable.

Figure 3.27 shows the same image but cropped to block out the barricades and heavy shadows. The image was also straightened by a simple rotation. From here, you can take this image into a 3D environment and map it on a flat polygon to create a 3D roadway. Taking it a step further, you can create bump maps from the image for added detail and realism. You'll learn about using one image in multiple variations later in the book.

Figure 3.27 With a bit of straightening and cropping, this image is ready to become a 3D roadway.

Your Next Shot

Digital photography for 3D is wide ranging, and it's the goal of this book to enlighten you to all the different ways you can use your photos for animation and imaging. This chapter has shown you how important composition is and that you need to be aware of not only the lighting of your subjects but also the shadows and indirect lighting. Digital photos can work for backgrounds, references, or as you've seen here, texture maps. And that's just the beginning. As the book progresses, you'll learn how to create high-dynamic range images so you can use what you shoot to light 3D environments. You'll also learn techniques for using your images differently with Adobe After Effects. In many ways, the digital photo uses for 3D described here are common uses, but did you ever think of using your digital camera for wallpaper?

In the early days of 3D imaging, a scanner was your best friend. Not only could you scan book covers, newspapers, or photographs to be used in 3D, but you could also scan decorating samples. Today, this process is even easier with the use of digital photography. Most home decorating and building stores have books upon books of wallpaper samples, carpet, and flooring samples you can sign out and hold on to for a few days. Instead of perusing through these books to remodel your kitchen or bath, take out your digital camera, and get shooting! If you've ever tried scanning a large sample book, you might know that it's not so easy. A single wallpaper sheet on a scanner? No problem. A 10-inch thick book with hundreds of pages? Not so easy. But if you photograph the samples, not only are you able to obtain even light across the entire sample, but you can work significantly faster as well.

Figure 3.28 and Figure 3.29 show two wallpaper samples that were photographed with a digital camera and then imported into the computer. With a tiny bit of color balance and straightening, you can easily map these images onto polygons in a 3D environment.

Figure 3.28 Rather than rebuilding images for something like wallpaper, you can photograph samples.

Figure 3.29 With a little straightening and cropping, a wallpaper border is ready to be applied to your 3D walls.

You see, the quality of the digital cameras today makes your life easier as a digital content creator. How you shoot and what you shoot are as important as what you eventually create. In the following chapters, you'll learn about image-mapping and image-compositing techniques in 3D, and much more. Now, put down this book, grab your camera, and go shoot! Here's the biggest advantage of shooting digitally, other than that you have no film to buy and develop: you are not limited to a few shots per roll. This means if something catches your eye, shoot it! Even in the slightest, shoot it! Too often, people tend to wait for that perfect picture. They hesitate and inevitably lose the shot that caught their eye. Don't hesitate. Don't pause. Shoot!

How to Shoot

By now, you should have a good idea of the process of digital photography and how you can use it on your computer. Certainly, you can use digital photography in a three-dimensional computer environment in many ways, most of which I'll cover in the chapters to come. The few chapters preceding this one have introduced you to the simple mechanics of the digital shooting age, as well as what to look for when taking that perfect shot. So although this book is geared toward using your digital photography in 3D, this chapter will step away from the computer for while and talk about how to shoot. Specifically, you'll learn about how to handle your camera, image orientation, balance, perspective, and more.

4

Chapter Contents

Camera Choice

I heard a story once about a party in which the famed photographer Ansel Adams met the famed novelist Ernest Hemingway. They chatted for a while—Adams complimenting Hemingway's work, Hemingway taking note of Adams's brilliant photographs of the Grand Canyon, and so on. At one point, Hemingway mentions he has an old camera and would like to dabble in the art of photography. He said to Adams that his photos were breathtaking and wanted to know what camera he used so he too could take such marvelous photographs. Adams replied politely that he primarily used a Hasselblad. After a moment, Adams said to Hemingway that he was fond of his books and even wanted to pen a story or two himself. He continued and asked Hemingway what sort of typewriter he used so he could get started writing. Hemingway paused, shocked at first and even offended. Then he got it.

You see, the type of camera you choose to use is not as important as your trained eye. Sure, using a full dSLR camera over a point-and-shoot camera has clear advantages, but in many circumstances, you don't need anything else. And when shooting for 3D, a point-and-shoot camera is often enough. The biggest difference between a point-and-shoot camera and a dSLR is response time. With a full dSLR camera, when you see something, you take the shot. Bam! With a point-and-shoot camera, it's more of a click-and-wait scenario. But again, it all depends on what you're shooting. Let's say your flight is delayed for four hours or so. What could you possibly do with that time other than work on your laptop? How about take some pictures of lonely travelers? With the state of the world these days, photographing in airports is kind of a no-no. This is where a slim point-and-shoot Nikon Coolpix S3 comes in handy! Figure 4.1 shows a shot of travelers waiting for their flight at Chicago's O'Hare airport. The shot was taken casually from waist height. Figure 4.2 is a shot over Kansas City, Missouri, also taken with a point-and-shoot camera. A small camera like this is easy to handle and convenient to use.

Figure 4.1
Traveling with a small pocket camera is perfect for capturing moments without being noticed.

Figure 4.2
Using a slim camera that fits in your pocket definitely has its benefits, especially when flying.

Aside from being inconspicuous with a point-and-shoot camera, it is convenient, especially when traveling. As you saw in Figure 4.2, a tiny camera makes taking shots from an airplane easy. Another advantage of using a smaller camera when you travel is that you might also be carrying a laptop, a suitcase, or even a small child. The last thing you'd want to do is have yet another big bag with lenses and cables to worry about going through airport security. A small point-and-shoot camera can work well for travel and for everyday use. In fact, it's highly recommended that you pick up a small camera to keep with you every day. Get one small enough that you can easily carry in a pocket or purse. Why should you do this? If you're always on the lookout for great reflections, textures, or interesting subjects to use in your 3D realm, carrying a camera with you every day is smart. Figure 4.3 shows a stone wall, taken with the same Nikon Coolpix S3 camera. I used this image in a project two weeks later!

Figure 4.3
Carrying a small
pocket camera with
you all the time
means you'll never
miss a shot.

By keeping a camera with you all the time, you'll soon realize how many great textures and images you'll start to collect. Going a step further, sometimes a larger, more controllable camera has its benefits. Sure, it might be a bit big for traveling light or being discreet, but when the only thing coming between you and that perfect shot is timing, you'll want every control you can. Figure 4.4 shows a shot you might be all too familiar with. You say "wait" and then click the shutter on your point-and-shoot camera, only to have the subject turn right as the camera takes the picture. This is the number-one problem with a small point-and-shoot camera.

Figure 4.4
Use a point-and-shoot camera for certain subjects, and you'll often realize the camera's weakness—speed.

Although you could always use a flash in low-light situations to help your exposure and freeze the action, you still have the issue of camera lag—that is, when you press the shutter release on a small point-and-shoot camera, your shot is not taken exactly at that time. And using a flash in many situations does not work well for later use in 3D. Knowing how to handle your camera, either a point-and-shoot or large dSLR camera is step one in mastering the perfect shot.

Which Camera?

Some of the topics covered in this chapter may or may not work for your specific 3D needs. However, learning how to shoot and handle your camera for different situations is fundamental in photography. Where you choose to use this knowledge is up to you. The examples in this chapter can work with your point-and-shoot camera or dSLR camera. However, for full impact and control, a dSLR will perform best.

No matter which camera you use, a simple snapshot camera, old film camera, or professional digital camera, the foundation remains the same. If you are someone who shoots with their old AE-1 camera simply because you don't want to invest in the digital age, consider this: with a film camera, your equipment is not too expensive. However, you'll forever be buying film and paying for processing.

With a dSLR camera, on the other hand, the cost is mostly up front. Once you go digital, you can shoot until your heart's content (or until your camera's memory card is full), unload the images onto your computer, delete the images from your camera, and continue shooting—no extra costs involved.

The examples in this chapter all use digital cameras: Casio QV3000 (3.2MP), Nikon Coolpix S3 (6MP), Canon D60 (6.3MP), Canon 20D (8MP), and Canon 5D (12.4MP). The lenses used vary and are noted as needed.

How to Handle Your Camera

How you use your camera is entirely up to you. You may choose to look through the viewfinder, or you may not. You may choose to shoot everything vertically, or perhaps you like to use digital effects found in many digital cameras to enhance the image. These topics are not important at the moment. What is important is how you handle your camera. Figure 4.5 shows a handheld shot taken at night without a tripod, using a Canon 20D dSLR. Although it gives you more control over light, the longer exposure can lead to blur. By steadying yourself against a window frame or wall, you can get the shot.

Figure 4.5 Even a point-and-shoot camera can shoot well in low light, as long as you handle the camera well.

With significantly less light, Figure 4.5 is still sharper and more in focus than Figure 4.4. Granted, the subject moved in 4.4, but the background is not sharp because of camera shake. This is a common problem in digital photography often because most digital cameras today lack weight. And without weight, it's difficult to hold the camera steady. But you can use a few tricks to steady your shot. Regardless of your camera's response times, some shots are always possible, such as architecture, still life, and so on, but camera shake is still an issue. To avoid the handheld blues, you can of course use a tripod. Mounting your camera on a tripod is one way to steady a shot. However, if you're like most people, you're not fond of carrying a tripod around with you everywhere you go. If you want to see something, pick up the camera, and shoot!

Camera Shake

To help alleviate the shakes (or camera shake as it were) and you don't want to or can't use a tripod, the best method is to use your body. One trick to steadying yourself while taking a photograph (with any camera) is to hold your breath. Frame your shot, get your camera ready, and then take a long, deep breath. Then, hold your breath, and take the shot. You can also brace yourself against a wall, a pole, or a table. In Figure 4.5, the camera was pressed up against a window as a support. Now, let's say you don't have access to a tripod or a wall, window, or pole to brace yourself. You can make your own tripod with your arms and legs. Kneel down on one knee, with the other knee up with your foot on the ground. Rest your elbow (of the arm that is holding the camera) on that knee. Lean in, and take the shot. You're using your leg as a support, as in Figure 4.6.

Figure 4.6
You can use your body as a
tripod of sorts by resting
your elbow on one knee.

Viewfinders

Depending on your camera, you may have a large liquid crystal display (LCD) to both
shoot and view your pictures. Other cameras might have a small viewfinder to look
through such as a dSLR. Whichever the case, you need to be comfortable with how
your camera works. If you're shooting with a camera that allows you to look through a
viewfinder, do so. You see, bringing the camera close to your body will help you stabi-
lize the shot and reduce, if not eliminate, camera shake.

Digital SLRs

If you're fortunate enough to be shooting with a dSLR such as a Nikon D200 or a Canon
30D, you have the ability to change lenses. What's more is that these lenses can be a great
way to hold the camera for a steady shot. Given that all cameras have their shutter
release on the right side, you'd grasp the camera on the right side, using your index finger
to take the shot. Then with your left hand, cup the lens, with the lens resting in your
palm. Next, tuck your elbow of your left arm into your midsection. Let the camera rest
on your hand using your arm as a brace. This is a comfortable way to shoot, and if you
happen to be shooting with manual focus, you can keep your eye glued to the viewfinder

while you focus to not miss the action. Too often, people hold a camera on both the left and right sides with elbows spread wide. If this is comfortable for you, that's great. But you might want to tighten that hold and narrow your stance for better stabilization.

Image Orientation and Proportion

In Chapter 3, "What to Shoot," I discussed composition, and for the most part, image orientation and proportion are part of proper composition. But what's more is that these two concentrations are important when used for 3D work. Perhaps you're creating a panorama or creating texture maps for an architectural project. How you place your camera and take the shots can make or break the final result later in the computer. You can use a few rules to help you set up your shots.

Framing

When you find that perfect shot, what do you do? You pick up the camera, put it to your face, and frame your shot. Generally, people don't concentrate on this action, but you should. Chapter 3 discussed using the rule of thirds to frame a photo, but sometimes you need to concentrate more on what's in the photo, such as certain patterns. The number-one action you should take when framing a shot is to look closely at the entire frame. Have you ever seen a picture of someone and their head is smack-dab in the middle of the frame? Perhaps you're guilty of this? We all are at some point! Rather than noticing the subject in the frame, pay attention to the entire frame. Look at all four corners of the viewfinder. Notice any elements in the shot that shouldn't be there, and look at the overall aesthetics. Figure 4.7 and Figure 4.8 show two shots, one taken quickly looking up at a high rise and the other framed much better.

Figure 4.7 This is not a terribly bad shot, but at first glance, what do you notice? The sky!

Figure 4.8 This is a better shot, properly framed, and the building steals your eye.

Figure 4.7 is poorly framed because all you notice at first glance is the sky. Figure 4.8 is better because the main focus is the skyscraper. By allowing the tree to enter the shot, you enhance the height and enormity of the building.

Paying attention to the entire frame not only allows you capture what it was that caught your eye, but it also gives you the opportunity to convey what you see to someone else. Perhaps a street performer caught your eye one day. You take the shot, and go about your business (after, of course, giving him a donation). When you look at the photos later, the street performer doesn't seem to stand out the way he did to you earlier. Figure 4.9 shows a shot with the performer in frame, but too many other things are going on—a guy on a cell phone is walking toward you, a woman is walking away from you, other people are walking down the street, and so on. They are all distracting. Figure 4.10, on the other hand, shows a similar shot but without the people walking by; your eye goes right to the subject matter at hand, the street performer. You'll also notice that he's not centered in the frame, and the shot is zoomed in a bit to bring you closer to him, but the image remains balanced.

Figure 4.9 Trying to capture the street performer doesn't work well with other distractions in the frame.

Figure 4.10 Bringing the subject closer by zooming in helps remove distraction from the image.

Symmetry and Balance

In Figure 4.9, people are walking by and distracting the viewer from the subject of the photo. In Figure 4.10, you clearly see the street performer because of two reasons: The shot is a bit closer, and there is less distraction in the frame. However, it's OK if things block your view. In many instances, this will not only add interest to the shot but also focus the viewer's eye even more. Figure 4.11 is a good example of this where a person blocks the majority of the shot. What's remaining is the subject looking curiously off-camera.

Figure 4.11 By shooting a subject with blockage, the image appeals to a different mood.

A shot like this gives the viewer a sense of spying, or voyeurism. Without the person blocking the shot, it would just be a photo of a guy looking at something. One simple difference in the shot, and the mood is entirely different.

All your shots need balance. That is, what you shoot can look different depending on how it's framed. In Figure 4.10, the street performer is to the left, looking into the frame. Figure 4.12 shows the same type of shot, a subject looking into the frame. Nothing seems out of the ordinary.

Figure 4.12 When a subject is photographed looking into the frame, the shot feels balanced and comfortable.

Now take a look at Figure 4.13. The framing is completely different. The shot is not that much different from Figure 4.10 or Figure 4.12, except for the composition. The street performer in Figure 4.10 is all the way on frame left, looking frame right (or in computer graphics terms, screen right), which is good composition.

The girl in Figure 4.13 is looking out of the frame but is centered, which changes the entire look and feel of the shot. What makes this shot not appealing is not just the framing of the shot but the surroundings as well. A subject looking off-camera like this would work well if she were standing against a brick wall or in front of a window. But because the area behind her is nondescript, the shot doesn't work.

What would make this better is to move the camera to the right, losing most of the column. Or, if your subject faces you as in Figure 4.14, the same framing will work well even with the column in the shot. Additionally, the image is a bit straighter. You can see this in the angle of the column. The differences are subtle, but images convey moods. They evoke emotion. You might not pick up on it at first, but these comparisons should put you in the right direction.

Figure 4.13 With the subject looking off-camera to the edge of the frame, the shot isn't much to see.

Figure 4.14 Here, the subject faces the camera, and the same framing now works.

When talking about symmetry in your photos, it's not quite the same as you might have come to know in 3D modeling. Symmetry in 3D modeling is essentially having a mirror copy across one axis. In digital photography, it's something else—it shows stability and strength. Figure 4.15 shows Daisy, looking right as you, center frame. The shot is framed well for a number of reasons.

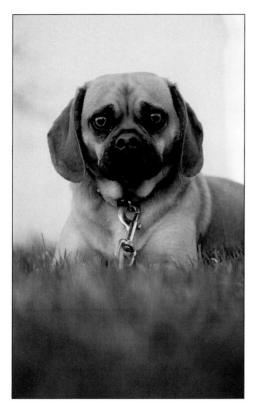

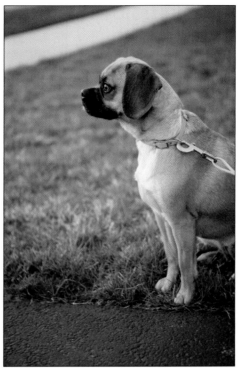

Figure 4.15 A shot that is balanced and has symmetry conveys strength and stability.

Figure 4.16 The same subject from a different vantage point and framed differently presents a not-so-balanced feel.

The dark grass is at the bottom of the frame, which helps give balance when contrasted with the light background. The dog is looking right at you, which pulls your eyes in from both sides of the frame, right to his face. His face is positioned slightly higher than center, which adds to the strength of the image. In Figure 4.16, however, the same subject now photographed from shoulder height isn't as balanced. Daisy doesn't appear as strong in a shot like this.

Symmetry and balance in your images are something for which you'll always be looking. They'll come from understanding your subject and knowing what you want out of the image. How do you want the shot to be received when someone looks at it? And as mentioned in previous chapters, think about where you're going with the image, be it 3D texturing, compositing, or something else entirely.

Patterns and Textures

What catches your eye when you take a picture? Perhaps it's the light, or perhaps it's the shadows. Or maybe it's the patterns. Patterns and textures are particularly important to discuss in this book because much of your digital photography for 3D will rely on these types of photos to be used as texture maps for buildings, roadways, clothing, and much more. So, how do you shoot patterns? As with anything you photograph, the project will dictate what you should shoot. But you can take certain steps to make your life easier after the shot. For example, Figure 4.17 shows an image of a brick wall.

Figure 4.17 An image of a brick wall shot in high resolution and evenly lit will work well for 3D.

This image works well for 3D because it's

- Evenly lit
- Shot head-on
- Taken in high resolution

Those three elements are key in taking good pictures for texture. The pattern of the bricks in the image blends well together. Nothing in the image jumps out at you and breaks the pattern. This is what you should look for because anything that will cause the viewer's eye to see something other than the pattern will become distracting. Figure 4.18 shows a shot that is framed well but lit improperly for good use in 3D.

Take a close look at the image, and you'll see dark, heavy shadows. A tiny leaf at the bottom-right corner is casting a shadow, and you can see larger shadows, cast from the dirt, throughout the image. Using a shot like this as a ground texture in 3D would look odd, especially when you add other 3D elements such as cars or buildings that cast their own shadows. Now refer to Figure 4.19; although the light is still strong, the rocks are not casting any large shadows upon themselves, making this a nice image to work with in 3D.

Figure 4.18 A great find, this shot of dirt and dead grass could work well for a ground texture in 3D if it weren't for the heavy shadows.

Figure 4.19 Although lit with the same sunlight, because the rocks are even in shape and size, no harsh shadows will distract from the texture image.

In addition, you can use this image in a program such as Adobe Photoshop to make a seamless texture (which you'll learn how to do later in the book). When shooting images that you'll use as texture maps in 3D or even if you're going to manipulate

them in Photoshop, you must shoot as straight on as possible. The slightest angle can cause problems later when the 3D process begins.

You can use patterns for many things in 3D including reflections, backgrounds, or even just reference. In fact, you don't need to look for patterns in nature only. Figure 4.20 shows a good example of patterns in everyday life you can capture.

You can also photograph some patterns with other patterns for interesting results. Figure 4.21 shows square patterns within other square patterns as a reflection.

Figure 4.20 Patterns are all around—in the ground, roadways, and of course buildings.

Figure 4.21 Patterns do not have to stand on their own. Here the patterns mix together through the reflections in the glass.

You may not always find a need for patterns in 3D, but this is just one more detail to look for when you're out shooting. You'd be surprised how often you might need a pattern image in your projects. Think beyond squares and buildings too. You can find patterns in fields of grass, rows of parked cars, baseball bats lined up before a Little League game, or even chairs like in Figure 4.22.

Figure 4.22 When you shoot, look for patterns. Here, a row of chairs on a boat taken from far away shows a pattern that can be replicated in 3D.

The image in Figure 4.22 shows a repeating pattern because of the rows of chairs. But what makes the shot stand out is how it was framed. Because the picture is taken from above, the zoom lens created less perspective and flattened out the image. You see less depth in a shot like this, which makes the pattern more noticeable.

Image Orientation

Clearly, image orientation is a subjective topic. That is to say, how you orientate your shot is completely up to you and for the most part will be dictated by the subject you're trying to capture. You have three ways you can take your shot: horizontally, vertically, and angled. Some shots will work both horizontally and vertically; some such as skyscrapers will require a vertical shot. Angling the shot will change the look and feel of the picture, creating sometimes a fun and whimsical image and other times an uncomfortable feeling. Figure 4.23 shows a shot that really is nothing more than a building beyond a tree.

Now, with the camera turned vertically (Figure 4.24), the same shot takes on an entirely different feel. You know what you're looking at, whereas the previous image doesn't really show anything significant.

Figure 4.24
With the camera tuned vertically, the photo shows a lot more and concentrates your focus on the pizza shop.

Shooting on angles can yield all sorts of results. Figure 4.25 is a close-up of a skyscraper. Generally, a window close-up would not let you know how tall the building was. But by simply rotating the camera on an angle, you can give a sense of height to the building without seeing the entire structure.

Figure 4.25
Using angles on buildings can help convey height even without seeing it.

Angles are always something to think about no matter what you're shooting—even patterns! You can achieve many of the results when shooting patterns on angles on the computer, but since you're shooting digitally, take more than one shot of a subject. Shoot your scene horizontally and then vertically, and then try some angles. Figure 4.26 shows how using an angle adds to the lighting and the singer (Adrian Dinu) in this shot.

Figure 4.26
Angling the camera during a concert increases the emotion in the image.

Going a step further, you can do a little trick with your digital camera for added effects. Figure 4.27 shows an angled shot taken with available light. The available light was a lot of red light to be exact!

Figure 4.27 Deliberately rotating the camera during a shot to capture the subject on an angle results in a funky-looking image.

The way this shot was taken was quickly rotating the camera as the picture was being shot. The result is a cool, blurred look. The psychedelic colors in the room are enhanced by the blur of the movement and the angle of the shot. Contrast that to the same room and subject taken with a flash, as in Figure 4.28. Uck.

Figure 4.28 Using a flash on the same subject as Figure 4.27 not only makes the photo lose interest because of the lack of color, but it's just bad!

Image orientation is a personal preference. The information presented should open your eyes to a few ideas, and perhaps you can take them even further.

Perspective

If you've ever taken a drawing class, one of the first topics discussed is perspective. You learn to understand and develop your eye to see perspective. The same is important in digital photography. Perspective is important because it allows you to add dimension to your photos. By using converging lines and diminishing sizes, you can create depth in your pictures. Figure 4.29 shows a strong perspective shot, looking up a tree.

Figure 4.29
Perspective creates depth in your photographs.

Noticing converging lines in an image is a great way to steer the viewer's eye. Figure 4.30 shows an image with many lines in the buildings that pull in your eye.

Figure 4.30
Noticing converging lines in an image is another type of perspective shot.

So, perspective shots don't necessarily need to be severe as in Figure 4.29; they can be subtle as in Figure 4.30. You can also use images or objects in a foreground perspective shot to drive the viewer's eye to a subject. In Figure 4.31, the people on the street corner would not be that noticeable without the arrow on the street pulling your eye toward them.

Figure 4.31
Paying attention to details in the foreground of a perspective shot pulls the viewer's eye toward the subject.

Perspective appears in so many subjects, from buildings to landscapes to portraits. Paying attention to the entire frame as described earlier in the chapter will help you set up shots deliberately and with purpose.

Your Next Shot

Many people think they know how to shoot pictures, and for the most part, they do. There's always a few tips and tricks you can employ to enhance your shots, such as changing your angles, watching perspectives, and paying close attention to light. But when shooting for 3D, there's even a bit more to consider, as you've discovered here in this chapter. Once you've taken your shots, the next thing you can concentrate on is image management. Turn the page to read how managing your images will help your workflow.

Image Management

Working digitally, it's likely you'll soon have, or perhaps already do have, a mass of photographs floating around your hard drive. These photos have odd names like IMG_096.jpg or some other hard-to-follow convention. With a few photos, it's not too hard to rename and organize them, but get to a few thousand, and soon you're spending more time sifting through photos than shooting them! This chapter will discuss ways you can organize your photos to make your life easier when calling upon them for use in 3D and other imaging programs. Beyond that, this chapter will discuss color management and key information regarding noise, image compression, and bit depth.

5

Chapter Contents
Organization
Color
Bit Depth
Image Types
Noise

Organization

The wonderful world of digital photography has opened up all kinds of possibilities—from simple everyday snapshots to vacation photos—for use in 3D imaging. No longer do you need to process film and negatives or store shoe boxes of prints. On the flip side, you now have gigabytes of data on your hard drive and need a way to organize the files. Whether you work on a Macintosh or Windows-based computer, you can easily organize your photos with the included software. On a Windows machine (running Windows XP), the default system stores your photos in your user account. You can access images and print them easily. On a Mac, using Apple iPhoto is simple and painless, and your photos are also stored within your system user account. But both systems have their flaws, specifically regarding naming and separating. Just putting digital photos in one location on your hard drive isn't going to help you find a particular photograph quickly. You might be able to get to the photos right away because you know where they are all located, just like a giant shoe box of prints you keep under your bed. But what about finding that great shot of your pooch or that image of a marble you found on the side of a building that is perfect for your upcoming architectural 3D project?

Let's say you're going to use your default system's photo organization software, iPhoto on the Mac or Windows photo management on Windows XP. When you plug your digital camera into your computer or connect a media card reader, each system will start your photo management software and ask whether you'd like to import the photos. Clicking OK simply drops them all into one key location within your system's user account. In most cases, you do have a bit of work to do with each import because nothing is completely automatic. Wouldn't it be nice if your camera could name your photos for you? Right now, the digital technology only numbers your photos, and it's up to you to name them. But before you do that, it's a good idea to organize your photos with folders. Figure 5.1 shows a folder list in iPhoto on a Mac on the left and a folder list in WindowsXP on a PC on the right.

Figure 5.1 In both Mac and PC environments, image organization and management is a little time-consuming but is easy to accomplish with just about any image management program.

Note: *Always* save your original images to a safe place; either burn them to a CD or DVD or use a backup hard drive. The original images are the shots that come directly from your digital camera, not those converted by an image management program.

Most digital file management systems work in such a way that you can organize your images into groups or folders. As in Figure 5.1, you have a general library in which all your photos reside. From there, you can create folders for specific topics and events. In iPhoto, you can drag images from the library into the folders. The images in the folders are reference copies of the original images, safely tucked away in the library. When you make changes to an image in one of your folders, you still have your original image to revert to if needed. As you build folders in your imaging program, you need to address only one other issue: naming. Figure 5.2 shows the information from a typical digital image file.

Figure 5.2

A typical image file has a unique number but not a default unique name.

Your digital camera will number your images but won't name them. That's your job when you get them into your computer. And how do you name them? That all depends on your project or your needs. Typically, a good way to name them is to set a name specific to the image. Leave the date, time, and place naming to the folder in which the image resides. For example, you might have a folder in your drive labeled Textures. Within the Textures folder is another folder called perhaps Marble, and within that folder are your specific marble images. Rename the marble images from IMG_0234.jpg (as an example) to BlackMarble.jpg, GreenMarble.jpg, and so on. Although this process of folders and image naming might be time-consuming now, it'll save time and frustration later. Naming and organizing your images should be a process you perform each time you bring photos from your camera to your computer. Get in the habit of this process, and you'll be exceedingly more productive.

Image Organization Software

Sometimes your system's standard digital image capabilities are not quite up to par. In that case, you can look to third-party software to help you organize your images. Some programs you can get for free, and others will cost you. Here's a list of both:

* FotoTime FotoAlbum (Windows and Mac)

* ACDSee (Windows and Mac)

* Triscape FxFoto (Windows)

* Google Picasa (Windows)

- IrfanView (Windows)
- Adobe Photoshop Elements (Windows)
- Apple Aperture (Mac)
- Adobe Photoshop Lightroom (Windows and Mac)
- Cerious ThumbsPlus (Windows)
- FotoWare FotoStation (Windows and Mac)
- iView MediaPro (Windows and Mac)
- Preclick Lifetime Photo (Windows)
- Photodex CompuPic (Windows)
- Phototools.com IMatch (Windows)
- Corel Paint Shop Pro or Photo Album (Windows)

The software today is similar in most respects, each allowing you to organize, search, name, and view your digital photos. In addition, most imaging programs allow you to export and convert your digital files on the fly. This is important when working with your images in other programs such as Adobe After Effects or Autodesk Maya. Although most digital cameras shoot JPEG images, sometimes you'll need a TIFF or PNG file. Your image-editing program, such as Adobe Photoshop, could handle the conversion, but without making too much work for yourself, it's likely that your image organization software can convert the digital photo for you.

Image organization sets a foundation for working with digital photos on a regular basis. Like an uncluttered desk at your office and an organized workspace to maximize productivity, you should set up your digital photo library in a similar fashion.

Color

Organizing your digital photos is the first step to complete image management. In addition to getting to your files quickly and easily, you also need to manage them individually. Each photo can benefit from color management. Paying close attention to each image's color depth, compression, and pixel size will help you work more efficiently later in a 3D environment. For example, if you keep every image at its default high resolution in which it was shot, as well as keep it uncompressed, you might run into a problem when you need to use multiple images in your 3D work. Add to that images that are just partially seen in your 3D work but are used as full size, and you'll quickly run into memory problems.

RGB vs. CMYK

Understanding color image management should be a priority for any digital photographer, whether you're just printing your photos for display or taking them to the next level in 3D animation. For color to exist, three components need to be present: the viewer, an object, and light. Often thought of as "noncolor," white is actually the result of seeing all the colors in the visible spectrum together. You can combine the

three primary colors in the visual spectrum—red, green, and blue—in an additive or subtractive process. An *additive* color mixing process blends the three primary colors over a black background, as shown in Figure 5.3. A *subtractive* color mixing process blends the three primary colors over a white background, as shown in Figure 5.4.

Figure 5.3 Additive color mixing happens over a black background.

Figure 5.4 Subtractive color mixing happens over a white background.

The colors in the nonoverlapping portions in the previous two images show the primary colors. Monitors, for example, display your digital photos with an additive approach by releasing light, and they work with red, green, and blue (RGB) color values. Printers, conversely, use a subtractive approach by utilize different dyes to absorb light. If you've ever prepared an image for a print shop, you know they often require a CMYK image, not RGB. Cyan, magenta, and yellow (CMY) are the three colors you see in Figure 5.4, with a subtractive color method. But although an RGB color scale can produce all the necessary colors for full imaging, CMY alone cannot. When a printer uses a black ink cartridge, CMY becomes cyan, magenta, yellow, and black (CMYK), and the full range of colors can now be reproduced.

Here's how the additive and subtractive color mixing breaks down:

Additive Color Mixing

- Red + Green = Yellow
- Green + Blue = Cyan
- Blue + Red = Magenta
- Red + Green + Blue = White

Subtractive Color Mixing

- Cyan + Magenta = Blue
- Magenta + Yellow = Red
- Yellow + Cyan = Green
- Cyan + Magenta + Yellow = Black

This book is designed to take you from digital photography into 3D. Although some 3D programs might use a CMYK image, most will require an RGB image. You should plan to use RGB images for your work in 3D, especially when your final output will be additive—that is, presented on a television or computer monitor.

Hue and Saturation

3D applications often allow you to control hue and saturation in your imported images. Hue and saturation are two properties of color that naturally occur. Color contains a range of wavelengths, and the *hue* can be described as the most dominant wavelength. The *saturation* is a measurement of a color's purity. As the color becomes more pure, its wavelength is narrow, and the blending between colors is sharp. To simplify, changing the hue value for an image will effectively tint the image. Figures 5.5 through 5.7 show how changing the hue changes the coloring of the image. Figure 5.8 and Figure 5.9, on the other hand, show how increasing the saturation brings too much color into the image, while decreasing the saturation takes the color out completely.

Hue and saturation are not something you need to control for all your images, but they are there if you need them. As a digital photographer using your images in 3D, you might find that you'll work with the Saturation values often to create quick grayscale images for bump maps or displacement maps.

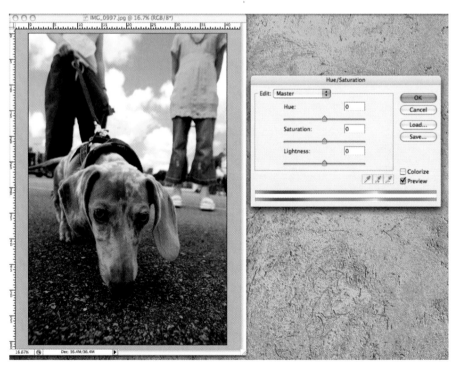

Figure 5.5 This is the original image, loaded into Photoshop CS2. You can see that the Hue and Saturation settings are 0.

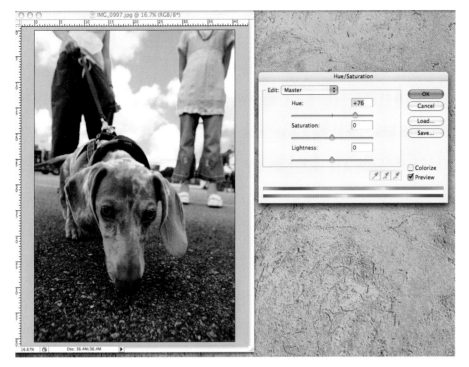

Figure 5.6 Increasing the Hue setting changes the blue sky to purple and brings the brownish gray color of the dog to more of a green tint.

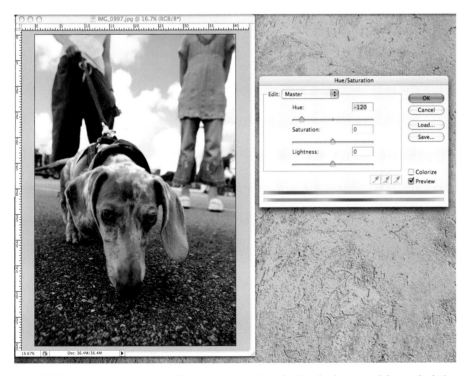

Figure 5.7 Dragging the Hue slider to the left, setting a negative hue value, tints the sky green and changes the dog's color to purple.

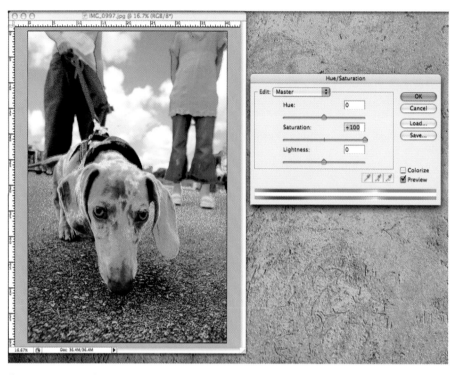

Figure 5.8 Increasing the Saturation setting strengthens the color values of the image.

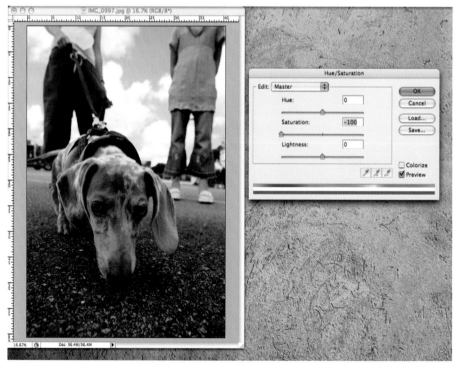

Figure 5.9 Decreasing the Saturation setting removes the color within the image altogether.

Bit Depth

Along the lines of color is bit depth. Bit depth is important when using digital photography for 3D. As a general photographer, it's not something you really need to worry about. The term *bits* is the amount of color depth an image contains. You may be familiar with a "24-bit" image. This means your image does not necessarily contain this much color data but *can* contain color precision up to this level.

Every digital image has colored pixels that contain some combination of the RGB values. The RGB values are the primary colors and often referred to as the *color channel*. By specifying the *bit depth*, you are determining the intensity of the specific color channel. The term *bits per channel* is the total of the bits in all three color channels and represents the full color available for each pixel. Now, a bit is identified in a digital image as a zero or a one (0 or 1), and true color is 24 bits per pixel. Digital cameras record images as at least 8 bits per channel, which equals 256 different intensity values for each primary color. When these primary colors are joined at a pixel-by-pixel level, you multiply (256 × 256 × 256) to see how many combinations they make, so you end up with 16,777,216 different colors.

As a 3D artist, you might be well aware of the use of 32-bit images. How does this vary from 24-bit images? Simply, a 24-bit image is true color, while a 32-bit image is true color plus a transparency channel. Many artists think they'll have better image reproduction in 3D by using 32-bit images; however, if the transparency channel is not accessed, the image will make no difference except that it takes up more memory.

Taking bit depth to the next level, you can also employ 48-bit images (48 bits per channel), which is the equivalent of 281 trillion colors. For 3D imaging, you can take advantage of this for HDR imaging, normal mapping, and more. You'll learn about these techniques later in the book. However, certain file types can handle only certain bit depths.

Image Types

JPEG images are a standard image file format that digital cameras use throughout the world. Internet and print developers often use JPEG image files. However, JPEG images can contain only 8 bits per channel. This means a JPEG can display true color, but no more, such as the transparency channel found in a 32-bit image. TIFF files, by contrast, can contain 16 bits per channel. Understanding the different types of files available can help you manage your image library for use in 3D.

JPEG stands for Joint Photographic Experts Group; this file format was designed for digital photography. These files types are great because they are much smaller than others such as TIFF or TGA files with comparable quality. The way a JPEG image can be smaller than others is because of a technique that compresses parts of the image more than other file formats. JPEG compression can vary from none to 100 percent, and the results can vary depending on the images. Figure 5.10 shows an image saved with JPEG compression at its best setting (or largest file size).

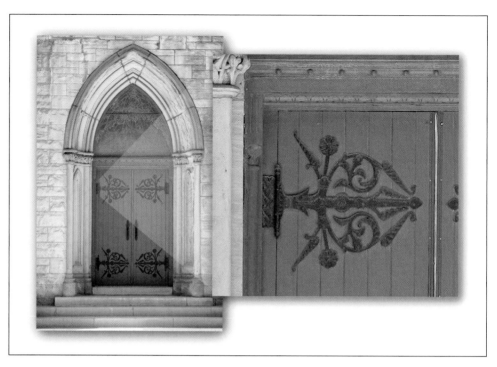

Figure 5.10 You can use JPEG compression for high-resolution images, as long as the compression setting is not too low.

Figure 5.11 shows the same image enlarged to show detail in the edges of the doorway. Here, with a JPEG compression of 50 percent, the image looks OK but is a good deal smaller in size.

Figure 5.11
With 50 percent compression, the image quality holds up while the file size decreases.

Figure 5.12 shows the same image enlarged with JPEG compression of 90 percent. Although the file size is much smaller, the quality of the image has decreased.

Figure 5.12
Using 90 percent compression, the image starts to break down in the edges of the textures, which may be a problem in 3D for image mapping.

As a printed photograph or reference shot, nothing is wrong with this picture. If, however, you were to use this image as an image map, you'd lose important quality details when rendered in 3D. You'll need a balance of compression and quality, and you'll have to determine the best balance for each project. As I said earlier in the book, each project is different and will require different images. Understanding the various options available to you will give you the most flexibility and enhanced workflow.

Other popular file formats are TIFF, PNG, and TGA (to name a few). TIFF is Tagged Image File Format, and many printers and publishers (such as the publisher of this book) prefer TIFF files. These images are a good deal larger in size, and (unlike JPEG files) TIFFs can have a bit depth of 16 bits per channel and can store layered files. Programs such as Photoshop can benefit from TIFF files and are great if you have to edit files later.

Lossy vs. Lossless

As you can see, image files can be compressed or uncompressed, and when to use compression depends on your projects at hand. You can determine compression in two ways, lossy and lossless, and there is always much confusion over the two. *Lossless* compression allows you to compress the image but save important image information, allowing you to decompress the image later. *Lossy* compression significantly changes the file size, creating much smaller files. However, lossy compression removes certain

image data, and often it is no longer identical to the original. You end up with *compression artifacts*. You should use lossy compression only if you are completely finished editing your image.

RAW

As a digital photographer, you should be aware of the RAW format. Usually used only by professional photographers, the RAW format is becoming more accessible to the everyday photographer for two reasons. First, RAW was available only on the top-of-the-line cameras, but today, many midrange dSLR cameras offer the RAW file type. Second, editing RAW files up until recently was difficult and required expensive software, but today, Photoshop offers support for RAW images, and specific programs such as Apple Aperture and Adobe Photoshop Lightroom (currently in public beta) are designed to edit RAW images. Many other general image management programs also support RAW files.

A RAW file is an image format that contains untouched "raw" pixel information direct from the camera's sensor. It is often considered the digital equivalent to a film negative. RAW files use lossless compression and have more information than TIFF or JPEG files, without compression artifacts. By shooting RAW files, you are able to balance and control many aspects of the image later in a RAW editing program (such as Aperture or Adobe Camera Raw).

White balance is very flexible with a RAW image, allowing you to change the overall tone of the image. For example, although most digital cameras automatically adjust for white balance, the sensor can misread the light conditions. Outdoor light can cast a bluish tint, and indoor lighting (*tungsten*) can cast a warmer, off-white cast. Although you can adjust the tonal quality of a JPEG or TIFF file, editing a RAW file allows you to change the white balance after the image is taken. The same goes for color and exposure control within the image. You can edit these values afterward, which is unlike adjusting the brightness and contrast. The downsides are the RAW file format is much larger than JPEG files, takes longer to save while shooting, and takes much longer to transfer to your computer.

Although you might think shooting RAW is the way to go for all your shots, it really depends on what you'll do with the photos in the end. Let's say you're shooting a studio portrait for a magazine cover. By all means, shoot RAW. On the other hand, say you're shooting textures of gravel or marble for an upcoming Department of Transportation 3D animation. The RAW format is overkill for a project like this. Not only are the file sizes huge, but you also need to edit and convert each file to use it in your 3D application. With a nice high-resolution JPEG or TIFF, you can import the image directly into your 3D program and get to work. With that said, some artists always prefer to shoot RAW and then edit their images, no matter where the image is ending up. Programs such as Photoshop Lightroom and Aperture make shooting RAW more practical than you might think.

Noise

Noise in an image is subjective. That is, some people like it, and some people don't. It seems that those coming from the film days of photography prefer a little noise in their digital images because this is sometimes thought of as the digital equivalent of film grain. Noise in digital images appears as random specks throughout the image and will appear more if you were shooting in low light with a higher ISO setting in your camera. The ISO setting tells the camera how sensitive the sensor is to light. The higher the ISO setting, the more noise, but the better you can shoot in low light, as well as fast action.

With any compression format, you will always have some amount of noise. It's important to be aware of this because if you're going to be using these images in your 3D applications, the noise can cause a problem, especially when bump mapping or displacement mapping. Figure 5.13 shows a nighttime shot of a house. This high ISO setting combined with low light creates a lot of noise in the image.

Figure 5.13 Higher ISO settings in low-light situations allow you to capture the image but also result in higher noise values.

An image like this is not suitable for most 3D work because the noise could be a problem. To avoid noise in a shot like Figure 5.13, a lower ISO setting (about 100) is a good choice. Then, using a tripod, you can take a much longer exposure resulting in a proper exposure with less noise.

Note: The ISO setting is a standard that determines a camera's sensitivity to light. ISO settings can range by factors of 2 from 50 to 2000, or more, depending on the camera. Higher ISO settings allow for greater sensitivity. An ISO setting of 200 will take twice as long to reach full exposure over an ISO setting of 100. Experiment with this on your own to see the different results.

Image Noise

Different types of noise exist, some of which are OK when working with digital images in 3D space, and others…not so much. Figure 5.14 shows an image taken with ISO 400 black-and-white film. The noise in this image comes from the higher-speed ISO but also partially from the development. In film, different development methods can increase or decrease grain.

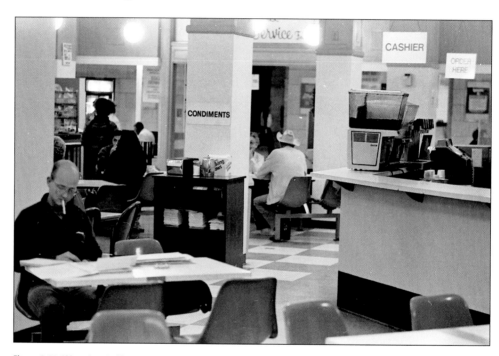

Figure 5.14 ISO settings in film are much more sensitive to grain than the ISO settings in digital.

Figure 5.15 shows a digital image, taken with ISO 800, yet you would think the noise would be greater. Often in digital photography, you can get away with using much higher-speed ISO settings without the noise.

Figure 5.15
Often in digital photography, high ISO settings such as 800 don't create much noise, as they would in film.

You might experience different types of noise based on your camera settings. With a long exposure and a low ISO speed, you'll experience fixed-pattern noise, similar to Figure 5.16.

Figure 5.16
With a longer exposure and low ISO speed, you'll experience fixed-pattern noise.

With fixed-pattern noise, you might see hot pixels. The pixel's intensity surpasses any ambient random noise fluctuations. If you were to take a photo with a short exposure but high ISO speed, you'd see a random noise pattern, similar to Figure 5.17.

Figure 5.17
Short exposures and high ISO speeds can add random noise to your digital images.

Random noise happens when you have color fluctuations above and below the actual image intensity. Most random noise comes from ISO speed, but you will always have some amount of noise in your images.

Your Next Shot

I could discuss so much more when it comes to color, noise, and file types. Frankly, you should find some time and pick up extra reading material on all the technical aspects of your digital camera. This chapter quickly brought you up to speed on key topics that are important to review when working with digital images in 3D. From here, you're ready to get into the 3D aspect of photography. I've already discussed the following: megapixels, image formats, shooting methods, your eye, angles, depth of field, and many other basic photographic principles. I've worked hard to not make this a technical book about digital photography, and to prove it, turn the page to Chapter 6, "3D Imaging with Photography," to see how your images and all the information up to this point can work for you in 3D.

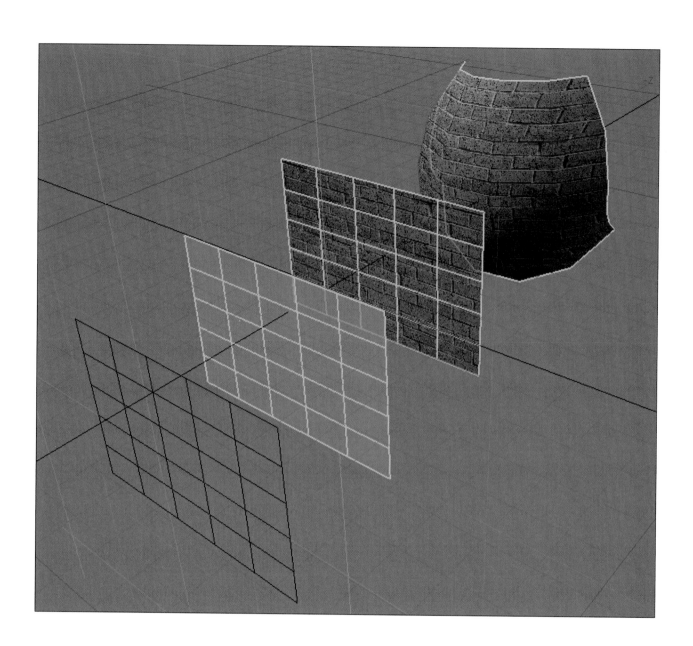

Image Mapping with Digital Photos

As you see more examples of how you can use your digital photography in 3D, one of the simplest, most common, yet most effective uses is image mapping. Image mapping is the technique of taking a digital photo and applying it onto a 3D shape—onto a flat plane, an industrial model, or a game character. This chapter will take you into 3D space and show you image mapping techniques for your digital photos. Although many texturing tutorials are available, I'll focus on how specific photographs can be useful in 3D. You'll learn about image sizes for your specific 3D needs, how you can use one photo for multiple effects on polygonal geometry, and how you can use your photos to shape geometry.

Chapter Contents
Advantages of Image Mapping
Digital Photos beyond Image Maps

Advantages of Image Mapping

The advantages and uses of image maps are wide ranging. Some artists try to avoid using photos as image maps because they think it might be cheating, but in many respects, the art of 3D is a cheat. Everything is fake—from the buildings you create to the emotions your characters evoke. The end result, the render, is your goal, and how you end up there is simply a means to an end. By incorporating digital photos into your workflow, you'll find that many of your 3D works are not only simplified but are also better looking. Figure 6.1 shows a tabletop created entirely in 3D, using only a procedural, computer-generated wood texture. Figure 6.2, on the other hand, is the same scene, but I used a digital photo of wood to create the wood tabletop.

You can see from the images that both methods work, but viewers are smarter today. Our eyes are more in tune with higher-end images, and using a digital photo to create a wood texture offers a clear advantage in gaining realism over a procedural-based texture. This is one simple image map, and clearly you could add details with additional image map layers.

Everyday surfaces contain many details that are often hard to duplicate in the computer without digital photography. Certainly, you may be a fantastic digital artist and have learned to paint your details by hand. For the rest of us, using digital photography opens a door in 3D to the real world outside the computer.

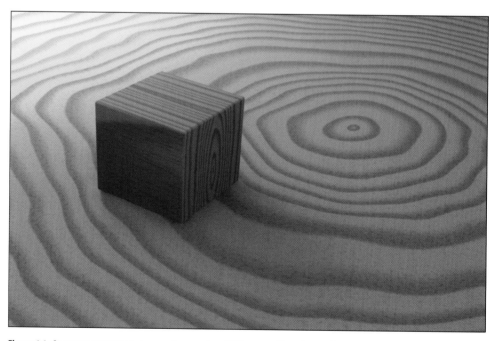

Figure 6.1 Computer-generated textures such as wood are OK for some effects, but results may vary.

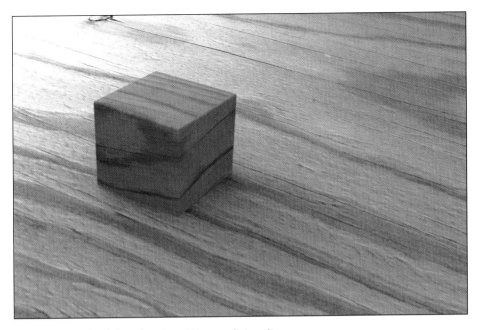

Figure 6.2 Using a digital photo of wood can yield more realistic results.

Your World

When you use digital photos as image maps in 3D space, you take advantage of real-world principles. Procedural textures are quick and easy to set up, but they lack the many nuances that are constantly around us every day. Take a look at Figure 6.3, which shows an aged pipe.

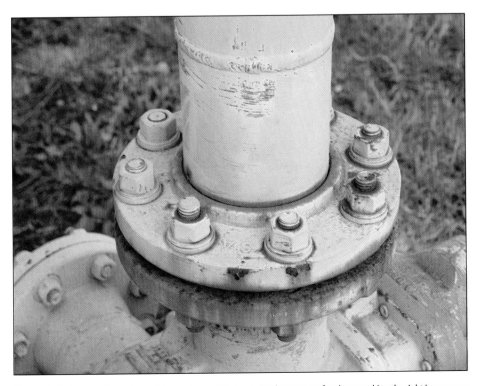

Figure 6.3 Paying attention to the world around you will help you develop your eye for photographing the right image maps.

You probably often don't notice subtleties and perhaps just discount something like this as merely rusty. But look closer. This isn't just a rusty pipe; it's much more than that. The effects of weather such as rain, heat, and cold have all taken their toll on this surface. The pipe has scratches and a few small dents from use, all of which contribute to the overall look and feel. In addition, age plays a role in the deterioration of this surface, and it's clear that the pipe hasn't been painted in years. What's funny is that if you found this pipe at your office or home, you'd most likely paint it. In the 3D world, however, we strive for surfaces like this. How would you go about creating such a surface? You can use a number of methods, but they all begin with digital photography.

In this next section, you'll see firsthand how image mapping your digital photos to 3D objects can create realistic textures. Later in the book, you'll take image mapping even further by building models from your images and then applying the images as textures. You can use digital photos for anything from creating simple pictures on 3D picture frames to shaping models from the luminance value within them. I already discussed procedural textures vs. image-mapped textures, but what often aids artists in creating realistic textures is combining image maps from digital photos with procedural textures. Applying an image map to a 3D model and then applying a procedural texture on top of that image can add a human touch. That is, everything we see in the world around us has an element of interaction from people, whether it's imperfections in the paint on a fence or fingerprints on a window. This extra touch added to age, weather, and normal deterioration are what you should strive for in your 3D models. And as mentioned earlier, it all begins with the right digital photo. Figure 6.4 shows a rust pattern and color that will serve the project well.

Figure 6.4
To re-create a rusty pipe surface, you need to first find the right digital photograph.

Once you've found the right digital photo, your work in 3D begins. Figure 6.5 shows a 3D pipe similar to the one in the photograph shown earlier in Figure 6.3.

Figure 6.5
Once you find a digital photograph, your work begins with the right 3D model.

When you import a digital photo into your 3D application, you often have the ability to image map them onto your models in many ways. You can map them flat and as planar maps, cylinders, spheres, cubes, and in some cases solids. The more you learn about your 3D program's mapping methods, the better. You can even take your image maps to the next level if you use an ultraviolet (UV) map. But on the simplest level, using cylindrical and planar image maps and using the right digital photo, you can begin re-creating reality in 3D. Figure 6.6 shows the same 3D model as in Figure 6.5 but with a digital photograph of rust applied throughout.

Figure 6.6
Using just one single image, you can image map it onto a model in various ways to begin re-creating real-world objects.

Figure 6.6 uses the same single image on the model. With just one image, you can see re-creating reality is quite possible. As you move into more complex image mapping work (also called *texture mapping*), it's important to understand the resolution, or size, of the image you'll need.

Digital Photo vs. Image Map Size

Earlier in the book I discussed resolutions and megapixels and compared them. Now when it's time to apply those great digital photos you've taken into 3D, what size should they be? Is a digital photo for print useful in 3D? How does it relate? These are all good questions, and the answers depend on your final project and the task at hand. Figure 6.7 shows a model with a digital photo applied.

Figure 6.7
Deciding the size of your digital photos for image mapping depends on the final shot. Here, the digital photo is more than large enough for the photo in the frame.

At this level, the digital photo used as the picture in a 3D picture frame works well. But what if the 3D camera moved in a bit closer, as in Figure 6.8?

Figure 6.8
With the 3D camera moved closer to the image map, the digital photo still looks good.

Sometimes, however, your 3D work will require you to move in very close to your subject, and as you can see in Figure 6.9, the digital photo doesn't hold up when viewed this close.

Figure 6.9
Move the 3D camera in too close to the image-mapped digital photo, and you suddenly are losing image quality.

So even if your digital camera shoots images at 8 or 10 megapixels, you may still need to be careful about how close you get to the image in 3D. This is because you are essentially enlarging the digital photo. Even though you've brought the image into the 3D environment and mapped it on geometry, it's still bound to its original resolution and quality. Zooming in close to the digital photo in 3D is the same as blowing it up for a large print. The larger you go (or in the case, the closer you get), the more the image will break down. So, what resolutions should you use?

Here's a breakdown of some common resolutions to which you might be rendering your 3D images and animations:

Broadcast

D1 PAL	720×576
D1 NTSC	720×486
DV NTSC	720×480
HDTV 720p	1280×720
HDTV 1080p/1080i	1920×1080

Film

Cineon Half	1828×1332
Film (2K)	2048×1536
Cineon Full	3656×2664

Determining your final output of course depends on what your project or client specifies. In many cases, rendering for broadcast at 720×486 means that most digital photos will work quite well in your 3D images. For example, if you have a digital photo mapped into a picture frame that is 4368×2912 (12 megapixels), you have more than six times the digital image you need. Taking that further, this means that if your 3D camera were to move in close to your image-mapped digital photo, you could not only fill the frame at 720×486 but you could push in to six times that distance on the mapped image without seeing deterioration in the image.

Image Size and Resources

Your image-mapped digital photos are raster images made from pixels, rather than vectors, or curves. Because of this, your images can lose quality or, more specifically, succumb to *pixelation*. This is when the pixels in the image are stretched to a point that is larger than their original shape. The result is not desirable. And although most 3D applications offer antialiasing of images as well as pixel blending, you need to remember the theory "garbage in equals garbage out." You can do only so much to clean up an image; even with image enhancements applied, you might not see the pixels of an image when viewed too closely, but you will see a blurry image. Always make sure the digital photo you're using to image map is sufficient for the 3D shot.

Of course, it's easy to say, "the larger, the better," but in 3D, size does matter, both big and small. You see, working with huge digital photographs in 3D is wonderful, that is, as long as you have the resources to handle it. One digital image can be as much as 12MB in size or more. Add that to multiple images, 3D objects, and computational data, and you can really tax your system resources. But you can avoid this as long as you determine to what your digital photo will be mapped. For example, perhaps you've photographed the cover of a book. In your 3D scene, the book never is seen more than half the size of the entire frame. If the frame is 720×486 for broadcast television, you can easily put a 400×300 size image on the cover of the book. It will render without jagged edges or blurs because the size of the image is appropriate to the size of the final render. With that said, if you have a good amount of memory (RAM) in your system, perhaps 2GB or more, always try to use digital photos that are a bit larger than what you'll actually need. It's sort of like having people over for dinner. You know everyone will eat just one filet of the grill, but it's always a safe bet to have a little more cooking, just in case.

Digital Photos beyond Image Maps

Earlier in the chapter you saw how you can use a procedural texture to create wood although an actual digital photo of wood produced better results. What really takes your 3D image mapping techniques to the next level is incorporating your digital photos into other mapping methods such as bump maps. *Bump maps* give the viewer a greater sense of realism in the 3D surfaces you create. Aside from a color image map, digital photography is exceedingly powerful when gathering and creating bump maps. Figure 6.10 and Figure 6.11 show how different an image-mapped photograph can look with and without a bump map.

Digital photography is ideal for creating bump maps because the world is full of imperfections. Even the smoothest surface has some amount of bumps, such as the imperfections in wood or the subtle inconsistencies in metal. Capturing these imperfections is easy, if you know what to look for and know how to manipulate your digital photos. Figure 6.12 shows a metal grate, photographed in downtown Chicago.

Figure 6.10
A digital photo mapped onto a 3D object is somewhat ordinary.

Figure 6.11
The same digital photo mapped with a bump map applied is a little more exciting.

Figure 6.12
A straight-on shot of a metal grate will be an excellent bump map in 3D but not until the lighting is even.

Certainly you could apply this image to a 3D plane and use it as a bump map. The problem, however, is that the image is unevenly lit. When you shoot photographs for use in 3D, you need to have them lit as evenly as possible. After all, you're going to be applying lights and shadows in your 3D application, so any existing light or shadows on an image can cause a problem. But you can correct an image like this in Adobe Photoshop. Figure 6.13 shows the image loaded in Photoshop.

Figure 6.13 This is the metal grate image loaded into Adobe Photoshop CS2.

Your first job in balancing this image is to convert its color. Select Image > Mode > Lab Color, as shown in Figure 6.14. RGB color gives you channel control over the red, blue, and green color channels, whereas Lab Color will give you access to the Lightness channel. Select the Channels tab, and then select the Lightness channel, as shown in Figure 6.15.

 Note: If you don't see the Channels tab (next to the Layers tab), just select Window > Channels from the menu bar.

Figure 6.14
Select Image >
Mode > Lab Color.

Figure 6.15
Using Lab Color, you gain access to the Lightness channel of your digital photo.

With the Lightness channel selected, you can balance the levels. You can do this by using Photoshop's Shadow/Highlight tool. Select Image > Adjustments > Shadow/Highlight, as in Figure 6.16.

Figure 6.16

Use the Shadow/ Highlight tool to balance tone in your images.

You typically would use the Shadow/Highlight tool for making someone's face brighter when they have been photographed with light from behind, such as in front of a window. It's also helpful for dark shadows outdoors when the shadow is so dark that you can't see anything but black. The Shadow/Highlight tool will lessen the shadow. This tool is exactly what you need for balancing the metal grate image. Usually, you'd use the Shadows Amount slider to lessen shadows, but in this case, you're going to change the Highlights Amount setting. If you drag the Highlights Amount slider to 100 percent, you can see that the image almost instantly evens out. Some hotspots still appear on the left, but overall the tonal image is much more balanced with this single change. Figure 6.17 shows the change.

Figure 6.17 By increasing the Highlights Amount setting, the tonal quality of the image balances out.

Remember, you're adjusting the Lightness setting of the image because you're using Lab Color mode. However, returning to RGB mode will show all the color within the image and change the look slightly. Instead, select Image > Mode > Grayscale. The left side of the image still has a bit of shine to it from the original light when the photo was taken, and overall the image is a bit dark. First, select the Burn tool from the toolbar, as shown in Figure 6.18. This will allow you to paint some darkness.

Figure 6.18

Select the Burn tool from the toolbar.

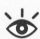

Note: Dodge and burn are old photography terms that were used in the darkroom when printing pictures. Since Photoshop originated as a "digital darkroom," it's only fitting that these tools are included. Dodging a photo in the darkroom means certain areas of the print were less exposed to light than others. Typically the photographer would slowly move his hand between the light and the print during exposure. On the flip side, burning allows more light on certain areas of an image. In the traditional darkroom, photographers would add additional exposure time to certain areas of a print. You can do the same today in Photoshop.

With the Dodge tool selected, press the right bracket key on your keyboard (two to the right of the P key) a few times to increase the size of the Dodge tool's brush. Keep sizing it until it's about 1500 in size; you can see the size of the brush at the top left of the Photoshop interface.

Change Range to Highlights, and set Exposure to about 25 percent, as shown in Figure 6.19.

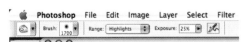

Figure 6.19

You should apply Range for the Burn tool to highlights with minimal exposure.

Then, click and drag over the brighter areas of the metal grate image. The area in question is the left side. Figure 6.20 shows the result.

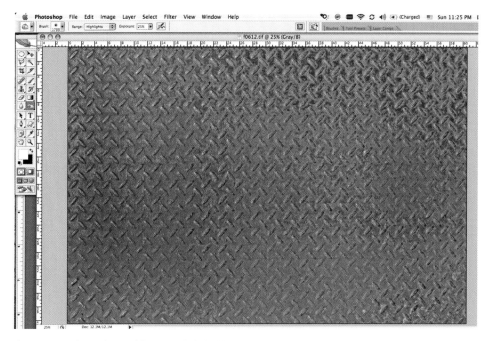

Figure 6.20 With a quick pass of the Burn tool, the highlights in the image for the most part are now even.

Not bad! But the image is still a bit dark. Select Image > Adjustments > Levels. In the Levels panel, change the last input level to 175. You can click and drag the small triangle at the bottom of the graph as well. Figure 6.21 shows the change.

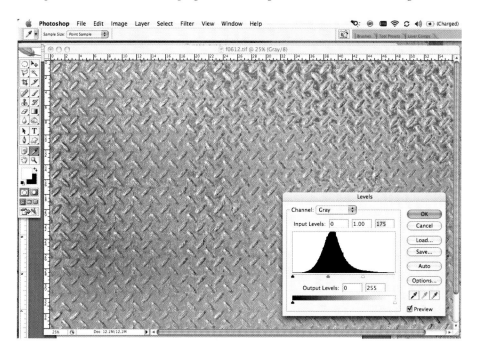

Figure 6.21 Use the Levels tool to brighten up the digital photo.

The only task to do now is save the image and load it into your 3D application. The tonal quality of the image is good and balanced. Figure 6.22 shows the final changed image.

Figure 6.22 With the Lightness value changed and the Highlights setting adjusted, the original image is ready for the big leagues in 3D.

Once your image is in your 3D program, you can apply it as a bump map. For example, Figure 6.23 shows the grate image applied as a bump map to a flat polygon.

Figure 6.23
This is the final metal grate digital photo mapped onto a single polygon in 3D space and applied as a bump map.

Bump mapping works because your 3D program looks at the color value of each pixel. The brighter values provide "bump" while the darker values do not. In fact, the bump mapping technique found in 3D applications looks at all values within an image. You can create bump maps with any image, not just grayscale. You may find that many artists, often out of habit, create grayscale images for their bump maps. These grayscale images are good to use because you can obtain greater control over what will bump and what will not. However, depending on the image at hand, you don't necessarily need to convert to grayscale. Figure 6.24 shows a digital photo that will work well for bump mapping. Figure 6.25 shows the result of the image as a color bump map, and Figure 6.26 shows the same image as a bump map with the image changed to grayscale.

Figure 6.24 This is a digital photo that will be used as a bump map.

Figure 6.25 The digital image is mapped and applied as a bump map in 3D.

Figure 6.26 The same digital image is first changed to grayscale and then applied as a bump map in 3D, yielding pretty much the same results.

There's not much difference in those two renders, is there? You see, what you photograph for use as a bump map can vary greatly. Understanding that you don't always need to use a grayscale image will help save memory and computer resources, as well as time, when creating 3D textures. Bump mapping is essential to any 3D project you work on, even for the slightest variations in surfaces—from machine markings in metal to bumps on an orange to imperfections on a painted wall. What takes a bump map further is the use of specularity mapping. You can create a specularity map with the same digital photo used for a bump map. Figure 6.27 shows the same model in Figure 6.26 with a specularity map applied.

A specularity map takes your applied digital image to the next level by telling your 3D program to use the high and low values in the image as a guide to specular placement. The greater values in the image allow more specularity, more shine. The lesser values hold back the specularity. Take a look at anything, even your computer mouse. Notice how the light falls in and out of the surface? Even at the smallest amount, light does not create perfectly round hot spots, and you can control this with your applied digital photos.

Figure 6.27 With a specularity map applied from your digital photos, you can add more realism to 3D models.

Displacement Maps from Digital Photos

You can really create magic in 3D with digital photography and image mapping. As you've seen throughout this chapter, mapped photos work well for simple image placement to texture creation. But your digital images are powerful enough to shape 3D geometry by using displacement maps. Similar to a bump map, a *displacement map* uses the high and low values in an image for its effect. However, a bump map creates only a visual bump—a fake, if you will; your 3D model doesn't undergo a physical change. A displacement map actually changes the geometry. In addition, many 3D applications today offer the power of micropolygon displacement, allowing even greater detail to be generated. Figure 6.28 shows the same donut shape as in Figure 6.27 but with a displacement map applied rather than a bump map.

Figure 6.28 A displacement map is created from an applied digital photo, and the model is physically changed.

Displacement maps are quite powerful in that you can create complex shapes with simple geometry. You can gain access to demographic elevation models (DEMs), and although they're not exactly digital photos, they are satellite images that you can use to accurately displace a model to create a specific terrain. This technology for many years was not available to the everyday 3D content creator, but with the advancements in systems and resources, this technique is much more common. When shooting for displacement mapping, the biggest issue is lighting, just as it is with bump mapping. The technique demonstrated earlier in the chapter shows you how to correct images that are unevenly lit, but it's best to take shots with as little shadows and harsh light as possible. Figure 6.29 shows a digital photo that won't work so well for displacement mapping, whereas Figure 6.30 is significantly better.

Figure 6.29 Shooting for displacements requires images unlike this one. Here, the shadows are too heavy, and the light is uneven.

Figure 6.30 Finding the right image for a displacement map can be difficult but will save you more time in the 3D environment. Here, tones are even throughout, and shadows are minimal.

Figure 6.29 might not be too useful for displacement mapping, but it's actually quite useful for image modeling and reference. Let's say your project requires you to rebuild this building for a client. It would be nice and easy to take the photo, apply it to a flat plane in 3D, and have the model displaced as needed. However, this image doesn't quite lend itself to such a task, but you can create this without much effort. First, when you shoot images like this, take more than one image. Figure 6.29 shows the reference for what the final 3D model should look like. By contrast, Figure 6.31 shows a close-up of the stone on the building. By having a digital photo of both the stone and the building itself, you can model and texture to match the real-world object.

Figure 6.31 By taking a close-up photo of the stone used to build the structure, you can create 3D elements and apply this image as both a color map and bump or as a displacement.

Note: You should know that displacement maps can take a significant amount of time to render and are often very taxing on system resources. If you're creating a 3D model, something like Figure 6.29 and your camera will not be traveling too close to the wall, you have absolutely no reason to use a displacement map. This is the beauty of bump maps—they give only the appearance of a displacement.

Second, when shooting for displacement maps, consider your angle. Earlier in the book you learned how important angles were to shooting when you will be using your images in 3D. This is important no matter what you'll be using the images for, from regular image maps to bumps and to of course displacements.

Normal Mapping

But how does normal mapping fit into the scheme of things with image mapping and digital photography?

Mapping is the process of bump mapping but much more powerful. A bump map, as shown earlier, uses a single channel approach for data that is interpreted as grayscale; a normal map will use multiple colors of an image. Even though you can create your bump maps with color images, your 3D software is looking only at the high and low values of gray. A normal map, on the other hand, is determined by the red, green, and blue values within the image. This technique is greatly used in video-game modeling because very low polygonal objects can appear to have much more detail. Normal maps are not usually created from digital photography, but they can be.

One way of creating a normal map is to take the appropriate digital photo, apply it to your model as a displacement map, and then have your 3D program generate a normal map from the displaced, higher resolution object. You can then reimport the normal map and apply it to a lower resolution model to create the same look at the high-resolution one.

The process for creating a normal map with a digital camera is more involved than shooting for a color, bump, or displacement map. Lighting is extremely important and often has to be specifically controlled. This makes shooting with available light more difficult. On the flip side, shooting in a studio with controlled lighting will give you the control you need. Photoshop has a really easy method to create normal maps in Photoshop directly from your digital images. Of course, they should be evenly lit. Once imported and converted to grayscale, you can convert them easily with nVidia's Normal Map creator plug-in, found here:

http://developer.nvidia.com/object/photoshop_dds_plugins.html

This plug-in is not available on the Mac at this time, however you can check out the ATI Normal Mapper at: http://www.ati.com/developer/NormalMapper_3_2.zip.

However, if you have an evenly lit image, you can create a normal map with just a bit of work and no plug-ins. Since normal maps store RGB normal data in the direction of the viewer, a straight-on shot is important.

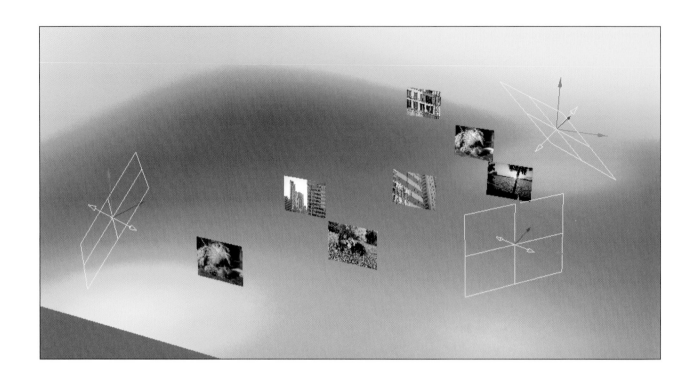

3D Imaging with Photography

7

Perhaps your work is mostly 3D, and you're starting to incorporate digital photography into your workflow. Or, maybe your work consists mostly of digital photography, and you're looking to 3D programs to enhance your image presentation. Whichever is the case, this chapter will guide you through some interesting techniques and uses for your digital photos.

Chapter Contents

Creating an Interesting 3D Slide Show

Have you ever created a slide show with your digital photos? Perhaps you've used Apple's iPhoto to quickly generate a photo slide show with the "Ken Burns effect" where the images slowly push in and pull out. Maybe you've played around with Photodex's ProShow on your Windows computer. You can use a slew of programs to turn your digital photos into a smart presentation. However, with the technology today, any Tom, Dick, or Harry can create a slide show. Choose some pictures, pick a song, and click a button. Bam! You have an instant slide show. So how can you make your slide shows better? What separates you from the pack is 3D. Read on to learn how you can bring your digital photos into 3D and animate them. You can create the project in this section using any 3D program that allows you to create a flat polygon, image map a photo, and animate the 3D camera. Figure 7.1 shows a render from the project.

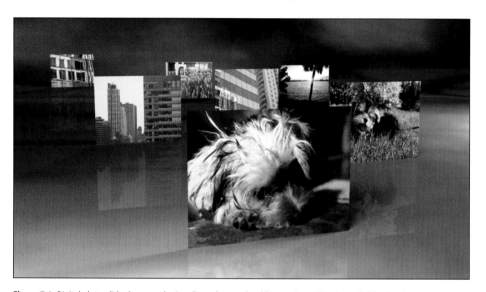

Figure 7.1 Digital photo slide shows are boring. Go to the next level by creating a 3D animated slide show!

A 3D digital photo slide show has much more impact than an ordinary slide show created with a photo management program or cut together in a nonlinear editor. Anyone can do that! Not too long ago, using 3D to create a digital photo slide show probably would not have been wise, simply because of render times and resources. Importing multiple images, even a dozen or so, could have really slowed your system, but today 3D applications are much more efficient, computers are faster, and systems have more base memory. Here's a good example of how a 3D slide show can be more effective than the ordinary flat slide show: Your client is a regional politician up for reelection. All they can give you, based on the election campaign's small budget, are photographs and newspaper clippings. Rather than just slapping them up on the screen for the viewer, you can apply them to flat polygons, put them onto a 3D set, light them with creative studio-type lighting, and render them. And rather than moving the photos around (which is always an option), it's often more interesting to move the 3D camera around the pictures, like an obstacle course. You can set this movement to an audio voice-over or to music as needed. What's more, you can add 3D text floating in front of the images for added value. It's a simple setup, with a great-looking result.

You can create your own digital photo slide show with just about six or eight photos from your library, or you can use the photos provided for this chapter on the book's DVD. This project begins by creating flat planes in your 3D modeler. They do not need to be subdivided or segmented; they're just single, flat, one-sided polygons. You'll do this in the next section.

Creating the 3D Shapes

Open your 3D application, and access the 3D modeling portion. Although it doesn't matter what axis you create your polygon in, it's best to orient it to your 3D camera. In most systems, this will be a flat plane on the z-axis.

1. Draw a flat plane on the x-axis and y-axis, without depth on the z-axis. Figure 7.2 shows the LightWave 3D version 9 modeler with a flat polygon created.

Figure 7.2 I created this flat, one-sided polygon in LightWave 3D, but any 3D program will do.

2. When creating 3D geometry for digital photos, you'll want to keep the aspect ratio intact. For horizontal images, the polygon in Figure 7.2 is 4 meters (m) wide by 3m tall.

3. Once your polygon is created, you need to assign a unique material to it. The reason for this is so that each photograph can be mapped on its own geometry. For the first polygon, you can assign a material name and then create a specific surface named for your chosen image (or simply use Picture_1 or something similar).

4. To help keep you organized, change the base color of each polygon you create. This way you'll know that each polygon has indeed had a unique surface applied as you build your 3D scene. Figure 7.3 shows the first polygon with a surface material applied.

Figure 7.3 This is the first polygon, which a digital photo will be image mapped to, with its own unique surface.

5. Now, save the object in its own directory. The easiest way to continue from here is to resurface the same object. (Rebuilding the same polygonal shape not only wastes time but also risks errors in size difference.) Instead, since the first polygon is already saved, assign a new material name, such as Picture_02. Then, save this as a new object. Continue the process until you have enough polygons with unique surfaces for your 3D slide show.

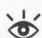

Note: Depending on what pictures you choose to use in your 3D slide show, some may be horizontal, and some may be vertical. You can take one of your 4:3 horizontal images and rotate it 90 degrees for a vertical picture.

6. Once you have enough polygons for your pictures, you need to create a new object for the set the pictures will live on during the animation. Depending on your 3D program of choice, create this object in a new layer or as a new mesh. Do not create it with the previously created flat polygons.

7. For the set your pictures will reside on, you can create a 3D cyclorama (cyc). If you've ever been to a photography studio and have seen a large wallpaper-like cloth dropped down in back of the set and onto the floor, you've seen a cyc. You can use this cyclorama for so many projects in 3D, including product shots, character studies, and prerendered backgrounds for use in other programs. Create a large box, roughly 80m or larger on all sides. Give it a few subdivisions on the x-axis, y-axis, and z-axis, as shown in Figure 7.4.

Note: If your flat polygons are roughly 4m in size, you'll need enough room for multiple copies within your set. Be sure to make the set big enough so you're able to freely place the images for animation. For example, if you have 10 images, you'll need at least a 40m box, and that's before you begin spacing them.

Figure 7.4 To create the 3D set for the digital photos, build a box with multiple segments.

8. Once you've created the box, convert the mesh to a subdivision surface, turning your polygons into curves. Figure 7.5 shows the model.

Figure 7.5
The box model converted to subdivision surfaces smooths out the geometry.

Note: Most 3D applications employ subdivision surfaces. A subdivision surface changes rough, coarse mesh objects into smooth curves. Each polygon patch within your object is subdivided, and the result is a smooth-flowing model, allowing greater control over shape without added geometry.

9. Once you've applied the subdivision surface, flip the polygons inward. Remember, this is going to be a 3D set, and you'll essentially be animating inside it. Figure 7.6 shows the result.

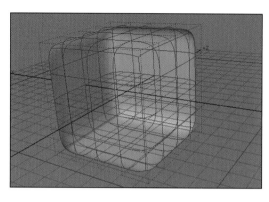

Figure 7.6
Once the box is created and subdivided, flip the polygons inward.

10. In a side view, use a vertex translation tool, such as move, to drag the corner of the box up and in. This will smooth out the bottom, back corner of the box, creating the cyclorama look often found in photographers' studios.

11. Continue shaping the box from a side view to essentially "recline" the back wall of the cyc. Figure 7.7 shows the example.

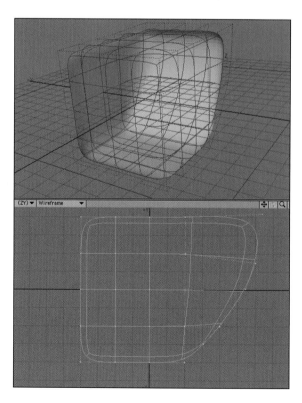

Figure 7.7
Drag the bottom, back corner of the box up and in to create the cyclorama. Note that the backside is facing the positive z-axis.

12. Continue shaping the box by moving or dragging vertices from the front view to fan out the sides, as shown in Figure 7.8.

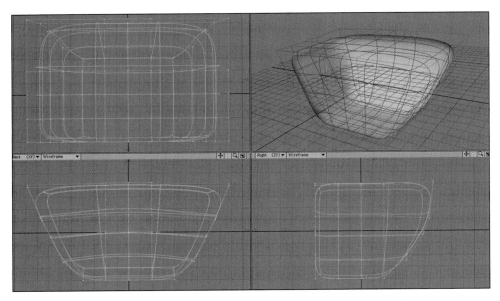

Figure 7.8 Continue shaping the vertices of the cyclorama from the front side to fan out the walls.

13. Next, since you won't need the front side and top of the box, select the polygons that make up those areas, as shown in Figure 7.9.

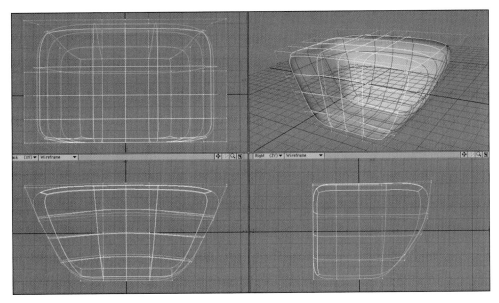

Figure 7.9 Select the front and top polygons of the box.

14. With the front and top polygons selected, remove them. Figure 7.10 shows your 3D cyclorama.

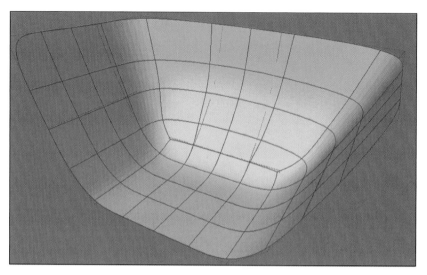

Figure 7.10 With the front and top polygons of the box removed, your cyclorama is just about complete.

15. Finally, apply a material or surface name to the cyclorama so it can have a unique 3D surface.

16. Save your model!

That wasn't a lot of work, was it? Sure, it can be a bit tedious to create, surface, and save copies of the polygons so you have enough of them for all your digital photos, but once you've done this, the hard part is done. From here, the project becomes more fun.

Setting the Scene

Simple geometry. That's all it takes to get your 3D slide show underway. The beauty of something like this is that in no time you can build the flat polygons you need for each digital photo. Once you map a digital photo onto the polygon, you can replicate it through instancing and use it repeatedly throughout the 3D scene. With a 3D cyclorama, you have created an environment for the 3D digital photos to reside. This is always a much better way to go; not only does it eliminate the worry of seeing the end of just a flat floor, it gives you a way to "catch" the light, as you'll see shortly.

1. Hop on over to your 3D animation program, or change to animation mode. If the new objects are not loaded, well, load 'em up!

2. Once you've loaded the objects you've created, place them staggered, something like in Figure 7.11.

Note: If your picture objects seem too large for your set, don't change them. Rather, select your cyclorama set, and size it as needed.

Figure 7.11 Place the picture objects around the 3D set.

3. With the picture objects in place, load your chosen digital photos into your 3D application. Then, apply each image to a polygon.

4. When applying the digital photos to the 3D objects, you'll want to planar image map them on the facing axis in which they were created. For the object examples described earlier, the digital photos are mapped on the planar z-axis. Figure 7.12 shows two polygons mapped with digital photos.

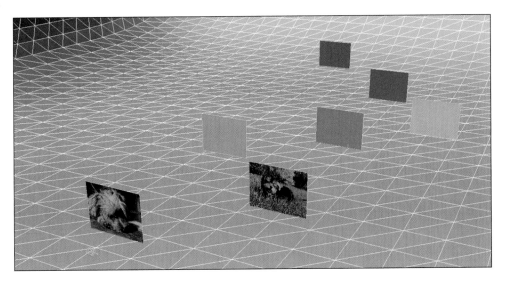

Figure 7.12 Two polygons have digital photos mapped to the planar z-axis.

5. Continue mapping all your photos. If you think you should add more, just follow the previous steps to create additional polygons with unique surface names. Then, apply them to your scene. Figure 7.13 shows all the digital photos mapped to the 3D objects.

Figure 7.13 Continue mapping your digital photos to the remaining 3D objects.

6. After the images are mapped to the polygons, be sure to save your work. You'll still need either to apply a digital photo to the cyclorama set or to use a computer-generated texture. For now, simply set the set color to a soft beige. Now you'll start creating the lighting for your scene, which is what helps this slide show really shine (pun intended!).

Lighting the Scene

How you go about lighting your 3D scene is really up to you and what you're comfortable with based on your program. If you like to use spotlights, go right ahead. Perhaps you're more of an omni-light type of person—no problem. However, the project here will use area lights for bright soft light with soft shadows.

Based on a simple three-point scheme, the 3D slide show will begin to come to life. You're not locked to this setup, but it's a good place to start. Figure 7.14 shows the setup.

Figure 7.14 Here you have a basic three-point lighting setup to begin lighting the slide show set.

1. For more specific control, the backlight can be a spotlight if you like. Add a spotlight to streak across the back of the cyc as you see fit. If you've spent time in a photographer's studio, simply mimic what you'd set up there. Instead of a person as your subject, you have flat 3D objects. Figure 7.15 shows a render of the scene so far.

Figure 7.15 After you have set up the initial lighting for the scene, use additional light to enhance the backdrop.

2. Feel free to add lights to your set. The light on the set in the back-left corner comes up from below. Perhaps add a light from above on the dark area to the back-right corner of the set. A warm light color, something from off-white to orange, might work well. Figure 7.16 shows the render.

Figure 7.16 Add lights to illuminate the set's darker areas.

3. Next, you can see that the lighting in the scene is good. It's not overpowering. But, some of the images appear a little dark. Although you could put more direct lighting on them, you don't want to take away from the set lighting you've already set up. Instead, increase the luminous value for each image until it's balanced with the existing lighting. Figure 7.17 might give you an idea of how the mapped images should look.

4. To add a little more interest to the cyclorama set, you can apply some noise to the object, using either a digital photo or just a computer-generated procedural texture.

5. You can add even more interest to the scene by making the set reflective. Increase the reflection value of the set to about 10 percent. Take a look at Figure 7.18 to see the result.

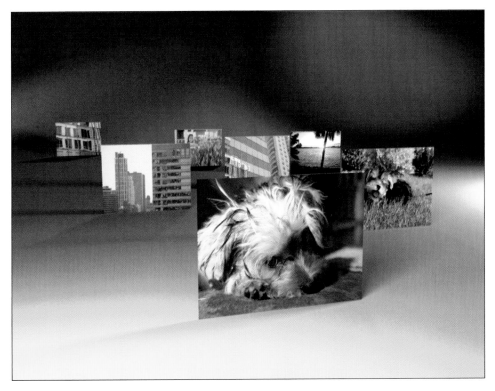

Figure 7.17 Increase the luminous value for each of the mapped photos to brighten them.

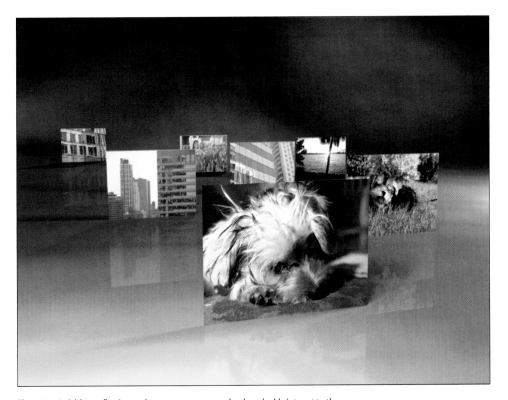

Figure 7.18 Adding reflection to the set creates greater depth and adds interest to the scene.

6. Often in photography and video studios, you can use gobos or cookies for added interest on a set. This is basically a filter, or plate with a shape cut out of it, that goes in front of a light to only allow so much light to pass through. Although many of these gobos are precut shapes, you can use digital photos for the same effect in your 3D program. Figure 7.19 shows a digital photo of a tree and its branches, useful for a creating additional interest on the back of the 3D set.

Figure 7.19 A digital photo of a tree and its branches will work well for a light gel.

7. Some systems will work with this digital photo just fine, but for maximum effect, you can change it to a grayscale image and increase the contrast. You see, the white areas will allow more light to pass through, and the black areas will hold back light. The result is that light is interrupted; not only is this a good look for a 3D set shown here, but it's a great way to create the effect of shadows from a tree or window frame. Additionally, blurring the image will soften the final effect. Figure 7.20 shows the image this scene will use.

Note: You don't need to use Adobe Photoshop to create a gel from a digital photo, although you certainly can if you like. Many everyday image management programs allow you to create a grayscale image. And, some programs allow you to sharpen the image, right? Try sharpening with a negative value, and often you can create a blurring effect if no specific blur tool is available. Save that image, and then repeat the steps to blur some more!

Figure 7.20 I changed the digital photo of the tree branches to a grayscale, boosted its contrast, and blurred it.

8. With the image loaded into your 3D application, create a new light. Place the image as a projection image on your light. Now, certain systems will handle this differently, but you can often find this control within the light properties. Some systems require you to use a spotlight for the effect.

9. Once the image is attached to the light, position the light so it streaks across the back of the set, blending with the additional set lights. Figure 7.21 shows the rendered result.

Figure 7.21 Using a digital photo attached to a light source, you can create a gel just like in a photographer's studio.

Creating a 3D set for your digital photos is something you can do just once and then reuse it time and time again. Any time you want to add more images, just make additional polygons, and map the new photos onto them. In this project, you saw how the photos are placed standing up, independently. Next, you'll see how to animate through them for the final result. But you can also use this same set in another way, such as stacking the photos. Read on to see how to animate the camera though this scene, and then continue to the next project to see how you can animate the image building onto the set.

 Note: The next section will show you how to animate this scene of digital photos, but you can always stop here. Use these techniques to create one larger digital photo by just rendering the image. You don't need to always animate if a still image is what you want. This is a great way to present a large number of images in one single frame.

Animating the Scene

Too often in 3D animation, users just move the objects around. Sure, that works well, and in fact, you'll do that soon for yourself. But a clever way to work through animated digital photos is not to move the pictures but, instead, to move the camera. This project will continue where the previous one left off and show you how animating the camera can create a cool digital photo slide show in 3D.

1. Begin by loading the scene you created earlier that incorporates a number of image-mapped digital photos and a 3D lit set.

2. When you're creating a 3D slide show such as the one here, you need to take your time moving through the images. Let's say you created an ordinary slide show in your photo management software. How long would each photo appear before you transition to the next? Five or maybe seven seconds? So, if the scene in this project has 7 pictures and you need to see each for roughly 5 seconds, you need at least 1,050 frames (given a 30-frames-per-second animation). That's 150 frames per slide times 7 slides. Now, you also have to take into account transition time. How long will it take to move between each image? Two or three seconds? OK, then maybe start your animation with about 1,500 frames (50 seconds).

3. Animating through these images should be evenly paced. What's the best way to do that? One way to set this up is to work with one first keyframe and one last keyframe right from the start. Move your camera close to the first image, but offset it and create a keyframe at frame 0 to lock it in place. The idea behind this is that as the animation starts, you pass by the first image rather than open up on it. Figure 7.22 shows the shot.

Figure 7.22 Set up your first shot offset from the first image.

4. Ordinarily you would keyframe animations in order, starting at the beginning and working your way toward the end. But with so many images to animate through in this scene, it'll be hard to judge the timing equally. So, move your camera to the ending shot of your animation, and create a keyframe at frame 1500. Figure 7.23 shows the shot.

Figure 7.23 Create a keyframe at the end of the scene for the last shot.

5. Now that you have a first and last keyframe, after you save your scene, jump to a top view of the scene. Perhaps switch to a wireframe shaded view to see all the elements better.

6. In Figure 7.24, you can see that the camera has its motion path visible. If your system has a visible motion path feature, be sure to enable it. This will help you determine the additional keyframes needed. By you setting the first and last keyframes, the computer has interpolated the frames in between. All you need to do now is change the camera's x-axis position and rotation. The movement on the z-axis is already in place.

Figure 7.24 A view from the top of the scene allows you to see the entire camera position at its first keyframe and at its last.

7. At frame 120, drag the camera to the right on the x-axis. Figure 7.25 shows the new position. This moves the camera across the first image in the animation.

Figure 7.25
Four seconds into the animation, frame 120, the camera is moved to the right on the x-axis, passing the first image.

8. Drag down your Timeline to about frame 280. At this point, the camera will be closer to the second image. Create a keyframe for it here. But also, rotate the camera so it's looking at the second image. Figure 7.26 shows a split view with the top view and the camera view both showing.

Figure 7.26 Move the Timeline to frame 280, and create a keyframe for the camera while also rotating it to see the second image.

9. Move the Timeline to frame 560, and the camera will be close to the third image. Rotate the camera to see the image, and this time, move it down slightly on the y-axis. Also for interest, rather than rotating the image on the heading (X and Z-axis) or Pitch (Y-axis), try rotating it on the bank channel. Figure 7.27 shows the setup.

Figure 7.27 For the third image, move the Timeline to frame 560, and rotate the camera to see the image.

10. Can you see how setting the first and last frames initially has made it easier to judge the timing between images? The computer has determined the time needed to go from frame 0 to frame 1500 on the z-axis. All you're doing now is positioning the camera's x-axis and y-axis positions to see each image. Add a slight rotation for the camera's heading and bank channels, and you've got it going. Continue this process for the rest of the images until you reach the end of the animation. Figure 7.28 shows the setup of the camera with the motion path.

Figure 7.28
Move the Timeline to frame 280, and create a keyframe for the camera while also rotating it to see the second image.

11. To further enhance this animation, you can add motion blur and depth of field to it. As you pass by the edges of the images, the motion blur will help add realism to the scene. The depth of field will slightly blur the images beyond the camera's focusing, adding even more to the scene. Figure 7.29 shows a shot from the middle of the animation with motion blur and depth of field applied.

Note: Take a look at the 3D_Slideshow.mov file on the book's DVD to see how this final animation looks rendered!

Figure 7.29 Adding motion blur and depth of field to the scene adds greater realism to the animation.

Stacking Photos in 3D

The previous projects showed you a way to build your images into a 3D scene and animate through them. You added a great-looking 3D set as an environment for the photos, and you can use that same set for an entirely different type of animation. Figure 7.30 shows a render from the animation described in this section. It shows a stack of digital photos, which are animated into the camera frame. You can do this with keyframes or dynamics.

Note: For an added touch, I scaled down the images slightly when I mapped them, and I disabled any repeating. The base polygon color is set to off-white, and the result is a border around the picture. Who needs Photoshop?

Figure 7.30 Changing the project up a bit, this animation brings each image in with 3D dynamics.

The project begins in the same set as the previous project. Figure 7.31 shows the flat images now laying flat on the y-axis, as opposed to standing up as in the previous project. They are also floating above the floor out of camera range.

Figure 7.31 To begin the animation, the image-mapped objects are floating above the floor out of camera range.

You have two options to animate these images into frame. First, you can apply dynamics if your system has the capability. With dynamics, simply add gravity with a −9.8m per second value on the y-axis, and calculate. Be sure to set the cyclorama as a collision object to effectively catch the dropped image.

You can even take this idea a step further and apply a cloth effect to the picture so it waves and deforms slightly as it drops.

Second, you can simply keyframe them down. If each photo should take approximately four seconds to land, you need to create keyframes for each image so it holds in place, out of frame, until it's time to drop. Otherwise, if all objects use the same keyframe, they'll all drop at the same time, which is OK, of course, if that's the look you want.

In the following steps, you'll use keyframing:

1. Set the first image you want to fall in place, out of camera range, if it's not already. Create a keyframe for it at frame 0. At frame 120 (four seconds), move the image down to the set. Create a keyframe to lock it in place. Figure 7.32 shows the image.

Figure 7.32 A single digital photo mapped to a flat polygon is animated down into the camera frame.

2. If the first image came down and landed at frame 120, you wouldn't want the next image to start until this time. So, select the second image, and create a keyframe for it at 120 out of camera range (assuming it already has a keyframe out of camera range at frame 0).

3. Then, move the second image down on top of the first image but offset. Perhaps even rotate it a bit. Create a keyframe for this new position at frame 240. Figure 7.33 shows the render.

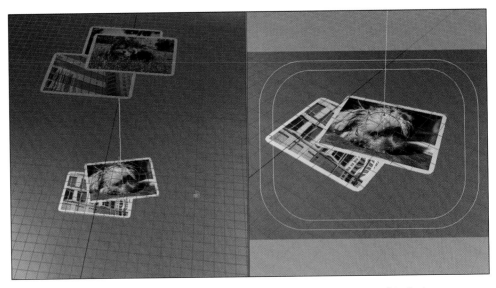

Figure 7.33 A second image is now animated down into the camera frame, resting on top of the first image.

4. Now, create a keyframe for the third image at frame 240. This holds the image in place until the second image lands. Then, move the third image down on top of the first two image, offset like the previous, and create a keyframe at frame 360. Frame 360 is 4 seconds from 240, so you can see that your images are consistent in their entry. Of course, you can change this timing however you see fit, perhaps to match the timing of music or a voice-over. Figure 7.34 shows the third image in place.

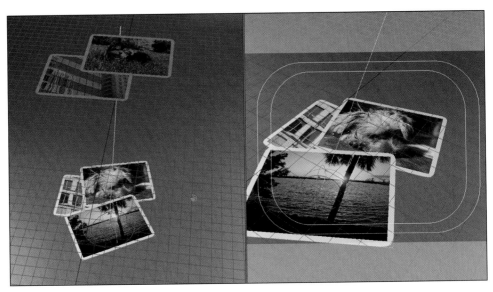

Figure 7.34 The third image is animated down into camera view, coming to rest on top of the first two images.

5. Continue this process for the rest of your images. Feel free to add keyframes to the motion of the picture if you like. As you did earlier with the camera, keyframe the picture at its start and end positions. Move the Timeline to the point at which the picture is in motion, and then adjust the position, creating a keyframe at that frame.

 Additionally, feel free to animate the camera slightly, perhaps zooming in slowly or panning around the images as they land. Be creative, and explore the different possibilities available to you within your system.

6. Finally, you should set an ease-in and ease-out to each of the images. You don't want an images to just land at one continuous speed. You want the images to ease into their resting positions.

Going from Photos to Particles

You can take the techniques described so far to many new levels. This section will show how you can use your digital photos in conjunction with a 3D particle system. Many 3D applications come with a built-in particle generation system or at least an add-on module. Programs such as Autodesk's Maya, NewTek's LightWave, Softimage's XSI, or Maxon's Cinema4D all have decent particle systems that can utilize digital photos. The process involves setting up a particle generator and then assigning images to those particles. Each program will approach this process in its own way, so the following information will offer insights and general instructions to the technique. It should spark some ideas for you!

Animated images are nothing new, but in 3D it's a different story. Even with the amount of 3D today on the Web, on television, and in movies, when it comes to moving pictures, for the most part it's on a 2D level. The previous exercise in this chapter showed you one way to animate a 3D scene with digital photos. This project will show you how you can "blow" around the digital photos using particle generation. Using particles might vary greatly between 3D programs, but the basic principles are the same: load a generator/emitter, set the particles' birth rate, set them in motion, and then apply a surface type to them, such as smoke, fire, water, or in this case, images. Figure 7.35 shows a shot of the final animation.

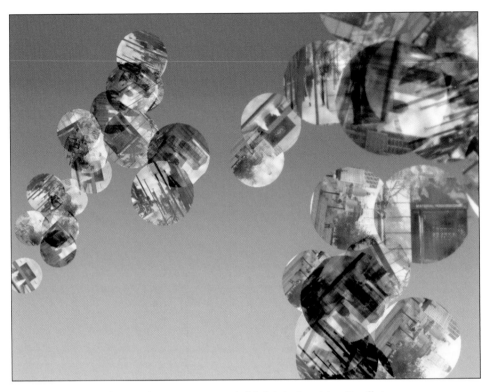

Figure 7.35 Using a particle generation system, you can apply digital photos for an interesting effect.

1. Create a particle generator/emitter, as shown in Figure 7.36.

Figure 7.36
Add a particle emitter to your
3D scene.

2. How you animate your particles is up to you. A good choice is to control the particles with wind. Most particle generation programs give you control over wind, gravity, and other dynamics. Add a wind effector to your particles.

3. The wind effector can push your particles around or, in some cases, make them follow a specific path. You may want to push your particles down an animated road, or perhaps they fly out of a 3D box, sort of a digital photo memory box. Figure 7.37 shows a curved path setup with the particle following.

Figure 7.37 Using LightWave v9, a particle generator is created and a path is set up to animate the particles.

4. Be sure you set the time frame of your particle generator to last infinitely or at least long enough to have the particles travel throughout your scene. Next, a default particle generator might have too many particles when it's initially created. It's enough particles for smoke or water, but for images perhaps it's too many. Set your emitter to generate particles at about only 10 per second. This is called the *birth rate* or *generation rate*. Figure 7.38 shows the change.

Figure 7.38 Use fewer particles so you're not killing your system trying to display too much data at once.

5. You'll want to animate your particles first, before you apply any images. Once you've done this, open your particle preferences, and load a few images you'd like to see attached to the particles, such as a company logo or a family picture.

Note: Too many images might slow down your system, and unless you're going to render any image at full frame, why not scale them down? Using your favorite image-editing program, you can create a new set of images to be used with the particles. Set up something like 400×300 or less, depending on how close your camera will be to the images.

6. You can spread out the particles a bit as you like so they are not as clustered, making sure there's enough distance around each particle to display an image. This might also mean you need to increase the size of your particle generator. As you apply images, you'll see how the images are being applied, and you can adjust everything to your liking. Figure 7.39 shows the particle path with the particles spread out more.

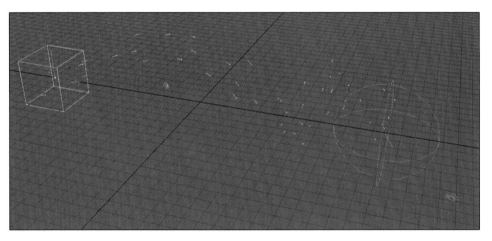

Figure 7.39 As you build a particle scene, think about each particle being an image. Make sure there's enough distance between the particles.

7. Within your system, you'll need to access the tool properties for your particles. Load a few images, and apply them to the emitting particles.

8. Position the camera as you like, such as up-close and underneath the particle stream. This will allow the particles with images applied to whiz past the camera. Using a little motion blur and setting depth of field for your camera will also add to the effect.

9. Render a frame, and see how the shot looks. Figure 7.40 shows a render from LightWave 3D 9 using a single particle emitter, path wind, and Hypervoxels with sprite images applied. The sprite generation rounds off the images for a different look altogether.

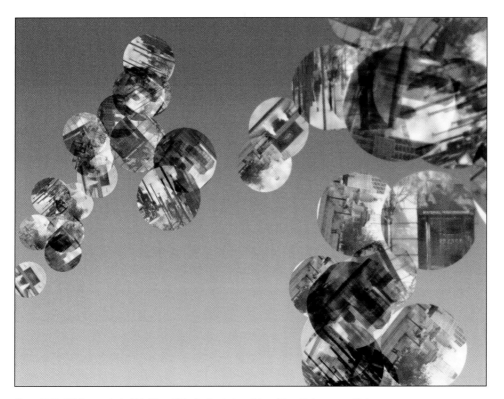

Figure 7.40 This is a render in LightWave 3D 9 of animated particles with sprite images applied.

Creating Dynamic Photos

Dynamics in 3D animation are a big deal. They allow you to apply real-world physics to 3D models. The results are realistic collisions for car-accident re-creations, on-target character fighting in video games, and even smooth, silky fabrics. But what a lot of people overlook with the power of dynamics in 3D is the use of digital photos. This section will show you how cloth dynamics can add more life to an otherwise flat, ordinary digital photograph.

1. Open your favorite 3D application. You'll need to create a flat cube, as you did earlier in the chapter. But this time, segment it a bit. Subdivide the flat cube so it has enough geometry to be bent, something like Figure 7.41.

Figure 7.41
Create a cube, flat on the z-axis. Be sure it's subdivided well so it can be bent with dynamics.

2. Next, find an image you like, and map it onto the object, as shown in Figure 7.42.

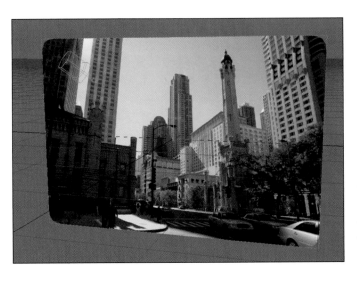

Figure 7.42
Map an image of your choice onto the flat, soon-to-be-blowing-in-the-wind cloth.

3. Access your 3D program's dynamic controls, and apply a cloth or soft body dynamic to the object.

4. Add a wind effector to "blow" the cloth around. But you'll need to lock down or "fix" a portion of the cloth to not be affected by the dynamics. Otherwise, the entire object will blow away.

5. For the cloth itself, you'll need to assign a bit of gravity to it so it falls downward. Gravity is 9.8m/s² (meters per second squared), so add –9.8 to the y-axis for the image-mapped cloth.

6. Then, preview your setup by calculating the dynamics. Figure 7.43 shows the example.

Figure 7.43
Once you add a little gravity to the cloth, you can calculate the wind dynamic to blow the cloth.

7. Get to your camera view. Position it in toward the image-mapped object, and frame the shot. Set the view so the cloth fills the entire frame. Of course, as it's blowing around, it might be pushed out of the frame, and that's fine. If you don't like how that looks, adjust the setting for the wind. Figure 7.44 shows the example.

Figure 7.44 Bring your 3D camera in close to the cloth to fill the frame.

8. Finally, add a little shine to the surface of the object with a Specular setting and gloss so that when it bends and folds, highlights appear. Render an animation, and see how you like it! Figure 7.45 shows a render.

Figure 7.45 Using the a camera shot closer to the object, the cloth effect is more visible.

If you wanted to take this shot further, try duplicating this cloth and applying a different image. Place the second cloth object behind the first. Add a third behind the second, and so on. Then, slowly push your camera down through the cloth objects as they flap in the wind. Pull each object out of the way as the camera gets close to reveal the next cloth image. This is sort of like the first project in this chapter where you flew the camera around static images on a set. This time, the camera can move through dynamically animated images.

Your Next Shot

The examples shown in this chapter can really take your digital images to the next level. Why be stuck with a simple two-dimensional slide show when you can animate your pictures in 3D? You're a creative type, and your job is to take the examples shown in this chapter and go even further. See what other ways you can animate your

image-mapped digital photos. Although these ideas are simple, the result is impressive and original, especially when incorporated with sound, video, and editing. Here are a few ideas:

- Create a sea of photos, perhaps hundreds or thousands, to bring your entire digital photo library to life.

- Apply color images to spotlights and project them onto different geometry shapes and even 3D people. Use movies of people on a 3D set!

- Go a step further by importing digital movie files and applying all the techniques described in this chapter with moving video.

- Use the example of dynamics shown here to turn your digital photos into waving flags, curtains, and signs.

- Incorporate different collisions so your animated digital photos can interact in the scene.

- Experiment!

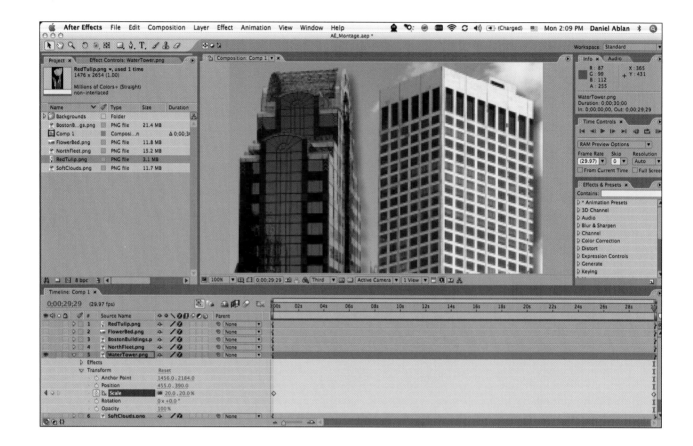

2D Imaging Techniques

As you shoot digital photos, you might find your-self in an interesting predicament. Suddenly, you have hundreds if not thousands of photos floating around on your hard drive—and you probably have no idea what to do these photographs. As you saw earlier in the book, you can use some of these photographs for image mapping to create textures and enhance dull surfaces, or as you saw in Chapter 7, "3D Imaging with Photography," you can use them to create animations. You can even animate your image map photos for inter-esting slide shows.

At this point many animators think there's nothing more they can do with the digital photographs, but you are not quite done yet! This chapter will take you even further with your photography by showing how to use two-dimensional (2D) imag-ing techniques and Adobe After Effects.

Chapter Contents
Creating a Digital Photo Montage
Animating Your Montage

Creating a Digital Photo Montage

After Effects, although primarily a 2D imaging program, can actually perform 3D. More specifically, you can incorporate the use of the z-axis to give greater dimension to your digital photos. You can create wonderful worlds all based around your shots. The techniques presented in this chapter are certainly open to your own style and interpretation, but read on to create a unique project—a digital photo montage. You can turn what you create into an animation or simply use it as a single image. Figure 8.1 shows a frame from the final project result.

Figure 8.1
Using Adobe After Effects, you can incorporate your digital photography to create slick-looking, unique images.

Figure 8.1 shows just a few photographs, but you can use this technique to layer as many photos as you want. You'll use some of the photos you incorporate in their entirety, and you'll crop others. By using just portions of images, such as a single flower from a garden, the look of the project will be different from, say, a creative slideshow. In Chapter 7, you saw how to map your digital photos onto polygons in 3D space, light them, and animate them. In After Effects, you don't have to worry about as many elements, and you can focus more on the layering effect of the digital photos and the effects you apply to them.

For a project like this, you need to get the right digital photographs. Of course, determining what your final piece should look like is a bit important too! This project begins with a background image. Figure 8.2 shows the digital photo you'll use for this project.

Figure 8.2 For the digital photo montage you'll create, it all begins with the base, background image.

The background image doesn't have to move and will be the bottom layer in the After Effects list. You'll add every other element on top of this one.

Setting Up After Effects

This first part of the project gets you going with the basic After Effects setup. Now, if you've never used After Effects, you should definitely try it. With After Effects, you can create slick motion graphics, add visual effects to film or video, and composite your 2D or 3D elements in a variety of ways. You can visit www.adobe.com and download a 30-day, fully functional trial version for both the Mac and Windows. For this project, you don't need to be an After Effects master, yet I will assume you know the basics of this powerful application.

Let's assume you're going to use the final montage for a DVD video you're mastering. You'll use this piece as the opening of your DVD, so you'll want to work in an NTSC (or PAL) television resolution. Start After Effects, and you'll see a pleasant-looking interface. (It's a blank interface but pleasant just the same.) Figure 8.3 shows the setup.

Figure 8.3 This is the After Effects 7 interface, redesigned and user-friendly.

Next, follow these steps:

1. The first step for anything you create in After Effects is create a new composition. This is like your blank canvas that you'll work on, so select Composition > New Composition.

2. In the Composition Settings dialog that appears, select the NTSC D1 Widescreen setting from the Preset list so that this new project will fit well on that awesome LCD display you just purchased. Figure 8.4 shows the panel.

Note: If you're not in the United States, you can certainly set up a composition as PAL for your country's video format. Or if you like, no matter where in the world you are, you can set up a composition that is formatted for your computer, such as 800×600. You can choose from different presets in the Composition Settings panel.

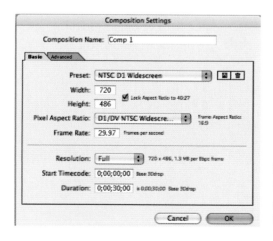

Figure 8.4
For this project, create a new composition with the NTSC D1 Widescreen setting.

3. In the Composition Settings panel, you'll see other settings you can change, from Pixel Aspect Ratio to Resolution to Duration. Because you're using a preset, your Pixel Aspect Ratio setting is already set. Make sure your frame rate is 29.97 (for video) and that the resolution is Full. Also set Duration to 30 seconds.

4. Click OK to close the panel, and you'll see a black panel appear in the main composition tabbed window. You'll also see that in the Project tab on the left, the name is set to Comp 1, as in Figure 8.5.

Figure 8.5 Once a new composition is set up, it appears in the Project and Composition tabs.

5. Choose File > Save As, and then save your newly created project as AE_Montage or something similar. Now you're ready to begin adding your digital photos.

6. Now select File > Import > File, and select the Cloud_Bkd.png image from the book's DVD projects, as in Figure 8.6.

Figure 8.6
Begin importing file footage for your project.

When you choose to import files into After Effects, you can choose from specific file types or simply select All Acceptable Files at the top of the Import File dialog box, as shown in Figure 8.7. You can also import movies and sequential images in this dialog box. Perhaps you've rendered out an animation from Maya or XSI and saved that animation as an RGB sequence. In the dialog box in Figure 8.7, you can select the first image in the sequence and then click the related Sequence check mark at the bottom left of the dialog box.

Figure 8.7

When you select the File > Import > File option, you are presented with a dialog box that not only allows you to import movies and image sequences but allows you to import your digital photos as well.

Note: After Effects is resolution independent, which makes it great for manipulating and using your digital photography in a different and creative way. *Resolution independent* means that although your project resolution is 720×486, your digital photos can be any other resolution you want. The resolutions of your project files can all be "independent."

7. Once the image is loaded, it's visible in the Project tab at the left of the interface. When you select it, you'll see its name and resolution, as shown in Figure 8.8. Notice that the resolution for the background image is 4368×2912.

Figure 8.8

Once a digital photo is loaded into your project, you can select it in the Project tab to see its resolution.

CHAPTER 8: 2D IMAGING TECHNIQUES

The After Effects resolution-independent architecture makes it a great choice for creatively using your digital photography. Not only do you not have to worry about matching resolutions, but you can bring in images that are much larger than the project resolution. Why is this good? It's good because you have more flexibility when it comes to positioning and manipulating your images.

Earlier in the book, I discussed resolution, and the same rules apply here—the more you have to work with, the better. It's that same old "garbage in, garbage out" theory. If you were to bring in a digital photo that is 800×600 in size but your project is 2880×1944 for large print or something similar, you would have to increase the size of your digital photo. Doing so would deteriorate the quality, losing sharpness and clarity.

8. At this point, you can load the rest of the project files or begin creating the composition. It's really up to you, but since you'll be adding digital photos as you go, how about placing the background photo to get the project started? To do this, select the Cloud_Bkd.png image from the Project tab, and drag it onto the main Composition tab. When you do this, you'll see a large *X* appear, representing the image placement, as in Figure 8.9.

Figure 8.9 As you move your image from the Project tab to the Composition tab, a large *X* appears for placement.

The *X* appears to help you align and place the image. Since the digital photo of the clouds is so large, you can place the image anywhere. When you see the *X*, just let go of the mouse, and the image will be placed into the composition. Ordinarily, if you have an image that is the same resolution as your project, it will snap to the edges of the Composition tab for easy alignment. When you place the image, you will most likely see only blue sky, as in Figure 8.10.

Figure 8.10 Placing a large digital photo into your video resolution composition crops the image.

9. Once the image is place, it appears cropped. However, since After Effects is reso-
lution independent, the image is still available to you in its entirety. At the bottom
left of the Composition tab is the Magnification Ratio pop-up list. Click this list,
and choose 12.5%, as in Figure 8.11. You'll see the Composition tab scale down
to 12.5 percent, which will allow you to see the full Cloud_Bkd.png image. It's
represented by a light blue bounding edge that you can grab and drag to size.

Figure 8.11 Changing the magnification of the composition allows you to gain control of the entire
digital photo background.

10. Click and drag one of the corners of the digital image. You can click and then
hold the Shift key to constrain the proportions of the image. Since you won't be
animating this image too much, you can scale it down to about 30 percent.
You'll change this again later. To see the amount you're scaling, look at the Info
tab at the top right of the interface. Figure 8.12 shows the setup.

Figure 8.12 You can scale your digital photo by clicking and dragging any of the corners of the image.

> **Note:** Until specified otherwise, you should be using the Selection tool to resize your image. You can find the Selection tool at the top left of the After Effects interface. It's the first icon, represented by an arrow. Figure 8.13 shows the toolbar.

Figure 8.13

Use the Selection tool by clicking the first icon, the arrow, in the toolbar.

11. Change your magnification back to 100 percent by using the Magnification Ratio pop-up list at the bottom left of the Composition tab. Now that you sized your cloud background a bit, you have clouds in view, not just blue sky, as shown in Figure 8.14.

Figure 8.14 After you size your image, you can change your composition's magnification back to 100 percent. You can see that the background now shows clouds in view, not just blue sky.

Note: Changing the magnification ratio for your composition does not change the size of the final composition output. This is a display option only.

So, you've created a project, created a new composition, loaded a digital photo, placed it, and sized it. That's not bad, but it's basic and boring. I know. But it's getting more fun, so read on to start adding elements. Make sure to save your work so far.

Adding Multiple Digital Photos in After Effects

Often when working in After Effects, you'll need to load a few images, by way of a sequence or as random files. Previously, you loaded just one image. Now you'll load multiple images to be used in your digital photo montage.

Loading multiple photos is as easy as loading a single image, but remember that you're still working from the background forward, even though you can always rearrange your project's layers. Rather than randomly choosing images to load, import them according to how you'll use them. Choose File > Import > Multiple Files, as shown in Figure 8.15.

Figure 8.15

Choose File > Import > Multiple Files.

Point the file browser to the CH8 project folder on this book's DVD, and load the WaterTower.png image as well as the OmniHotel.png image. Select them both at the same time, and click Open. Once you do this, the files will load, and After Effects will open the Import Multiple Files dialog box. If you wanted to load additional files, you could. For now, click Done at the bottom of the dialog box.

Follow these steps to continue the photo montage project:

1. Taking a look at the Project tab, you can see that you now have three images loaded, as well as your composition, which is listed as Comp 1. To keep organized, right-click (Ctrl+click on the Mac) the Project tab, and select Create a New Folder. Name the folder Backgrounds. Figure 8.16 shows the folder.

CHAPTER 8: 2D IMAGING TECHNIQUES

Figure 8.16

Creating a new folder is a good idea for organization as you begin to add files to the project.

2. Drag each image into the new folder. You can now collapse and expand the Backgrounds folder to access the three images, as shown in Figure 8.17. Then, save your scene to keep the changes.

Figure 8.17

Drag the loaded images into the newly created folder.

3. Next, take the OmniHotel.png image, and drag it into the Composition tab. Like before with the background cloud image, the OmniHotel.png file is much larger than the composition. This gives you flexibility for the project but initially needs to be sized down.

4. As you add images to your composition, you can see them listed at the bottom of the interface on the Timeline tab. Expand the OmniHotel.png listing in the Timeline by clicking the triangle to the left of its name. There, you'll see the listing Transform. This is the only control property assigned to the image currently. Expand this, and you'll see the controls for Scale. Select Scale, and then click and drag the values until the image is about 15 percent of its original size. You'll see the image scaled down on the Composition tab, as shown in Figure 8.18.

Note: Notice that when sized down, the OmniHotel.png image is on top of the Cloud_Bkd.png image. This is because it is listed before, or on top of, the Cloud_Bkd.png image on the Timeline panel. If you were to reverse these listings by clicking and dragging them, the OmniHotel.png image would be obscured.

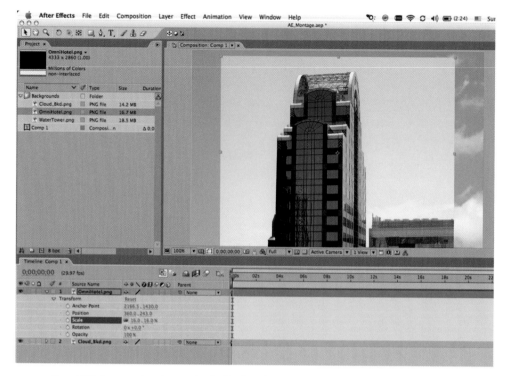

Figure 8.18 You can scale an image using the Timeline tab.

5. Looking more closely, the OmniHotel.png image has a sky of its own. For your project, you want it to float over the background sky you've already placed in the composition. First, save your work. Now to drop out the sky, you have a few options. Since the sky in the OmniHotel.png image is bright and clear, it's pretty easy to use a color key to drop out the sky. Making sure that the Omni-Hotel.png image is selected on the Timeline tab, select Effect > Keying > LumaKey.

6. When you select LumaKey, the Effect Controls tab will appear next to the Project tab at the top left of the interface. Expand the effect by clicking the triangle. For the key type, select Key Out Brighter.

7. Next, expand Threshold, and drag the value to about 188. You'll see the sky behind the hotel drop out. Figure 8.19 shows the change.

Figure 8.19 Adjusting the threshold for the LumaKey applied to the OmniHotel.png image makes the sky drop out.

8. Now that your hotel image is keyed, click and drag the image directly to the Composition tab, and place it toward the bottom left of the view, as in Figure 8.20.

Figure 8.20 Move and position the OmniHotel.png image to the left of the view.

9. Now you can scale the image up a bit. Just grab the corner of the image on the Composition tab, and size it up so that the hotel image fills the frame more but the building at the base is hidden off-screen. Remember that you can click the corner of the image and then hold the Shift key to constrain the image proportions. Once it's scaled up about 20 percent (watch the value on the Timeline tab), click and drag it into a position similar to Figure 8.21.

Figure 8.21 Scale the OmniHotel.png image up to about 20 percent, and then position it to fill the left of the frame.

10. Save your work! Click the Project tab, and select the WaterTower.png image. Drag it onto the composition as you've done with the other images.

11. Down on the Timeline tab, expand the WaterTower.png listing, and then expand the Transform effects. Select Scale, and then click and drag the numeric values to scale the image down to about 20 percent.

12. On the Composition tab, move the WaterTower.png image over to the right of the frame, as shown in Figure 8.22.

Figure 8.22 Scale the WaterTower.png image down to about 20 percent, and position it at the right of the frame.

Note: The images you're working with are quite large, and depending on the system you're using, you might start experiencing some slowdown. What you can do, other than being patient, is to change the composition to display at half resolution. You can do this right at the bottom of the Composition tab. It will currently read Full, for full resolution. Click it to see the available options, and note that these are display settings that don't affect the final output. When you render the final project, you can tell After Effects what resolution the render will be.

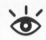

13. Select the WaterTower.png image in the Timeline tab. Select Effects > Keying > Color Key. This is another way you can key out portions of your image.

14. On the Effect Controls tab, expand the Color Key effect, and click the eyedropper icon next to the color swatch in the Key Color control. This allows you to tell the keyer what color you want to drop out. And since the sky color is significantly different from the white building, it will key out nicely. With the eyedropper selected, click the sky area of the WaterTower.png image.

15. On the Effect Controls tab, expand the Color Tolerance option, and drag the slider to about 32. You'll see the sky drop out, as shown in Figure 8.23.

Figure 8.23 Using the Color Key effect, you can drop out the sky from the WaterTower.png image.

16. If you can see a border or edge remaining after the sky is keyed out with the Color Key, you can use the Edge Thin control (within the Color Key settings on the Effect Controls tab) to remove it. Just change this value to about 3.

17. Save your work.

What you've done up to this point was pretty easy, wasn't it? Well, the rest of the project is pretty similar. This technique of layering and keying images can work really well for your digital photography that has a clean, open sky. But what about the images in which only one portion needs to be extracted? Or what if the key just doesn't

quite look right and you want specific areas to not be keyed out? You'll soon learn how to layer even more images, and you'll see different ways to use your digital photos. How about adding some dimension to the project?

Adding Shadows to your Digital Photos

This section will help build some depth into the project. You'll do this by adding shadows to the two images you've already placed. Technically, you're not really adding shadows to the images, but because the images have the sky keyed out, adding a shadow effect will cast a shadow on the original background image. Follow these steps:

1. Continuing with the project you've been working on, select the OminHotel.png image on the Timeline tab.

2. Select Effect > Perspective > Drop Shadow.

3. This adds the new effect to the Effect Controls tab. If you want, you can collapse the Luma Key effect to keep your interface neat. Expand the Drop Shadow effect by clicking the triangle to the left of its name. You want the drop shadow to be soft and not too close to the building. Click and drag the numeric value for Distance, and set it to 110.

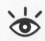

Note: Now, typically you wouldn't have a building cast a shadow onto a bright clear blue sky. This probably goes without saying! But for this montage, you're creating a stylized element, and the shadow helps the dimension and uniqueness of a project like this. You can be as creative as you like!

4. Set Softness to 165. Note that you can click the numeric value and wait a second, and then you'll be able to enter a value numerically, rather than dragging the value. Figure 8.24 shows the composition with the added shadow.

Figure 8.24 A drop shadow added to the keyed OmniHotel.png image creates a shadow for the building.

5. Now apply a shadow to the WaterTower.png image. You could select the image on the Timeline tab and choose Effects > Perspective > Drop Shadow again, but here's an easier way: on the Timeline tab, select the Drop Shadow effect under the Effects listing for the OmniHotel.png image. Figure 8.25 shows the selection.

Figure 8.25
Select the Drop Shadow effect on the Timeline tab for the OmniHotel.png image.

6. With the Drop Shadow effect selected, choose Edit > Copy. Then, select the WaterTower.png image on the Timeline tab, and choose Edit > Paste.

7. Expand the WaterTower.png image on the Timeline tab, expand the Effects listing, and you'll see the Drop Shadow effect applied with the same settings used for the OmniHotel.png image. However, the shadow falls to the right, so you might not actually see it in the composition. Making sure the Selection mode is active (press V), click and drag the WaterTower.png image in the Composition tab over and down to see the shadow, as shown in Figure 8.26.

Figure 8.26 Move the WaterTower.png image over and down so the shadow is visible.

8. Adjust any shadows and the position of photos as you like. When you're OK with your project to this point, save it.

One of the cool features of keying out the sky from your digital photos as you've done here is that adding a drop shadow affects the building, not the actual image. This shadow helps pull the image from the background and gives the project some depth. But these are just the background elements. Read on to start adding more details; after that, you'll add more effects and animate the images.

Creating Secondary Elements

This section will take you through creating the secondary elements of the montage. These pieces are digital photos that will live between the background images from the previous section and the foreground images you'll apply in the next section. The images here will also be animated. Follow these steps:

1. Continuing with the project you've been working on, click the Project tab at the top left of the interface. Collapse the Backgrounds folder to clean up the Project tab.

Note: If you accidentally close a tab, such as the Project tab, go to the Window menu, and select it to open.

2. Select File > Import > File, and choose the SoftClouds.png image from this chapter's project folder on this book's DVD. Figure 8.27 shows the image loaded.

Figure 8.27
Load the SoftClouds.png image into your project.

3. To help give the buildings a sense of scale—and frankly, just for added interest—use the SoftClouds.png image to blend even more elements into your montage. Drag and drop the SoftClouds.png image from the Project tab onto the composition. You'll see that your entire composition now is full of clouds and blue sky, as shown in Figure 8.28.

Figure 8.28 When adding the SoftClouds.png image to the composition, you obscure the buildings.

4. On the Timeline tab, expand the SoftClouds.png listing, and then expand the Transform effects. Scale the image down to about 30 percent by clicking and dragging the numeric value. Figure 8.29 shows the result.

Figure 8.29 Scale down the SoftClouds.png image.

5. With the SoftClouds.png image selected on the Timeline tab, select Effect > Keying > Color Range, as shown in Figure 8.30.

Figure 8.30

Select Effect > Keying > Color Range.

6. On the Effect Controls tab, expand the Color Range listing, and also make sure the preview window is visible within it. You'll see three eyedropper icons on the right side of the preview window. Select the middle eyedropper, which has the plus sign next to it.

7. With the selected eyedropper, click the upper-left corner of the SoftClouds.png image on the Composition tab. In a moment, After Effects will fade out the range of blue in the sky you chose, as shown in Figure 8.31.

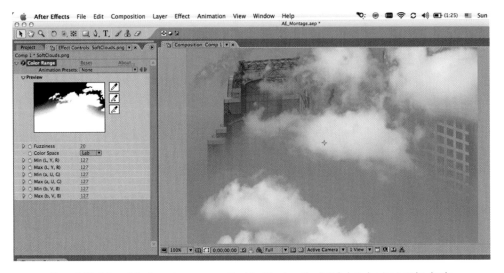

Figure 8.31 Using a Color Range key, you can pull out the blue from the digital photo, leaving just the clouds.

8. Select the middle eyedropper with the plus sign again, and then click the bottom right of the SoftClouds.png image on the Composition tab. The rest of the sky will fade out, as shown in Figure 8.32. This Color Range key works well for the clouds because the transition from the clouds to the transparent area is soft and natural, perfect for clouds.

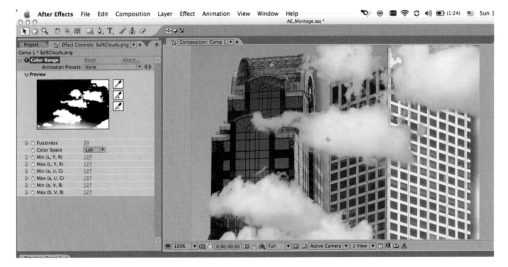

Figure 8.32 Select the bottom right of the image to expand the range of color for After Effects to key out. The result is soft, floating clouds.

9. You can do a bit more to the clouds to blend them further. Expand the Fuzziness setting on the Effect Controls tab, and set it to about 42. Figure 8.33 shows how the edges of the clouds are soft, transparent, and natural looking.

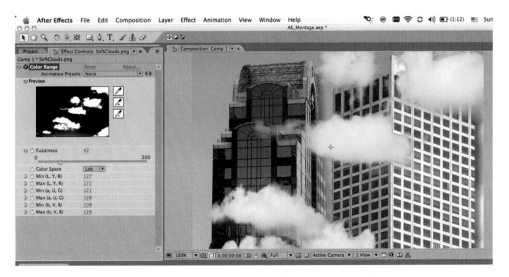

Figure 8.33 Increasing the fuzziness of the Color Range key allows the clouds to be soft and transparent around their edges.

10. Soon, you'll get these clouds moving in the montage. For now, you can make them appear in front of one digital photo and behind another. On the Timeline tab, drag the WaterTower.png image above the SoftClouds.png image. Figure 8.34 shows the interface with the current composition and Timeline tab.

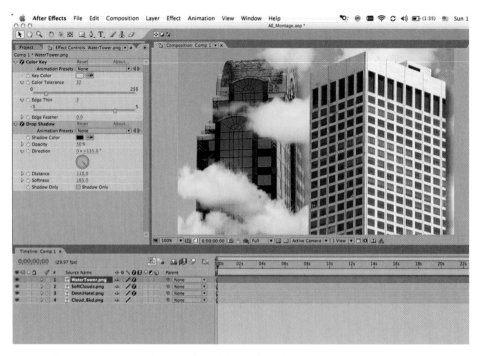

Figure 8.34 You can place the digital photo of clouds in front of one building, while they're floating behind another.

11. Save your work. Now let's add a few more secondary elements before the final top layers. Click the Project tab, and from the File menu, add another image. Load the BostonBuildings.png file from the book's DVD.

12. Drop the image onto the composition as you've done previously. Scale the image down to about 27 percent or so, until you can see the tops of the buildings.

13. Move the image down to the bottom of the composition, as shown in Figure 8.35.

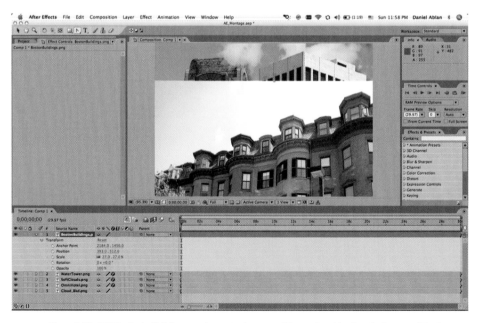

Figure 8.35 Add the BostonBuildings.png image to the composition, and position it at the bottom of the frame so you can see your other digital photos.

Layering and keying your digital photos can really produce some nice results. But you can make this montage even more dynamic. Read on to learn about creating masks with your digital photos in After Effects.

Masking Digital Images

For this image, you could try keying out the sky as you did with the previous images, but it won't properly key, even with all the After Effects top-notch keying tools. The windows in the buildings are so close in color to the sky that keying out the sky would also remove the windows. It might be a good look, but not now. So, you're going to use a mask. A *mask* is simply a way to isolate one portion of your image. Masks can get pretty complicated, but the usage you'll see here is easy to set up. Follow these steps:

1. Continuing from your previous project, you should have the background clouds and sky, the two buildings, another cloud layer, and finally the row of buildings. You need to mask the BostonBuildings image, allowing the sky to completely drop out without affecting any part of the bricks or windows. To do this, make sure the BostonBuildings.png image is selected in the Timeline, and then select the Pen tool from the toolbar. (You can also press the G key to select the Pen tool.) Figure 8.36 shows the tool selection.

Figure 8.36
Select the Pen tool to create a mask for your buildings.

2. With the Pen tool selected, start at the bottom-left corner of the buildings at the roof level. Click once on the edge of the roof to start creating the mask, as shown in Figure 8.37. Click a few more times to begin tracing the building.

Figure 8.37
Click and trace the roof of the building with the Pen tool at the top-left corner of the building to begin creating the mask.

3. Continue adding points across the entire roof. To see the area more clearly, you can zoom in by selecting the zoom amount from the Magnification Ratio pop-up list at the bottom-left corner of the Composition tab. It will most likely be 100 percent currently. Take your time, and follow the contours of the buildings, as in Figure 8.38.

Figure 8.38 Continue creating the mask across the edge of the roof of the buildings.

4. After you create the mask by laying down points across the top of the buildings, continue all the way around by first adding a point in the upper-right corner and then adding one in the upper-left corner.

5. Carefully move the mouse to the originating point, and you'll see a small dot appear next to the cursor. When this appears, click once to close the mask. When you do this, the buildings will drop out, as in Figure 8.39.

Figure 8.39 Finish creating the mask by encompassing the entire sky. When you do, the buildings will drop out.

6. The reason the buildings go away when you finish creating the mask is because the mask effect is set to Add. Instead, change this to Subtract, as in Figure 8.40.

7. To help blend the masked images a bit more, expand the controls for the mask on the Timeline tab. For Mask Feather, set Pixels to about 20. This will *feather*, or soften, the edge of the image that's masked. Figure 8.41 shows the result.

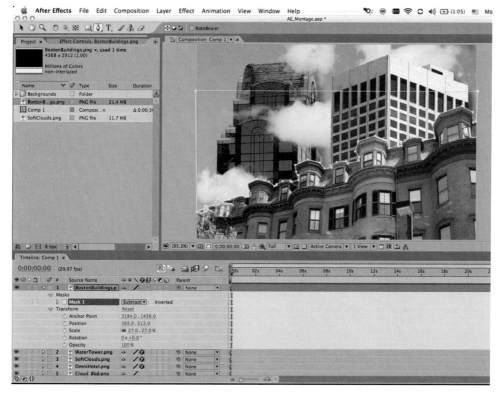

Figure 8.40 Change the mask's effect from Add to Subtract to remove the sky and leave the buildings.

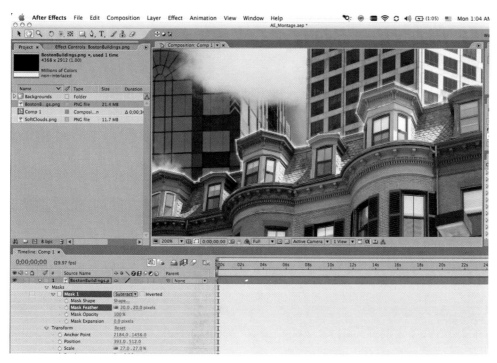

Figure 8.41 Feather the newly created mask slightly to help soften the edges of the image.

8. How about adding a shadow to the newly placed buildings? You can copy the shadow from the WaterTower.png photo, or you can simply add a new one. To add a new drop shadow, select the BostonBuildings.png image on the Timeline tab. Then select Effect > Perspective > Drop Shadow.

9. Open the Drop Shadow controls in the Effect Controls tab, and change the direction so the shadow appears at the top of the buildings by entering 0 and −50 for the values.

10. Set Distance to 25 and Softness to 120. You can also increase the Opacity setting to about 60 percent so the shadow is a bit stronger. Figure 8.42 shows the result.

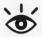

Note: If the yellow lines for the mask are bothering you and you want to remove them, you can. Select the View menu, and uncheck Show Layer Control.

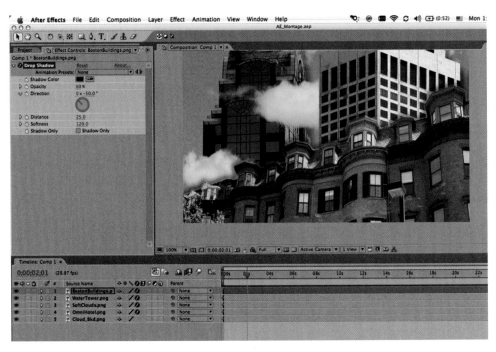

Figure 8.42 Change a few of the shadow parameters so that it pulls the BostonBuildings.png image from the backdrop buildings.

11. Save your project.

Even though the angles are all different on each of the buildings composited so far, they look good together. Although you might need to be a little more careful about how your digital photos are lit for a montage like this, you can still get away with mixed lighting. In the next section, you will add the final top layer of images, and then you'll animate all of these digital photos for a cool-looking animation.

Adding Final Elements

Before the animation begins for the clouds and other elements, add just a few more small details to the montage by following these steps:

1. From the book's DVD, load the NorthFleet.png image from the CH8 project folder.

2. Once you have it loaded, drop the image onto the composition. Open the Transform effects for the image on the Timeline tab as you've done with the other images, and scale it down until you see the entire shot of a street sign, as shown in Figure 8.43.

Figure 8.43 This is the street sign loaded into the composition on top of the other digital photos.

3. You'll need to use the Mask tool again to isolate just the sign. Select the Pen tool in the toolbar, as shown in Figure 8.44. You can also press the G key.

Figure 8.44

Select the Pen tool by clicking its icon in the toolbar.

4. Starting at the bottom of the image, click with the Pen tool, and trace around the pole, up through the signs, as in Figure 8.45.

Figure 8.45 Using the Pen tool, start creating a mask for the street sign.

5. If your system seems to hang a bit while trying to keep up with your work, that's normal for After Effects, especially with so many high-resolution images loaded. What you can do is turn those images off for the time being. On the Timeline tab, at the left of each image listing is a small eye icon. Click this to turn the visibility on or off for each image. You can hide the visibility for all of the images except the NorthFleet.png image on which you're currently working. Figure 8.46 shows the selections.

Figure 8.46
You can click the eye icon on the Timeline tab to hide the images in the background to help speed up your workflow.

6. Continue adding points around the sign to build the mask. Expand the Mask effect for the NorthFleet.png image in the Timeline, and make sure it's is set to Add.

7. You don't need to consider the back-facing sign on the bottom of the pole in your mask, just the two street signs. As you reach the bottom of the pole, coming around to the position where you started, move the mouse toward the first point you created. When a small dot appears next to the cursor, click once, and the mask will be closed. Figure 8.47 shows the operations.

8. You can scale the image up a bit to fit the frame and then make the other images visible again. Select View > Hide Layer Controls to hide the mask outline. Figure 8.48 shows the montage.

Note: If you want to tighten up the mask around the sign, expand the Mask effect on the Timeline tab. You can click and drag the numeric value for Mask Expansion to increase or decrease the mask.

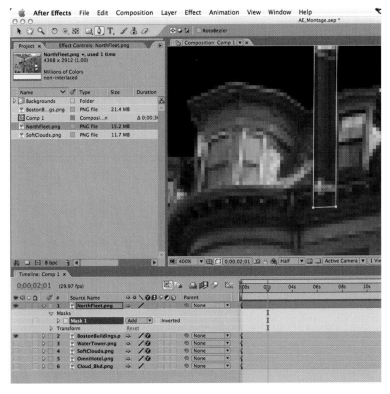

Figure 8.47 Finish creating the mask by clicking the first original point you created. Also make sure the Mask effect is set to Add in the Timeline.

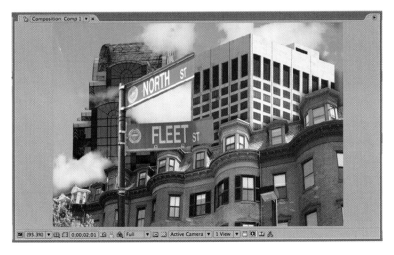

Figure 8.48 Hide the mask using the View menu by choosing Hide Layer Controls. The sign is now floating alone over the buildings.

9. Add a shadow to the NorthFleet.png image by first selecting it on the Timeline tab and then selecting Effect > Perspective > Drop Shadow. Feel free to place the shadow where you like, soften it as you like, and adjust its opacity. Once the shadow is in place, you might want to position the sign elsewhere. Press V for the Selection tool, and then click and drag to move the sign. Figure 8.49 shows how it looks.

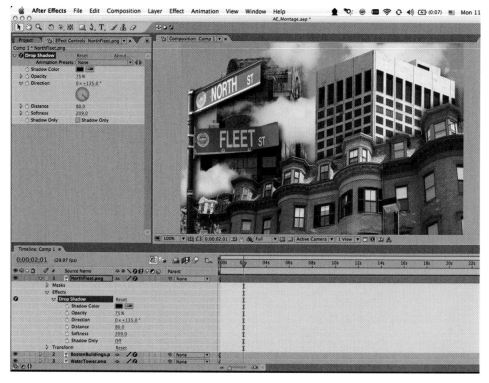

Figure 8.49 Add a drop shadow as you like to the make the sign stand out.

10. Adding just a bit more to the montage, load the FlowerBed.png image from the CH8 project folder on the book's DVD. This digital photo contains a low-angle shot of a bed of tulips. I have painted out the background for you in Adobe Photoshop. It's an image in which a key wouldn't work, so I used Photoshop to paint everything out but the tulips. Saved as a PNG file, the transparent background is retained. Drag and drop the image onto the composition, and you'll see that it needs no keying or masking, as in Figure 8.50.

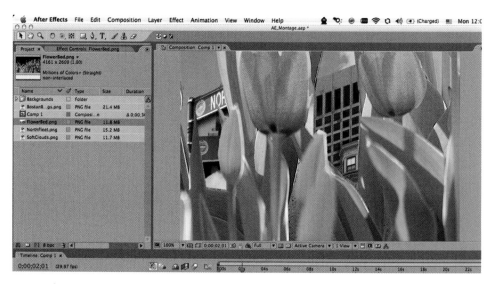

Figure 8.50 An image of tulips is loaded onto the Composition tab, and because it contains 32-bit alpha channel data, only the flowers in the image appear.

11. Scale down the FlowerBed.png image to your liking, and place it at the bottom of the composition, as shown in Figure 8.51.

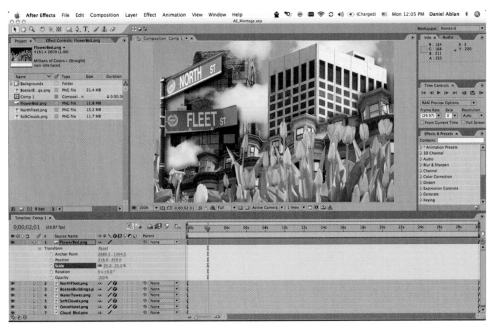

Figure 8.51 Scale and position the flowerbed in the composition.

12. Add a drop shadow to the flowers. You can select the Drop Shadow effect from the NorthFleet.png image on the Timeline tab, and then select Edit > Copy.

13. Select the FlowerBed.png image, and then select Edit > Paste. This copies the drop shadow to the flowers. Figure 8.52 shows the result.

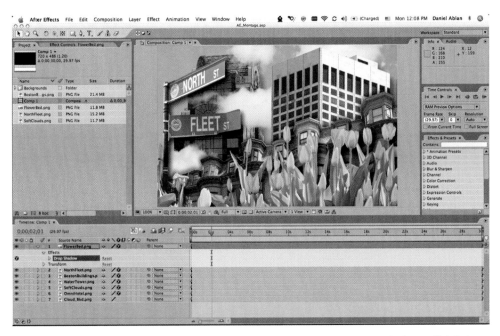

Figure 8.52 With the FlowerBed.png image loaded and placed in the composition, once a shadow is added, the image stands out nicely.

14. How about adding one more image? Go to the CH8 project folder on the book's DVD, and load the RedTulip.png image. This is a single tulip, also with its background painted out and saved as a PNG image to retain the 32-bit alpha channel data. Load it from the File menu, and then drag it from the Project tab onto the Composition tab.

15. Scale the RedTulip.png image down using the Timeline tab. Add a drop shadow, and place the image where you like. Figure 8.53 shows the result.

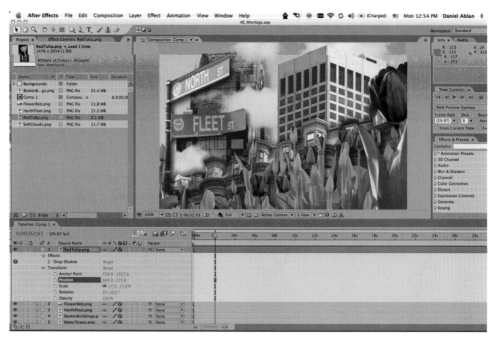

Figure 8.53 Add the last image, a red tulip. Scale, shadow, and place it as you like.

16. At this point, your montage it looking well populated and balanced. Of course, this is all open to your own interpretation. Save your work, and get ready to put your montage in motion.

The resulting image shown in Figure 8.53 is a great collection of digital photos; you can also add your own as you like. Before you move on to animating these images, feel free to adjust anything you like and perhaps experiment with some other effects. You've added a single red tulip on top of the other images. What about moving it behind a building? Who says it has to be in front? Or how about the street sign? Maybe move that behind the buildings to hide some of the pole. You can simply select the NorthFleet.png image on the Timeline tab, and then drag it beneath the BostonBuildings.png image. Another technique you can try is to add effects to the flowers to make them glow or maybe change their color. Or perhaps you might try beveling or embossing the background buildings into the sky. You can even duplicate an existing image, such as the clouds. Isolate just one of the clouds with a mask and increase the size, and you have added elements.

All of these effects are available in the Effect menu. Just select the desired image on the Timeline tab, choose an effect to apply it, and then open the Effect Controls tab to adjust the settings. If you don't like how an effect looks, select it on the Timeline tab, and press Delete on your keyboard to remove it.

Animating the Montage

Animating in After Effects is one of its powerful features, allowing you to take these images and give them more appeal by putting them in motion. You can animate everything you've done in this chapter, from scaling to positioning to adding a shadow. This project is fairly simple, but you can apply these principles to anything else you decide to tackle in the program. For now, you'll start from the back of the montage, working your way forward, just as you built it. Follow these steps:

1. To start, you're going to just slowly move the background buildings and sky. The idea is to have some movement in everything, even if just very slight. Start by selecting the Cloud_Bkd.png image on the Timeline tab.

2. Click the eye icons on the far left of the Timeline tab to hide their visibility. A trick you can do is click and drag your mouse over them, up or down, to quickly hide them. Leave the Cloud_Bkd.png eye checked.

3. To the right of the Timeline effect listings you've been working with is the complete Timeline for the project. You'll see a blue handle at the top of the Timeline, which you can grab and drag to move through your animation; this is the Current Time Indicator. Nothing is set to move just yet, so dragging this slider won't have much effect. Make sure the indicator is all the way to the left at frame 0, the beginning of the animation. You'll be able to see numerically where you are in the Timeline by viewing the Current Time display at the bottom of the Composition tab, just above the Timeline. Figure 8.54 shows the arrangement.

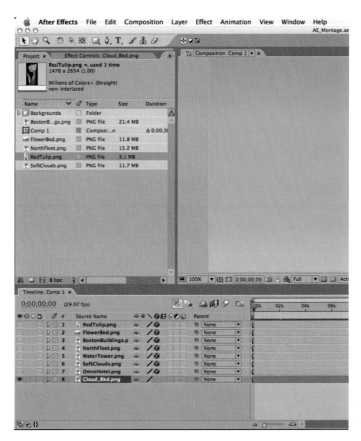

Figure 8.54

Start setting up the animation by making sure the Current Time Indicator is set to 0.

4. At the bottom left of the Timeline, expand the Transform effects for the Cloud_Bkd.png image. Select the Position effect. Click the stopwatch icon to the left of the Position listing. This creates a key telling the Position effect to lock in the set value at the point in time you've indicated in the Timeline. Figure 8.55 shows the selection. Note that you'll also see an orange triangle appear within the Timeline.

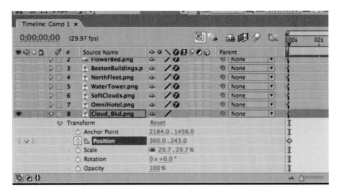

Figure 8.55
Click the stopwatch icon for Position to set a key at frame 0.

5. Now, move the Current Time Indicator to the end, at frame 30.

6. Press V to activate the Selection tool, and then click and drag the Cloud_Bkd.png image in the Composition tab. You can drag it to the left so the clouds begin entering the frame. Position the image so that the right edge of the image is not showing in the composition. Let go of the mouse, and look in the Timeline. You now have an orange triangle at frame 30, as shown in Figure 8.56.

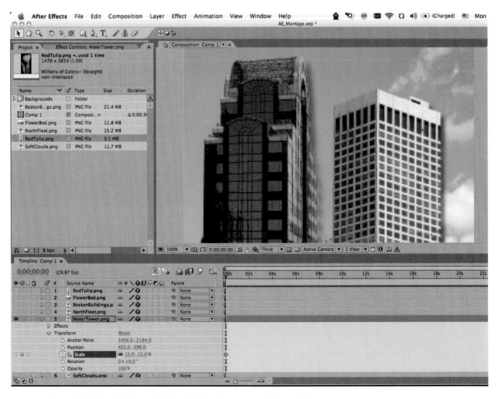

Figure 8.56 Move the image to frame 30 to set an automatic key position.

7. Save your work, the press the spacebar. In a moment, After Effects will begin generating a preview of your animation. You can also just click and drag the Current Time Indicator to see the motions.

> **Note:** Because the digital photos you're working with are so large, playback might be quite slow in After Effects. If so, change the composition preview from Full to Third. You can do with from the Magnification Option at the bottom of the Composition tab.

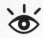

8. Congratulations! You just moved your clouds. Now, unhide the OmniHotel.png image and the WaterTower.png image.

9. Drag your Current Time Indicator back to frame 0. Select the WaterTower.png image, and expand its effect controls in the Timeline. Click the stopwatch next to Scale to turn on keyframing capabilities for this effect.

10. Next, scale the WaterTower.png image down to about 15 percent. You've now created a keyframe for this value, as shown in Figure 8.57.

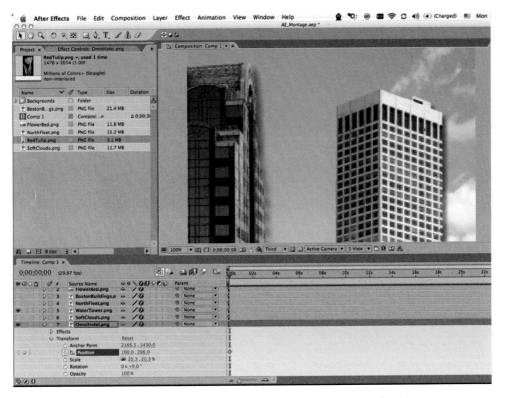

Figure 8.57 Scale the image down to create a key at 0. Scale the image down to create a key at 0.

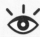

Note: If you scale your image down and see a fringe, or portions of the sky you previously keyed out, just expand the effects for the image in the Timeline tab, and increase Color Tolerance for Color Key.

11. Drag the Current Time Indicator to the end of the animation at frame 30, and then scale the image up to about 20 percent by clicking and dragging on the numeric values. Your image is now animated, growing from smaller to larger over 30 frames. Figure 8.58 shows the change.

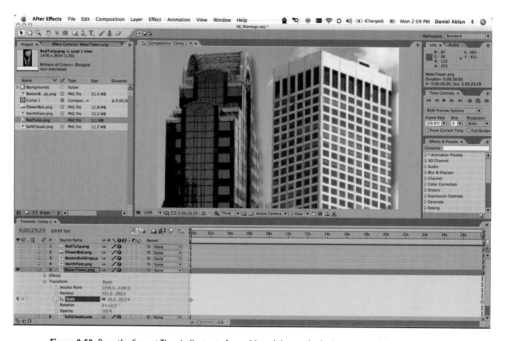

Figure 8.58 Drag the Current Time Indicator to frame 30, and then scale the image up to 20 percent.

12. You can make another preview of the animation by pressing the spacebar or simply dragging the Current Time Indicator. Drag the Current Time Indicator back to frame 0.

13. Now select the OmniHotel.png image on the Timeline tab.

14. Expand the Transform tools for the OmniHotel.png image. Click the stopwatch icon next to Position to start creating keyframes. With the Selection tool (press V), move the image to the left of the composition, slightly off-screen, as shown in Figure 8.59.

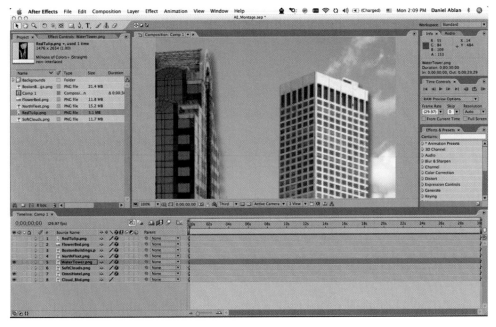

Figure 8.59 Move the OmniHotel.png image to left of the composition for its key position at frame 0.

15. Drag the Current Time Indicator to frame 30, and then move the Omni-Hotel.png image back into its original position. A keyframe is not set for this new position, and your building now slides into the composition from the left.

16. Make the rest of the images visible. Select the SoftClouds.png image, and just as you did with the OmniHotel image, create a keyframe for the clouds at frame 0 and at frame 30. For these, however, move them to the right for frame 0 and then to the left at frame 30. This will match the movement of the background image, but because they are a different size, they'll move with a slight timing difference. You can also make the position for frame 30 less or more, as you like, which will change the timing. Because these clouds, unlike the background image, are keyed out, you can move them from the far right to the far left of the Composition tab without seeing any edges.

> **Note:** If you zoom out of the Composition tab a bit by choosing 50% from the Magnification Ratio pop-up list in the bottom-left corner, you'll actually see the bounding representation of any elements you move out of the visible composition. This will give you extra control over placement during animation. Figure 8.60 shows an example. You might need to select View > Show Layer Controls to see the guides, if you've previously turned them off.

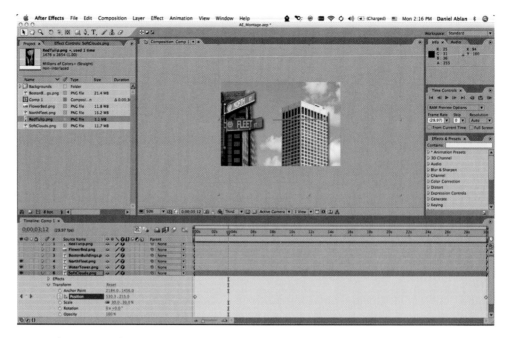

Figure 8.60 Use the Composition tab's Magnification Ratio pop-up list to see elements moved beyond the visible composition.

17. Once you've animated the clouds, select the NorthFleet.png image. Expand its Transform tools on the Timeline tab, and click the stopwatch icon for Position. At frame 0 in the Timeline, move the NorthFleet.png image down, out of view.

18. Drag the Current Time Indicator to frame 30, and then bring the NorthFleet.png image back up into the frame. Your sign now animates into the composition. Remember to zoom out to see the image once you move it off-screen.

19. Save your work.

From this point, you can bring the flowers in by scaling, by positioning, or even by rotating. Perhaps take the flowerbed of tulips from their existing position, and just scale them up slightly during the course of the animation. The single red tulip can come up from the bottom over time, and you may want to experiment with keyframing some other effects. By adding any effect to your image, clicking the stopwatch icon on the Timeline tab, and making a change, you're creating keys. Do this over time by dragging the Current Time Indicator to a new point in time, and you're animating. You can use this process for all of the After Effects tools, not just transform tools. Try animating the drop shadows, or try animating the color coming out or fading into the tulip. The techniques in this chapter are truly universal, especially when working with digital photography. Experiment on your own to see what sort of montages you can create with your shots.

Now it's time to ramp your skills up even more; in the next chapter, you'll learn how to turn your digital photos into HDR images. You can then bring the HDR images into various 3D applications and use them to light your 3D scenes.

Your Next Shot

Creating moving elements with digital photos is not limited to just 3D. Using programs like Adobe After Effects, employing masks and just portions of digital photos can take your creativity to the next level. You can use the techniques described in this chapter in programs other than After Effects, such as Apple's Motion. Or, how about using your non-linear editor to move an animate your digital photos?

From here, move on to Chapter 9 and learn how you can create your own high-dynamic range digital photos to light objects in 3D.

Creating and Using HDR Images

If you've worked in the 3D animation field for a while, you might have heard of, or even used, HDR images. HDR stands for high-dynamic range, and HDRI stands for high-dynamic range imaging. You can use HDRs in 3D for image-based lighting. This is a powerful feature many 3D applications support, and it's something that can help make your 3D renders look very realistic.

9

Chapter Contents
What HDR Is
Light Probe Images

What HDR Is

If you want to use HDR images, you must first understand what *high-dynamic range* means. When you hear the word *dynamic*, what do you think? Do you think of something or someone who is exceptional—beyond the norm—and stretches the boundaries?

In photography, digital photos have dynamic ranges. This range is a ratio that stands between the brightest and darkest parts of the image. So, how do you determine the range of your digital photo, and can you control it? Yes, you can control it, and you can build high-dynamic range images. Let's say you have a dull, dirty dishcloth outside on a cloudy day. An image of this would be a low-dynamic range image. The dirty dishrag has even tones, little contrast, and not a lot of data. Or, perhaps you're stuck inside working on a gorgeous summer day. Your office window faces out to a blue sky and bright sunlight that, no matter what you do to try to stop it, streaks in onto your desk. A photo of this would be a high-dynamic range image because there is strong contrast, and a wide range of tones. An HDR image is one that has more data than what you can see on a standard computer display. Additionally, these images are not something you can just go out and photograph on a moment's notice; rather, they require a bit of work and multiple exposures.

A digital photo contains pixels whose values are nonlinearly encoded. This means the pixels within the image are random. An HDR image has pixel values that are proportional to the amount of light in the environment around it. To create your own HDR image, which you'll do in this chapter, you'll use a series of regular digital photos of the same environment with different exposures. From there, using Adobe Photoshop CS2, you'll build an image that contains a greater dynamic range than the normal image. By "normal," I'm talking about digital photos that, when viewed with an RGB value, top out at 255 brightness. These low-dynamic images have a range only from 0 to 255, whereas a high-dynamic range image's values go well beyond 255, even though your computer display does not show it. A dynamic-range image uses floating-point values that are capable of representing light values of 1 million or more. You can then use this high-dynamic image in a 3D application to completely illuminate a scene! But why would you want to do this?

Imagine how easy it would be to just dump an image into your 3D environment and be done with lighting. Nice, eh? In addition, because a typical HDR image has that dynamic range of highs and lows, your 3D object is then lit by those different values.

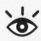 **Note:** An HDR image contains values of light, captured by your camera. HDR images are not pre-processed like the JPEG images your digital camera takes. Because of this, they do not fully display on your standard computer monitor. HDR images do not contain gamma data, which is a form of tone mapping.

The result is a photo-real render. Figure 9.1 shows a render with one area light. Figure 9.2 shows a render with one area light, with indirect illumination applied. The indirect illumination (or *global illumination*) is calculating the rays from a gradient blue background. But then check out Figure 9.3. This image is rendered without lights, without a colored backdrop. Instead, an HDR image alone lights the image.

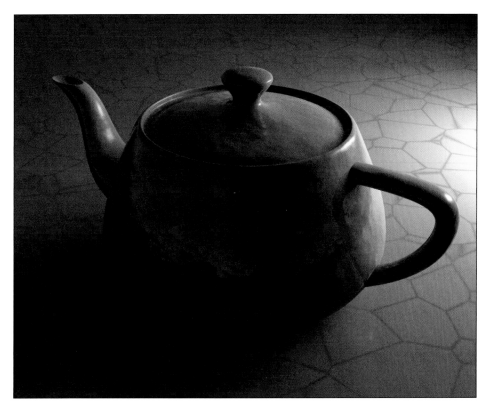

Figure 9.1 This is the preverbal computer-generated teapot, rendered in Luxology's modo with one area light.

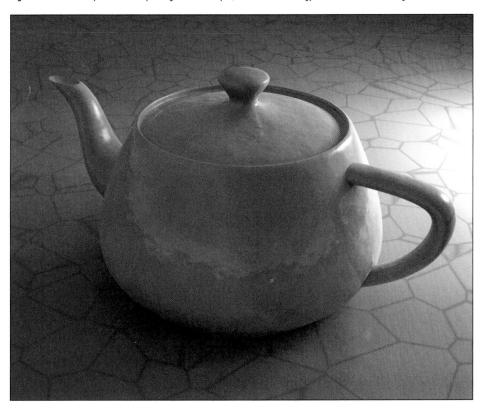

Figure 9.2 This is the same teapot, now with global illumination applied, with a blue sky.

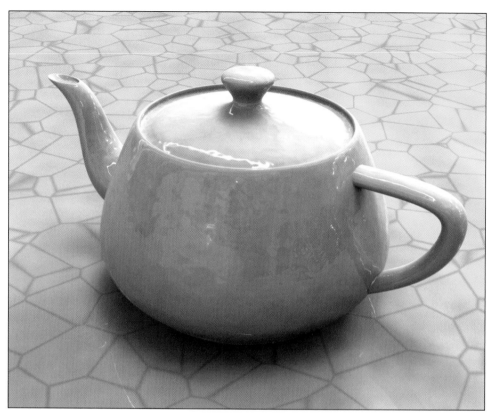

Figure 9.3 This is the teapot lit only with an HDR image.

Note: Not all 3D applications allow you to use HDR images for image-based lighting, so be sure to check your documentation to make sure you can use these dynamic files.

You should be aware that in order for an HDR image to work in your 3D environment, your 3D application must first be able to use HDR images. Programs such as Luxology's modo perform well with these types of images, as you can see in Figure 9.3. In addition, global illumination must be present and turned on for the HDR image to light the scene.

High-dynamic range images can be powerful in achieving realistic lighting in 3D. You might have also heard of image-based lighting or light-probe images. These are high-dynamic range images also, which I'll explain in a moment. So, where do you begin? The easiest way is to purchase images already created. Here's a list of a few good resources, starting with the pioneer of the technology, Paul Debevec:

```
http://www.debevec.org/Probes/
http://dosch.de/products/hdri/
http://public.fotki.com/TriStar/hdr/hdr/
```

Purchasing a set of HDR images is an excellent idea because you'll have a library that you can use in any 3D program that works with HDR. You'll save time by having a prebuilt set of images, but it's also possible to make your own HDR images. And at times, you'll want to do this. Let's say your 3D render requires that you model

and render a specific object that needs to be placed on a table in a model home you're photographing. Most likely, the purchased HDR image set won't have an HDR image that matches the interior lighting you need. That's simple enough—just photograph it yourself! Before you learn how to do this, you'll learn about variations to HDR images.

Light-Probe Images

So, you know that an HDR image contains more information than an average image. But is a light-probe image the same as an HDR? Yes. A typical HDR image is created by combining at least two images. But one good way to properly use an HDR image in 3D is to photograph a reflective ball. In an ideal setting, you would take a panoramic image of an entire environment and stitch the images together to make a spherical image. Given that an HDR needs multiple exposures to be created, you would have a lot of work ahead of you to shoot multiple images of each shot in the panorama. Also, some cameras will shoot a full 360 degrees in one shot. However, you can often get away with photographing just one side of a reflective ball with multiple exposures to create a perfect HDR image to be used in 3D. You'll see the process of this shortly.

The term *light probe* refers to an HDR image that is spherical in shape, like the graphic image at the beginning of this chapter. It's basically an image taken of a small chrome sphere within the environment you intend to capture. The idea behind taking a photo with the sphere is that you essentially photograph a full 360 degrees. You take a few shots at different exposures, and then you can create an HDR image of the lighting in the entire environment. 3D applications that use probe images will map this image around your environment by unwrapping it spherically. You can buy complex probe-image rigs and expensive metallic, reflective spheres to photograph environments. But simpler methods exist. One way is to find just a silver ball ornament you might hang on a holiday tree. Or how about a metal ball? You can set it on top of a large tube or fence post if you don't have a tripod for it. By photographing a close-up view of the ball as it reflects the environment, you'll capture the surroundings. Figure 9.4 shows an example.

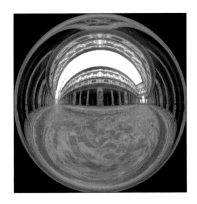

Figure 9.4
Photographing a reflective ball allows you to capture a full environment.

A probe image is good because it allows the 3D artist to re-create lighting in terms of time of day. The probe will accurately allow you to cast shadows and gain reflections and highlights, all based on the image. To photograph an environment as a probe image, you start with your mirror ball or chrome sphere. Some people place this sphere on a table or the ground, but ideally you want it a good bit above the ground.

Another key step is to place it on a tripod and raise the tripod high enough so that the reflection in the ball minimizes the tripod reflection. Once you shoot the image, you'll need to paint out the reflection of yourself, your camera, and your tripod. It's minimal work, but it's one step you'll have to consider just the same. If you have a remote trigger for your camera or a timer, you should use it. You can set your camera up on a tripod, focus on the sphere, set the timer, and then get out of the way. This is ideal, because you'll gain more reflection of the environment. Another trick is to move the camera farther away from the sphere and zoom in. The camera and tripod in the reflection will be a tiny blip of a reflection and less work to remove.

Setting Up a Sphere Rig

Setting up a sphere rig to create probe images isn't as hard as it might seem. You can do it with a little cost and effort. Certainly, you could go out and buy expensive tripods and metallic spheres of different shapes and sizes, but really you can set it all up for about $8. Figure 9.5 shows how it begins, with a box of ornaments.

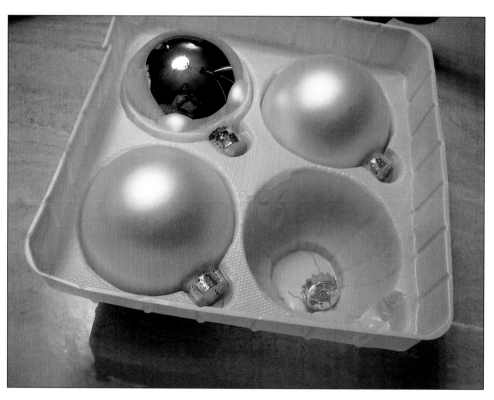

Figure 9.5 Photographing a reflective sphere requires just a little setup, which begins with a shiny reflective sphere.

Once you have the right reflective ornament, you can get a small piece of Styrofoam and a wood stick at your local hobby store. Take the hook off the ornament, and set it on top of the stick. Depending on size, you might want to push some cotton or paper inside the ornament to keep it from bobbling around on the stick. Then, press the stick into the Styrofoam, which acts as a base. Voila! It's an instant sphere for photographing. Figure 9.6 shows the setup.

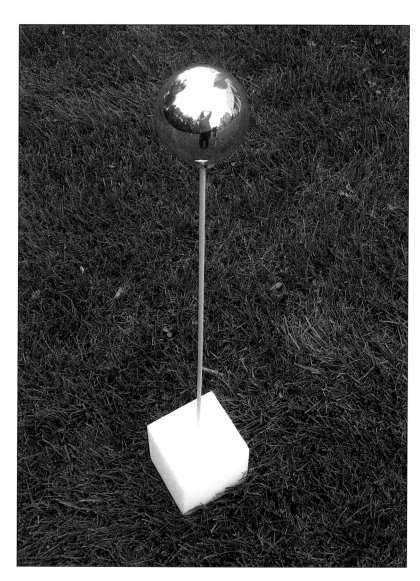

Figure 9.6
By using just a metallic ornament, a stick, and a chunk of Styrofoam, you have a working sphere for shooting probe images.

Note: If you intend to shoot outside in the grass or dirt, you won't even need the Styrofoam—just push the stick into the ground.

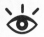

The next step is to position the sphere rig and your camera. You can use this rig anywhere you like, including indoors, outdoors, warehouses, and so on. The light in the environment you choose is important, and something with significant high and low values will work well. When placing the rig, try to have it centrally located in the environment, not too far from any one subject and of course not too close to any one subject. You want the camera to be as far away as possible. The reason for this is so you maximize the reflection of the environment in the sphere, rather than reflecting your camera. Level the camera on a tripod at equal height to the sphere. Figure 9.7 shows the setup from the camera's point of view, and Figure 9.8 shows the reverse.

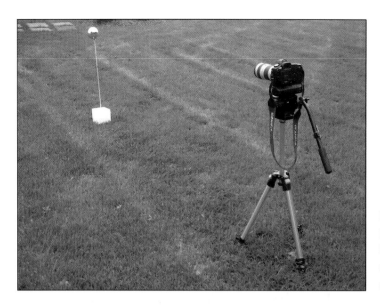

Figure 9.7
Place the sphere rig in a central location, and position your camera at equal height, as far away as possible.

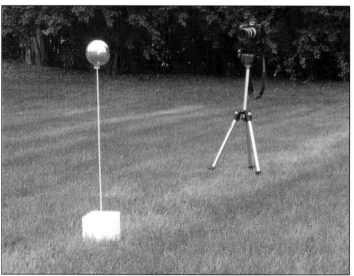

Figure 9.8
The camera is positioned as far as possible from the sphere rig, using a zoom lens.

Taking Shots for Probe Images

The camera in Figure 9.7 is a Canon 5D camera with a 70–200 mm f/4L Canon lens. You can use a point-and-shoot camera, as long as you can control the exposure. This is the only caveat in the entire process—you need manual camera control.

You're ready to shoot! Fill the frame with the sphere, and set the focus. Determine your exposure as you would normally. Then, stop the camera down so that it's underexposed. You can set your camera to Program mode and bring the exposure to a minimum. Set the timer on your camera so that you don't shake the camera by depressing the shutter. Each shot will match up by using a timer. This also allows you to step out of the frame to maximize reflectivity in your sphere. Your camera might have automatic exposure bracketing, and if it does, feel free to use it. This will automatically take an underexposed, normal, and overexposed shot in one take. For the example here, I took five images, starting with a –2 exposure bias at f5.6 with a shutter speed of 1/400. Figure 9.9 shows the first shot.

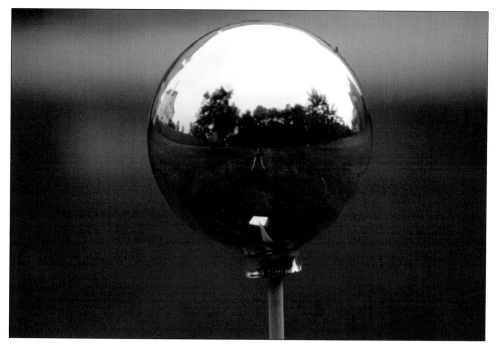

Figure 9.9 The first image is underexposed at f5.6.

The next shot was taken with the same setup, just a bit brighter at f 5.0, as shown in Figure 9.10.

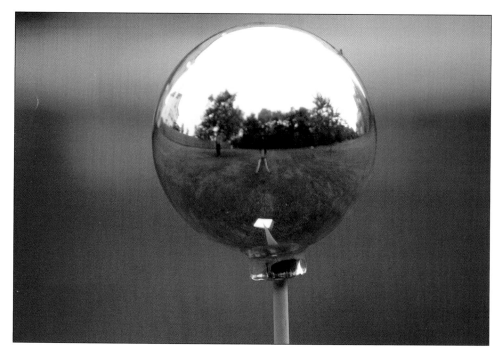

Figure 9.10 The second shot is more exposed at f5.0.

Figure 9.11 shows the next shot taken at f4, which is well balanced at a shutter speed of 1/200. This exposure is even.

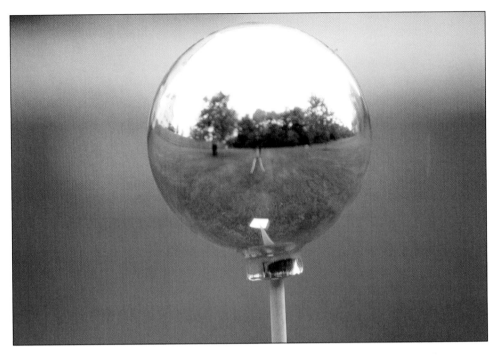

Figure 9.11 The third shot is evenly exposed at f4.

Figure 9.12 shows a slightly overexposed image at f4, but with a shutter speed of 1/125, more light is let into the camera, overexposing the image.

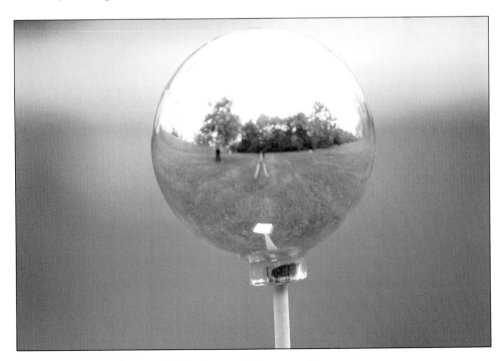

Figure 9.12 With a slower shutter speed, the shot becomes slightly overexposed.

Finally, the last shot is highly overexposed, taken at f4.0 with a 1/80 shutter speed, which lets in too much light. Figure 9.13 shows the image.

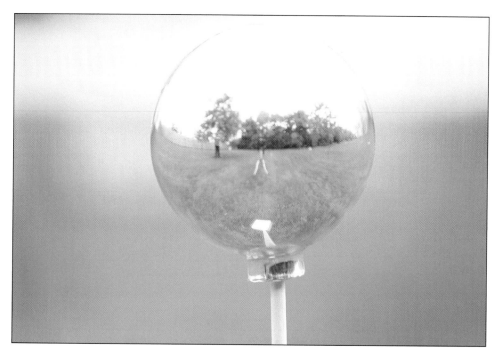

Figure 9.13 The last shot is overexposed.

Note: You can go much further when shooting your probes. After your series of exposures, try moving the camera to a 90-degree position while leaving the sphere rig in the same position. Then, take another series of exposures.

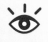

Now what? How can you combine all these images to make one HDR image? You can do it in a few ways, one of which is with Paul Debevec's HDR Shop. You can learn more about this powerful software at www.hdrshop.com. You can also create the HDR image in Photoshop CS2. Photoshop is a good choice because you can clean up the images, crop them, and blend them into an HDR image all at once.

Creating an HDR Image

The first step in creating your own HDR image, as you've seen, is to take the shots. Although I used a reflective sphere to build a probe image, you can simply use straight images. Regardless, the most important factor is photographing the scene in different exposures, from dark to light. How dark and how light? The underexposed image should be featureless; that is, it should be so dark that you can't make out various features in the image, be it trees, furniture, or people. On the opposite end, the overexposed shot should also be featureless. Figure 9.14 and Figure 9.15 show two images—one underexposed, one overexposed—not taken as a probe image like earlier in the chapter.

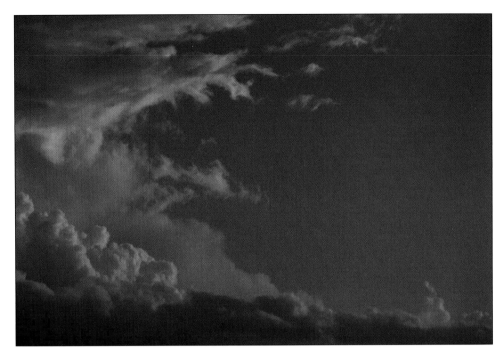

Figure 9.14 You can use an underexposed shot in combination with overexposed shots.

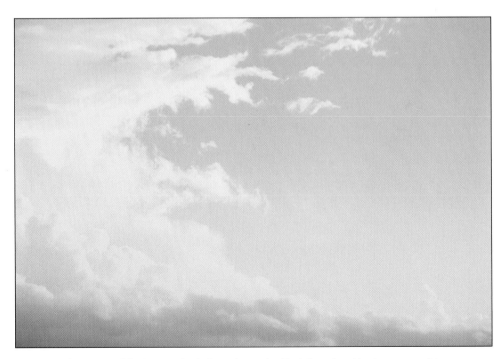

Figure 9.15 The overexposed shot is not good to look at on its own, but blended together with other exposures it becomes a high-dynamic range image.

In Figure 9.14, the shot is underexposed. The reason for taking underexposed shots is so you'll be able to pull the highlights from the image. On the flip side, Figure 9.15 shows the overexposed shot, taken for the shadow data. And although you can try to combine just a few images for an HDR, the more exposures you have ranging from the darkest exposure to the brightest will be the most "dynamic" and give you the widest "range."

In the following exercise, you'll convert the series of exposures into a single image using Photoshop CS2. This image will use tonal mapping, which approximates what is "normal," or what our eye perceives as normal. Once this is complete, you'll crop and clean up the image for use in 3D.

First, combine the images:

1. In Photoshop CS2, select File > Automate > Merge to HDR, as shown in Figure 9.16.

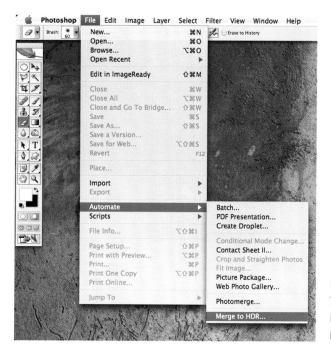

Figure 9.16

To begin creating the HDR image in Photoshop CS2, select the Merge to HDR command.

2. Select the five images (provided on this book's DVD in the CH9 projects folder) named f0909.tif through f0913.tif, as shown in Figure 9.17.

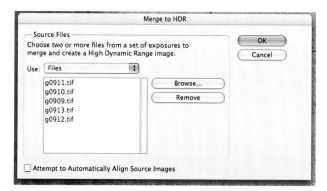

Figure 9.17

Load the probe images, either ones you've shot or the exposures provided on this book's DVD.

3. Once loaded, click OK. Photoshop will begin computing the camera response curves. Remember, you can do this with as little as three images. After a moment, a window will appear showing all the image thumbnails on the left and the combined histogram on the right, as in Figure 9.18.

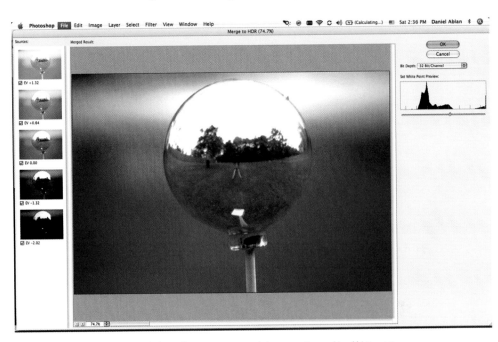

Figure 9.18 Photoshop calculates all your exposures and shows you the combined histogram.

Note: A *histogram* is a graph that shows the various frequencies within the image. You can view histograms in Photoshop, and many digital cameras have the capability to display this data.

4. What you're viewing in Figure 9.18 is a 32-bit image. This image is an HDR image, and you can simply click OK and save it. However, sometimes the white areas of the image may be too hot, and if so, you can adjust the histogram before closing the window. Figure 9.19 shows the adjusted image with the histogram slider moved slightly to the right to bring the white (highlight) areas of the image down.

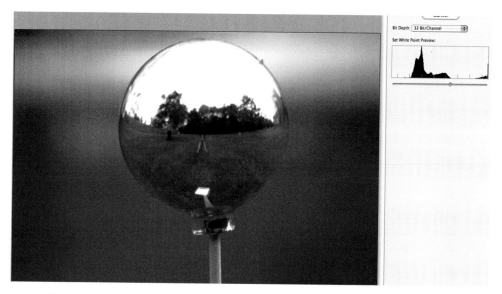

Figure 9.19 By adjusting the histogram, you can control the highlights in the image.

5. If your image looks good to you, click OK. This 32-bit image now contains a much greater dynamic range than a normal 8-bit image (0–255) or 16-bit image (0–65,535). If you were going to adjust this image more in Photoshop, you'll would find that you're limited in what tools you can apply. For use in 3D, you'll want to keep this image as a 32-bit file.

6. What's next is to paint out the tripod and camera in the reflection and the base of the rig. Mostly, this would not make that much of a difference when used as an image-based light in your 3D applications, but it's good practice to clean up the reflection. First, crop the image to isolate the entire reflective sphere, as in Figure 9.20.

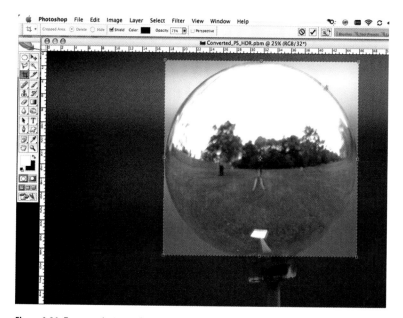

Figure 9.20 To set up the image for use in 3D, first crop to just the sphere.

7. Next, using the Clone Stamp tool, create a brush about 150 in size, and by holding the Alt/Option key, sample some grass in the image. Then, click and paint over the sphere rig in the image, as shown in Figure 9.21.

Figure 9.21
Use the Clone Stamp tool to paint out unwanted reflections in the image, such as the sphere rig and tripod.

8. Continue sampling and painting out areas of the image you want to remove. Figure 9.22 shows the final image.

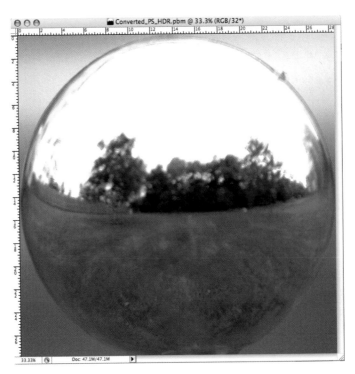

Figure 9.22
Finish sampling and painting out unwanted reflections, and then save the image.

9. To isolate just the probe image, you need to black out the areas outside the reflective sphere. Normally in Photoshop this is pretty easy, but as stated earlier, many controls and tools are not available when working with 32-bit images. So, select Image > Mode, and then change to 16 bits per channel.

10. Next, you can use the Elliptical Marquee tool to select a spherical image. Once you have selected this tool, you can reverse the selection by choosing Select > Inverse. This will select everything outside the sphere, as shown in Figure 9.23.

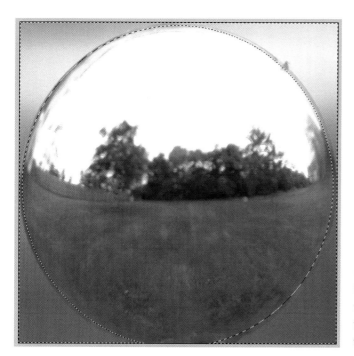

Figure 9.23
Using the Elliptical Marquee tool in Photoshop, select the sphere, and then invert the selection.

11. Once the outer edges are selected, choose the Brush tool (press B), and set the foreground color to black. Then, paint out the selected areas isolating the sphere, as shown in Figure 9.24.

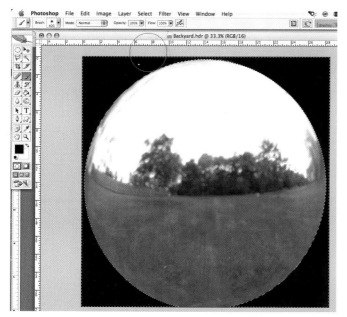

Figure 9.24
Paint out the selected areas isolating the spherical image.

12. Deselect the selection, select Image menu > Mode, and then convert the image to 32 bits per channel. Finally, you need to save the image in a format that your 3D application will understand, so choose File > Save As > Radiance as the file type. This will give the image the .hdr extension.

Everything you've just done to create an HDR probe image can also be done with regular photographs. It's not always necessary to use a probe image—a picture shot into a reflective sphere—to work with HDR. What's important is to understand how to create the data within the image. Once you've generated the HDR image, it's possible to map it in your 3D environment cubically or cylindrically.

Using HDR in 3D

Now that you've created an HDR image through Photoshop CS2, you can use it to light a scene in 3D. Programs such as Autodesk's Maya, NewTek's LightWave, or Luxology's modo can all put the HDR data to good use. Figure 9.25 shows the same teapot image from earlier in the chapter entirely lit with the backyard probe HDR image created in this chapter. If you look closely at the reflections in the teapot, you can make out the tree line, the bright sky, and yard.

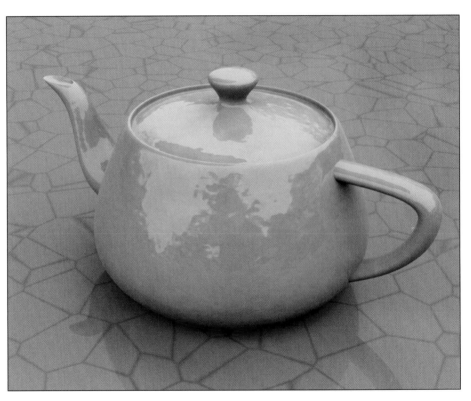

Figure 9.25 The HDR image created in this chapter is put to good use in modo to light a scene.

Applying an HDR image in 3D is relatively easy. In fact, it's often easier than setting up 3D lights. The setup requires you to load the image into your 3D application (or After Effects). In Figure 9.26, you can see the image loaded in Luxology's modo 202.

Figure 9.26
Load the image into your 3D application as you would any other image.

Different 3D applications handle .hdr images differently; however, because this technique relates to the 3D environment, you'll generally be able to find the tools within the environment settings of your 3D application. Figure 9.27 shows modo 202's environmental settings with the .hdr probe image applied. Figure 9.28 show's NewTek's LightWave environmental settings with the .hdr probe image applied.

Figure 9.27 The probe image in modo 202 is controlled within the Environment settings.

Figure 9.28 You also use the Environment settings in LightWave 9.

Once the image is applied in 3D, you need to tell your application to calculate for global illumination. This allows the rays to render the data within the 32-bit HDR image. Do a quick render of the scene with just the HDR image applied, and you'll see it lights the entire scene, thereby casting shadows, creating reflections, and creating hotspots. Figure 9.29 shows a quick render.

> **N o t e :** An HDR image using global illumination isn't really casting shadows. Rather, the 3D elements are being both lit, but not by the image. The areas not lit are simply darker because less light hits those areas, resulting in the illusion of a shadow.

Taking the HDR image to the next level, you can image map a similar photograph from the environment in which you shot the probe. You can place this image in the scene to act as a backdrop. Figure 9.29 shows the similar image, and Figure 9.30 shows the image applied in 3D. To help the look of the scene, you can blur the image if you like.

Figure 9.29 This is an image of the environment in which the probe image was shot.

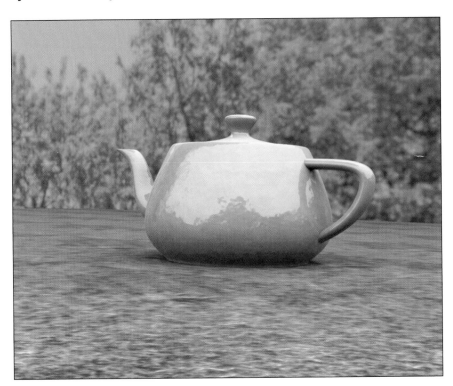

Figure 9.30 This is the environment image applied in 3D as a backdrop.

You don't have to place an image in the background, however. Often, just setting up the probe image is enough. Figure 9.31 shows the old-man model in modo 202 rendered entirely with one probe image, the same image created in this chapter. And what's cool about something like this is that with a probe image, it encompasses your scene, so no matter where you turn the camera, you have a backdrop image. Figure 9.32 shows the old man from a different angle.

Figure 9.31
Depending on the model you're rendering, you can simply allow the probe image to appear as a backdrop.

Figure 9.32
With a probe image applied to your scene, it envelops the environment spherically. The benefit of this is that you can turn the camera and still have a backdrop.

Adjust the settings in your 3D application to your liking, boosting the HDR image if needed. Experiment with the image and different ways you might be able to apply it. Add other 3D elements to populate the scene, and you're on your way to rendering HDR image-based scenes.

Your Next Shot

HDR imagery is often the only way you can truly match real-world lighting. In many cases, probe images work best for image-based lighting because you obtain the most amount of data with a full 360 shot. However, you can merge even simple photos taken at multiple exposures from underexposed to overexposed to create an HDR image. You can then apply the image in your 3D application as both a backdrop and a light source. Try experimenting with photographing different environments for your 3D projects. Use the techniques in this chapter, and try to see what variations you can create.

From here, turn the page to learn about other methods of digital photography in 3D. You'll be able to use your digital photography for creating 3D, but this time not with image-based lighting but with image-based modeling!

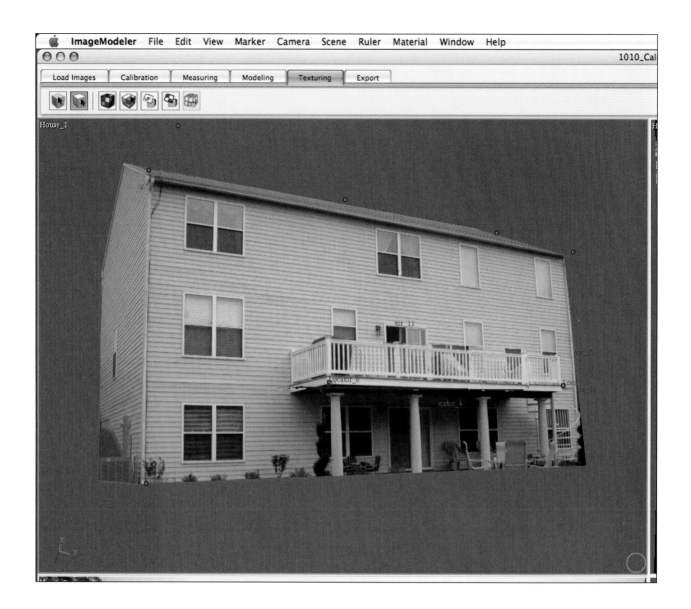

Image-Based Modeling

Image modeling has been around for a while, and as a clever secret for many 3D artists, this was the darling of photo-real 3D renders. Today, with computing power becoming increasingly more powerful and the digital photography industry exploding, image modeling has never been easier.

10

Understanding Image-Based Modeling

The process of image-based modeling involves creating a realistic 3D model based on a series of digital photographs. Typically, you'd model a building, a church, or a home, for example, by referencing photographs or blueprints. You'd then use a 3D modeler such as Autodesk's Maya, NewTek's LightWave, Softimage's XSI, or Luxology's modo to build the structure. As you build the structure, you create materials and later use computer-based and image-based textures to surface the model. This approach is tedious and requires specific modeling methods. Often, using computer-aided design (CAD) models helps the process, but even then, you are required to convert and clean up the data set, in addition to texturing and lighting the model for rendering.

Image-based modeling is different; you'll still use photographs of the subject you want to build, but you'll use multiple angles to build simple geometry. In this chapter, you'll explore this process for creating 3D models from photographs (specifically, a photograph of a building). However, you can apply this process to all sorts of objects including electronics, household items, or even people. Image-based modeling is also referred to as *photogrammetry*. It is used in architecture, engineering, video games, and of course 3D imagery for movies and television.

To perform this process, you'll generally use a third-party application. Although various software packages are available, the clear leader is Realviz's ImageModeler. You'll learn how to create a 3D object from digital photos in this chapter using Image-Modeler 3.5. The process requires the following:

1. Photographing the real-world subject with multiple angles
2. Importing and balancing the digital photos
3. Calibrating the images
4. Building geometric shapes based on the imported images
5. Applying the digital images as textures
6. Exporting the model to your 3D application, such as Maya, LightWave, XSI, or modo

ImageModeler is based on 2D and 3D calibration methods derived from photogrammetry algorithms. The way this technology works is quite amazing: you create 3D objects from measurements or calculations from two or more photographic images. You then identify similar points on each image you choose. Then, the software calculates the camera location, and the combination of these values determines the 3D geometric shape. Photogrammetry can be technically described as obtaining reliable measurements from photography. It's a science that has been used for years, especially in aerial topographical maps and digital terrain models. This is a far-range photogrammetry use, but photogrammetry has many close-range uses as well, which is what you'll learn how to do in this chapter.

Photogrammetry is a complex science that can be overwhelming when deeply investigated. As a 3D animator and digital photographer, you might not want to study it as much as you'll want to use it to create photo-real 3D models. If photogrammetry is something you're serious about, check out Appendix B, "Reference Materials," for a list of websites that contain more scientific data on the subject. For now, move on to the next section to see the photogrammetry process in action.

Shooting for Image-Based Modeling

Before you start using the software to build your 3D model, you'll need some photographs to use. Of course, you can use images you already have, but you should know a few facts that will help the process along when you work with those images later in ImageModeler. First, make sure you're not shooting in automatic mode. You see, as you take different photographs of the building or subject you've chosen, you'll need to take photos from different angles. As you move to different positions, the light entering the camera will change, and with your camera set to automatic, the images will be exposed differently. Therefore, find an even exposure for the subject, and set your camera to shoot at the same aperture and shutter speed for all the shots. However, sometimes you'll be limited to the current light conditions, as you'll see in the upcoming shots. This is especially true on sunny days where shadows are heavy and long. Figure 10.1 shows an image of a building whose shadows are a bit strong for the project. Figure 10.2 shows the same building with softer light and softer shadows.

Figure 10.1 You could use the building in this image for image modeling, although the shadows are bit too strong.

Figure 10.2 This is the same building with less light and shadows that are not as harsh.

But no matter how little or how dark your shadows are, you'll find that ImageModeler does a decent job with your digital photos—and the goal, of course, is to make your 3D modeling life easier. For that, composition and angle are quite important. Try to shoot with the focal length as even as possible as well. Different focal lengths will give ImageModeler a hard time when trying to calibrate the shots. Figure 10.3, Figure 10.4, and Figure 10.5 show the three shots you'll use in Image-Modeler to build and texture a 3D model.

Figure 10.3 This is the first shot, taken from the southeast corner.

Figure 10.4 This is the third shot, taken from the northeast corner.

Figure 10.5 This is the final shot, taken from the northwest corner.

The images shown here can work well for image modeling, even though difficult objects such as trees appear in the shots. Ideally, you'd try to shoot around objects blocking the building or paint them out in an image-editing program such as Adobe Photoshop. For our purposes in this chapter, the images will work just fine. What's better, these images were taken with a 13-megapixel Canon camera, producing images that are 4368×2912. This is a great resolution to use for two reasons—identifying calibration points in ImageModeler will be easier, and the final image maps will be large enough that you can zoom into the 3D model when completed, without much pixelization. (Earlier in the book I discussed pixelization with regard to resolution.) With higher-resolution images, you'll be able to zoom in closer to them, even when used for image-based modeling.

Using Realviz's ImageModeler

To begin, open ImageModeler in Windows or on the Mac. The functionality is the same, but the panels will look a bit different. On the Mac, every panel is floating, whereas in Windows, the panels are nicely contained. Regardless of your platform, you can use a demo version or full version. Figure 10.6 shows the program.

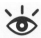 **Note:** You can download a demo version of ImageModeler from www.realviz.com.

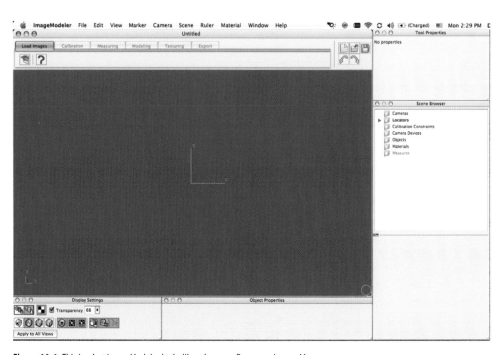

Figure 10.6 This is what ImageModeler looks like when you first open it on a Mac.

At the top of the interface, you'll see well-organized tabs. The first, already selected for you, is Load Images. To begin creating a 3D model with images, you need to load those images! Of course, you knew that! Click the first icon under the Load Images tab, or press Ctrl+L/⌘+L. The Load Images dialog box appears, as shown in Figure 10.7.

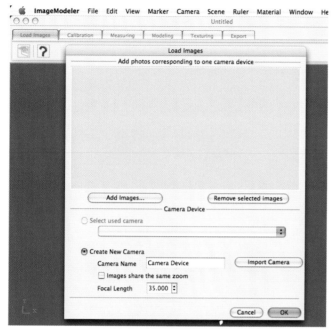

Figure 10.7

Use the Load Images dialog box to bring images into ImageModeler.

Select the House_1.jpg, House_2.jpg, and House_3.jpg images from this chapter's project folder. Once the images are loaded, you'll see the thumbnails arranged, and you'll have a few more options to choose. If you shot your images at the same focal length, select the Images Share the Same Zoom option. For the images loaded from the book's projects, you can enter 35 in the Focal Length box if the program doesn't already set it for you. Also, you can name your camera, but it's not necessary, and you can import any camera data. Figure 10.8 shows the dialog box.

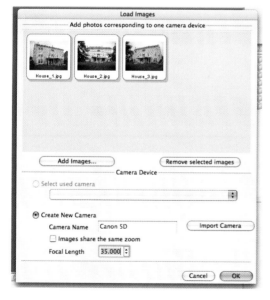

Figure 10.8

Once the images are loaded, you can tell ImageModeler whether the shots share the same zoom, and you can import any camera data.

Click OK, and ImageModeler will process the loaded images. Next, you'll be asked whether you want to load any more images. The three images are enough for this project, so click No.

Calibrating Images

Once the images are loaded, ImageModeler switches over to the Calibration tab, and you'll see the images arranged within the interface, as shown in Figure 10.9.

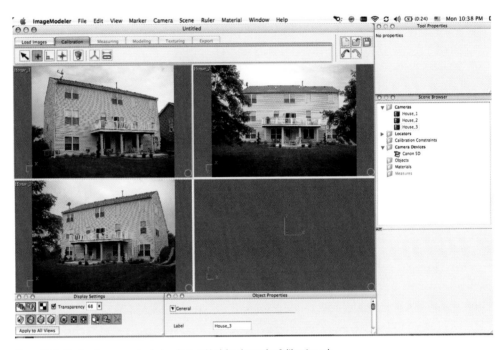

Figure 10.9 The four images are loaded, and ImageModeler shows the Calibration tab.

As you begin working, make sure you can see the entire images. In the bottom-right corner of each viewport is a small circle. Right-click it, and choose Fit to View, if needed, as shown in Figure 10.10.

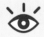 **Note:** When you load images, you'll see that they're listed in the Scene Browser panel. Your images are now considered cameras in ImageModeler.

Still on the Calibration tab, you need to place *markers* in the images. The markers are points that are common to all four images. You'll place these until there are enough images to calibrate, which will take place through triangulation in 3D space (photogrammetry). The second icon at the top within the Calibration tab is the Place Marker tool, as shown in Figure 10.11. Make sure it's selected, and then click the top-left corner of the building in the House_1 view.

Figure 10.10
Make sure you can see each image in its entirety by right-clicking the circle in the bottom-right corner of the viewports and selecting Fit to View.

Figure 10.11
Click the Place Marker tool to begin calibrating the photos.

After you click once, you'll see a zoomed thumbnail view appear to help you align the marker. Place it at the corner of the building. Figure 10.12 shows the example.

Figure 10.12
When you click to place the first marker on the upper corner of the building, a magnification window appears to help placement.

Once you place the marker, you can't click to place another in that view, which is why your cursor is now a red *X*. You can undo (Ctrl+Z/⌘+Z) and place it again, however. Shortly, you'll learn how to add the other markers, but first, add a marker in the House_2 view, clicking the point of the corresponding corner. When you place this first marker, you'll see the word *Locator* in red. Click to place the marker in all the other views at the same corresponding points. Once in place, you'll see a Locater listing in the Scene Browser panel, as shown in Figure 10.13. You'll also see in this shot that the locator is now visible in all views.

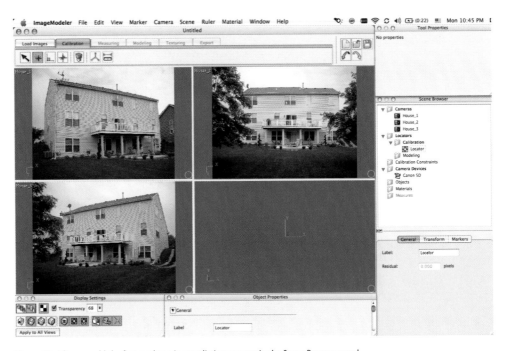

Figure 13 After you add the first marker, a Locater listing appears in the Scene Browser panel.

Now you'll add the other markers. To do so, make sure the Place Marker icon is selected as you did earlier, then hold the Ctrl/Cmd key down, and finally click the top corner opposite of the first corner where you already placed the first marker on the House_1 image. This sets the second locator. In the House_2 image, do *not* press the Ctrl/Cmd key; instead, just click the same corresponding corner to position the locator for that image. Add the marker in the other house image, House_3, to finish setting Locator_2. Figure 10.14 shows the new locator added, and you can see it's also listed in the Scene Browser panel.

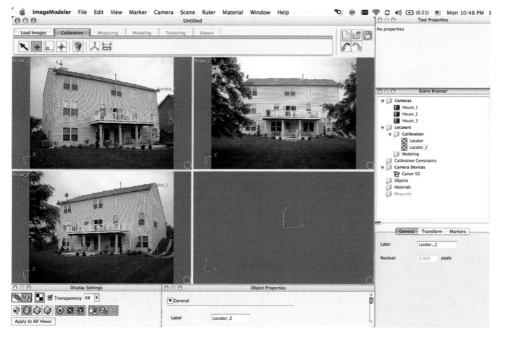

Figure 10.14 Hold down Ctrl/Cmd to add a new locator.

You need to continue adding markers but in other areas of the photographs so that the system can begin calibrating. So, for locator 3, hold the Ctrl/Cmd key, and add a marker to one of the window corners in all the views, as shown in Figure 10.15.

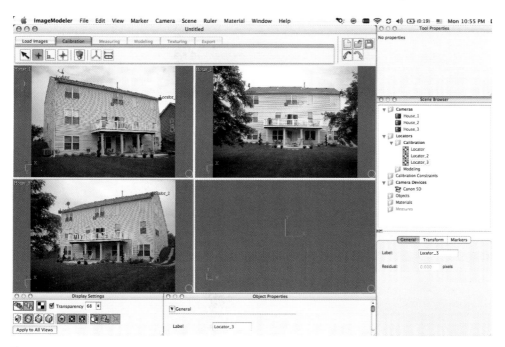

Figure 10.15 Continue adding markers in all three images.

Add makers throughout the images exactly as you've done. Hold down the Ctrl/Cmd key to add a new marker, and then click the point in the image to place the marker. Click the corresponding point in the image from a different view. Note that you may not be able to match all points equally in all images. But if you can set markers in at least two images, you're good to go. Continue the process until you've placed as many markers as you can to create locators around the entire house.

Note: You should need roughly eight to twelve points for a full calibration to be performed.

When placing the markers, look for contrasting points, such as the corners of the house, the windows, even the roof and patio. Once you've placed enough corresponding markers to create the locators, ImageModeler will present a pop-up window telling you that the cameras have been successfully calibrated, as in Figure 10.16.

Figure 10.16

Once you have added enough locators, ImageModeler will notify you that your camera has been calibrated. You can, if you want, add more markers for accuracy.

When the program tells you that your camera has been calibrated, click OK, and you should see your locators turn green, as in Figure 10.17.

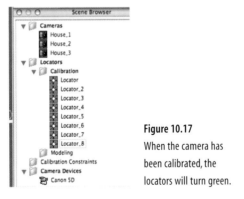

Figure 10.17

When the camera has been calibrated, the locators will turn green.

Right-click the bottom-right circle of the House_2 image, and select Fit to View so that each image is filling the frame. The lines you see throughout the images now are called *site lines*. Notice that Locator_8 is still selected in the Scene Browser. The site lines predict where Locator_8 should be. Figure 10.18 shows a single site line for House_1 and House_3.

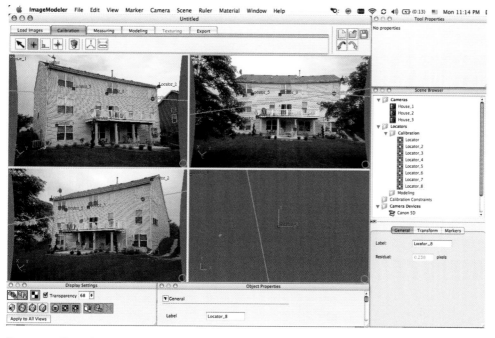

Figure 10.18 The site lines predict where the marker should be. For House_2, the site lines intersect at the determination point.

The House_2 camera has two site lines; this is where ImageModeler is predicting, or determining, where the next marker should be. If you click the intersecting site lines, you'll be able to add a marker. But, hold the Shift key while you do so, and you'll be able to snap the marker to the site line. If you think you need to move a marker, you can do so. Select the Move Marker icon (fourth from the left) at the top of the Calibration tab. Taking a look at Figure 10.19, you can see that the House_3 image, or as ImageModeler understands it, the House_3 camera, has a Residual value of 0.318 (located at the bottom of the panel).

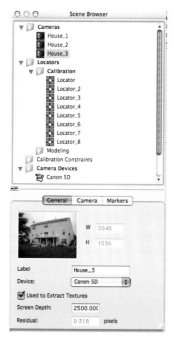

Figure 10.19
When the cameras turn green, the residual value is close to 0 pixels.

This value represents how close the calibration is to being perfect. The camera has turned green, which indicates that all is well. But if the value is more than 1.0 (in terms of pixels), the camera and locator would turn yellow. This is not ideal, but it's workable. If the residual value is 2.0 or greater, the camera would turn red and is not ideal. Take the time to adjust markers, add markers, and get your scene as calibrated as possible. You'll want your locators to be either yellow or green, preferably green.

Creating Models

Once your cameras are calibrated and you've added any other markers for accuracy, it's time to begin creating the 3D model. Because the house is nice and flat and is basically cubes, you can use the primitive tools in ImageModeler to build it up. If you were building something basically round, like a car or a face, you would use the Create Face tool. For now, you need to define your *worldspace*. This will tell ImageModeler what way is X, Y, and Z. This is an important step because you'll want to place your primitive shapes accordingly to build your model.

At the top of the interface, click the Define Worldspace icon. It's second from the last in the toolbar on the Calibration tab. When selected, you'll see a 3D XYZ indicator appear: red for the x-axis, green for the y-axis, and blue for the z-axis. In the center of the XYZ indicator is a light blue dot. Click and drag that until it snaps onto one of your points. Then, click and drag one axis to set the worldspace. Figure 10.20 shows the example.

Figure 10.20

Using the Define Worldspace tool, you can tell ImageModeler which axis is the x-axis, which is the y-axis, and which is the z-axis.

What you're doing here is defining the world orientation to match the viewer's perspective. Drag the y-axis bar to a vertical marker, and again, you'll see it snap into place. The green, y-axis indicator should travel evenly up the house, and the red X indicator should move toward the left of the house. The blue Z indicator will adjust accordingly. By the same token, you can adjust the x-axis and z-axis and the y-axis will adjust accordingly, or you can adjust the y-axis and the z-axis and the x-axis will adjust accordingly.

Defining the worldspace is a little tricky. The Define Worldspace tool is going to be looking for markers, which are points to snap to. If you don't seem to have enough markers to orient the Define Worldspace tool properly, then return to the Calibration tab, and add a few more. At this point, you need to be careful not to disrupt the existing calibration. Adding locators might do this. A trick is that you can often just get away with placing markers in two camera views, rather than all three.

When finished, select the Modeling tab. Click the Add Primitive icon in the toolbar, and then click the Add Plane button in the Primitives category of the Tool Properties panel. Figure 10.21 shows the selection.

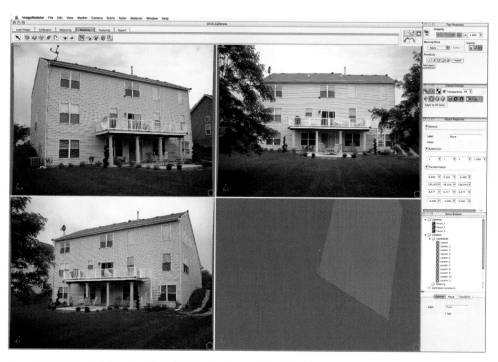

Figure 10.21 On the Modeling tab, click the Add Primitive icon, and then click Add Plane in the Tool Properties panel.

When you've chosen the Add Plane tool, click the House_1 camera view on the corner of the porch. You'll see a dotted line representation of a flat plane, and it is snapping to the corresponding markers and the worldspace you defined. When the plane lines up, click to apply one corner. Then, move the mouse, and click to set another corner for the plane, perhaps on the top of the porch. Figure 10.22 shows the example.

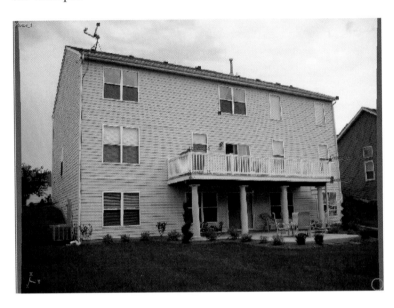

Figure 10.22
Click to add a primitive into the camera view on top of the porch, and then set its other corner and click again.

The primitives will snap to the locators you've set up. If you need to place the primitive in a spot where you don't have any points, ImageModeler will snap to the corresponding axis. This is why calibrating the images and defining the worldspace are important. If you need, you can add a marker from within the Modeling tab. Just select the icon at the top of the interface, and add a marker to help you align primitive shapes.

Note: You need only three points to align and position a primitive.

Your plane might be inverted after you apply it. From the menu bar, choose Scene > Edition > Invert Face Normals, as shown in Figure 10.23.

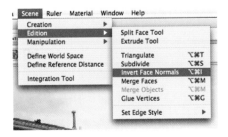

Figure 10.23
If your flat plane is inverted, use the Invert Face Normals command to flip it.

You should see the flat plane across the front of the porch. Depending on how well you placed your plane, you can use the Move tools to adjust it. At the top of the software interface, select the Move tool (still on the Modeling tab); next, in the Tool Properties panel, select Edge for the selection mode, and then click the edge of the plane to adjust. Figure 10.24 shows the adjustment.

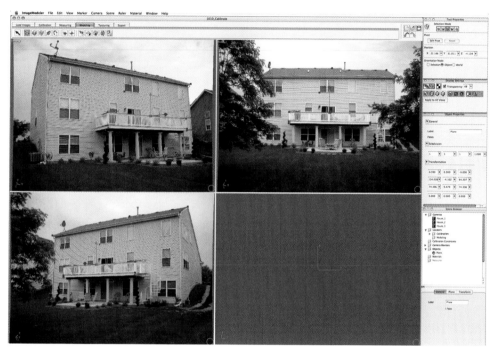

Figure 10.24 You can select the Move tool, and then move a face or edge to adjust the flat plane.

Note: If you would like to see your flat plane in a 3D view, click the desired camera view, and then right-click the circle in the bottom-right corner. Click Lock View, and you'll see a 3D view. Hold down the Alt/Option key, and then click and drag to rotate the view. To return to camera view, right-click, and choose Lock View again.

Note: You can press the spacebar to change from a four-view display to a single view, and vice versa.

You can easily give the flat plane some depth. First, with the Move tool selected, in the Tool Properties panel, click the first icon, and then click the Select Objects icon for the section mode. Then, select Scene > Edition > Extrude Tool. Click and drag to extrude the flat plane to give the porch depth, as shown in Figure 10.25.

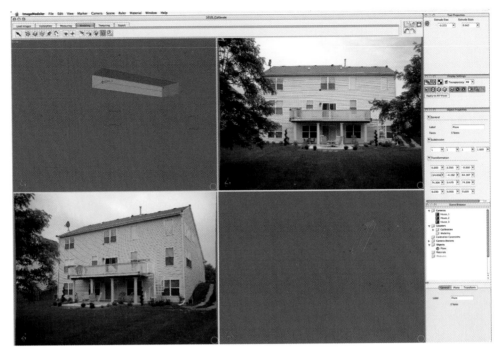

Figure 10.25 Using the Extrude Tool command, you can add depth to the flat plane.

Now you can add geometry for the back of the house. Select the Add Primitive icon, and then choose Add Cube in the Tool Properties panel. Click in the House_1 view at the bottom left of the back of the house. Then click across to the other side of the house, almost as if you were tracing the image. Figure 10.26 shows the progress.

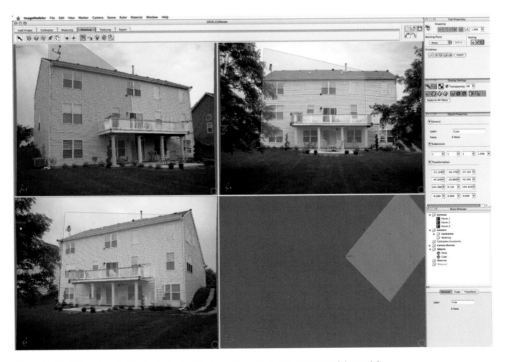

Figure 10.26 Add a cube primitive to the back of the house to begin building the rest of the model.

You can then edit and adjust any edges, faces, or vertices as needed to align the cube. Remember that you can select Rotate, Move, Size, and so on, in the toolbar at the top left of the interface. Figure 10.27 shows the right edge moved.

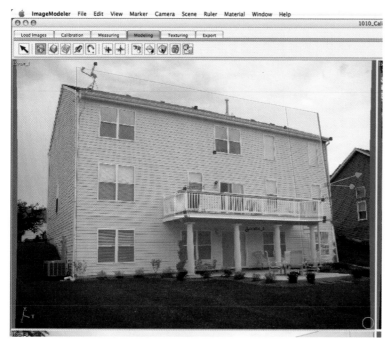

Figure 10.27 Edit the edges of the cube primitive to align it with the house.

As you edit your geometry, you might find that even though ImageModeler has aligned the primitive shapes, you might need to rotate on one axis. If you do so, you want to rotate from the alignment, not from the center of the object. So, at the top of the interface, select the Rotate tool, choose Select Objects mode, and then choose Edit Pivot. Move the pivot to the alignment edge, and you'll now rotate the object from that new position.

If you find that you're able to align the cube in one camera but not the other, your calibration might be off. What you can do then instead of moving edges or vertices is use the Pin tool. It's the thumbtack icon in the toolbar. Select it, and you'll be able to "pin" the corners of the cube to the locators in the camera views. Figure 10.28 shows the example.

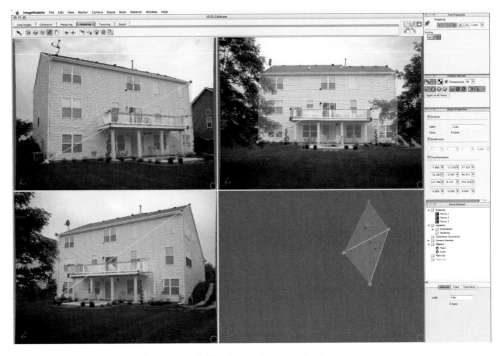

Figure 10.28 Try using the Pen tool to lock the primitive shape to the cameras' locators.

If you have trouble seeing the geometry as you're applying it, turn off the transparency. You can do this by clicking the check mark in the Display Settings panel. At this point, you should have a good idea of how you can build 3D models with Image-Modeler. Your digital photographs can really go a long way in the computer, and in 3D, with the right tools. Take some time to move, position, and rotate any edge or face as you see necessary. Then, in a 3D view, select the face polygon representing the top of the house. With the face selected, choose the Split Face command. It's the icon that is third from the right on the Modeling tab. When the tool is selected, move the mouse to one edge of the face, and you'll see the cursor snap. When it does, click the center of the edge. Then, move to the other side of the face, and click the corresponding edge. Essentially, you're telling the program to slice from here to there, as shown in Figure 10.29.

Once split, select the new edge, choose the Move command, and then move the selected edge up on the y-axis to create the pitch of the roof, as shown in Figure 10.30.

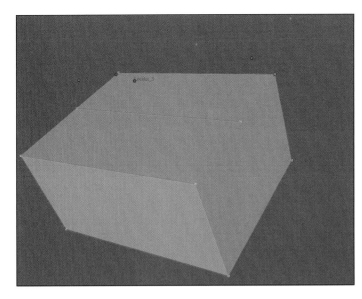

Figure 10.29
Select the face that makes up the top of the cube for the house, and then split it once.

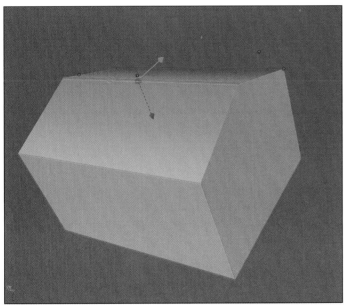

Figure 10.30
Move the newly created edge up on the y-axis to create the pitch of the roof.

If you're using a demo version of ImageModeler, you can't save your work. If you're using a licensed version, by all means, save it!

From here, continue the process as described in the preceding pages to add geometry and adjust, rotate, and move vertices, edges, or faces as needed. This program takes a bit of getting used to, so keep at it. For now, read on to texture this model.

Using Textures from Photos

With your model built, it's time to start applying surfaces, or *textures*, to the house. Although you can always add more geometry to all your models, the examples shown here are enough to learn how the texturing process works in ImageModeler.

Click the Texturing tab, just to the right of the Modeling tab. Choose the second icon, the Select Face icon, and click the back of the house, as shown in Figure 10.31.

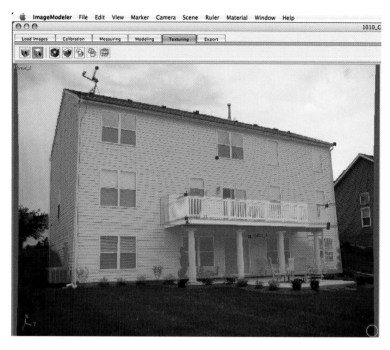

Figure 10.31
Click the Select Face icon, and the click the back of the house to select the geometry.

With the back of the house selected, click the checkerboard icon. This is the Extract Textures tool. You'll be presented with a panel that asks you to choose shots for extraction. Select them all, and click OK, as shown in Figure 10.32.

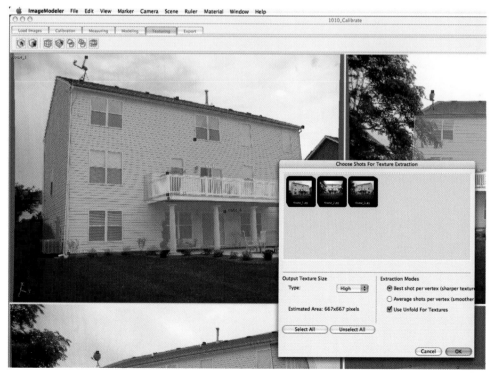

Figure 10.32 You can extract textures from your selected photos to automatically map them to the geometry.

Once you click OK, ImageModeler will begin processing. Shortly, you'll see an image-mapped model, similar to Figure 10.33.

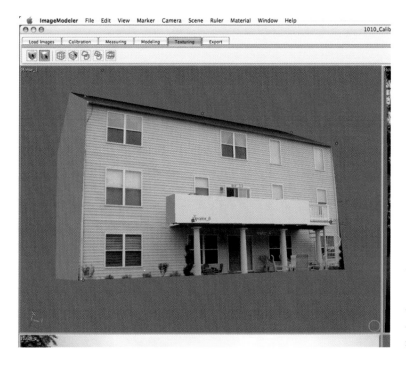

Figure 10.33
When the photos have been extracted, they are automatically cropped and mapped on the selected faces.

Make sure one of your camera views is set to a 3D view. Do this by right-clicking the small circle in the bottom corner of the screen and choosing Lock View. Repeat this process for the porch, as well as the side faces of the house. Figure 10.34 shows the model.

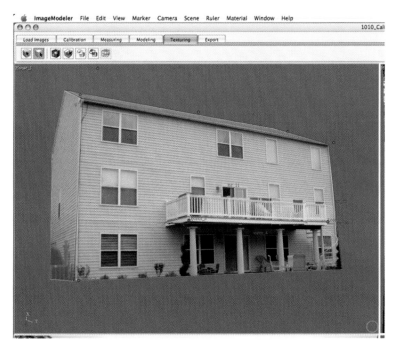

Figure 10.34
Continue selecting faces for the porch, roof, and sides of the house and extracting textures.

Exporting the Model

Once you have the textures extracted from the photos, it's simply a matter of exporting the model. You can choose between a wide range of programs to export to, including Maya or LightWave. Select File > Export As. The Export Scene dialog box will appear asking you where to save the file and as what file type you want to save it. Pick your 3D application of choice, and generally, you would leave all the options on by default. Adjust as needed depending on your system and program. Figure 10.35 shows the dialog box.

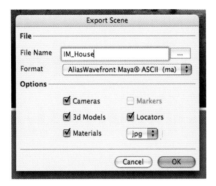

Figure 10.35

Choose File > Export As, and you're presented with the Export Scene dialog box, which provides various save options.

When you import your model into your 3D application, it will load as a scene. The image map data will be applied, and your model will be presented in the same worldspace you defined in ImageModeler. Figure 10.36 shows the model imported into LightWave 9.

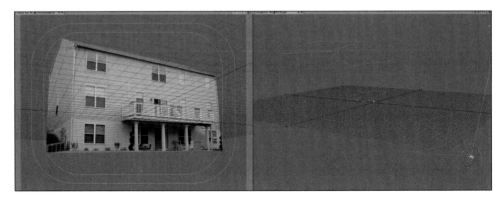

Figure 10.36 Importing your model into 3D also brings in the applied textures.

Your Next Shot

The project in this chapter really works well for a 3D scene that requires only a little movement around the house. If you noticed, there's not much of an image for either side of the house or the roof. If you look at the mapped model in your 3D application, the texture will be applied as best as it can be but will be stretched without a straight-on shot. Regardless, you can expand the techniques presented here to larger, more complex models. And it all begins with a digital photograph. Some additional photos are included on the book's DVD for you to use, so try modeling with other photographs. Also, check out the tutorial video covering this topic, which shows you firsthand how to calibrate and work with ImageModeler.

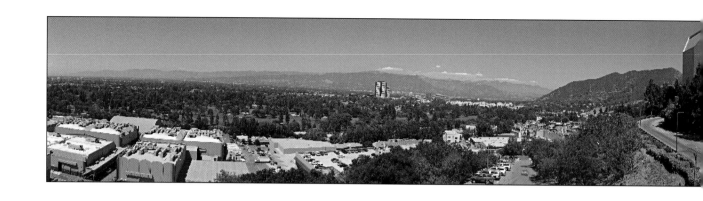

Creating Panoramic Environments

Digital photography for 3D can go far beyond the simple reference images and texture maps that you've probably created. With megapixels always on the increase and resolutions becoming larger each year, you have even more flexibility when working with digital images in 3D applications. This chapter will concentrate on using digital photography for building full 3D environments. You'll see how you can use both Adobe Photoshop and Realviz Stitcher to blend and combine a series of digital photographs and then use them as an environment in your 3D application. You'll also learn what to look for in shooting, as well as the benefits and problems when shooting with both point-and-shoot cameras and full digital SLRs.

11

Envisioning Good Panoramas

When shooting good panoramas, exposure issues will come into play as well as angles, optimization, what time of the day to shoot, and so on. Figure 11.1 shows an image put together with a series of photographs to create a 180-degree panorama.

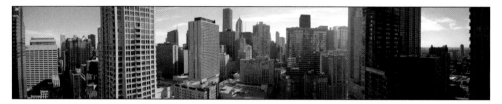

Figure 11.1 Using a sequence of shots, you can create a panorama image to be used in a 3D environment.

Earlier in the book, you saw how to use a large photograph in a 3D environment and that by using a high resolution and animating the camera, you can effectively create movement from a still photo (Figure 11.2).

Figure 11.2
A large photograph can work well for slight camera movements but not for full 3D environments.

Although the example in Figure 11.2 works well for some images, it's not really filling a 3D environment. Often, 3D artists can get away with using one large photograph as a backdrop in an animation, but even so, movements are limited. It's then that the use of a panorama comes into play. You can use the techniques described in this chapter to create higher-resolution images by "stitching" together multiple images. Panoramas can range from a wide image as shown in Figure 11.1 to a full 360-degree spherical image. Figure 11.3 shows a 360-degree spherical image mapped in Autodesk's Maya.

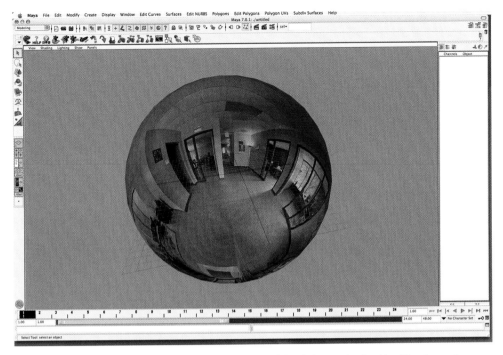

Figure 11.3 This is a full 360-degree panorama created from a series of digital photographs, placed in a 3D environment.

Using a full 360-degree panoramic image, you effectively can create a full 3D environment. Wherever the 3D camera turns, it will see the image, without stretching or distortion. Going a step further, you could use the information provided in Chapter 9, "Creating and Using HDR Images," to create HDR images and then create a panorama as well. A panorama can be anything as simple as a wide extended shot or a full 360-degree one as shown in Figure 11.3. The term *panorama* doesn't just relate to digital photography but to film, video, drawing, and painting. You'll see panoramas everywhere, from fine art galleries to posters to real estate. In fact, you can find panoramic paintings dating back as far as the late 1800s. Artists would use this technique to depict landscapes. Today, you may be familiar with various realtor sites that allow you to see a "virtual tour" of a house or apartment over the Internet. These interactive 360-degree panoramas are created the same way wide extended shots are created, as shown in Figure 11.4. Images are shot in a row, as you'll read about in a moment.

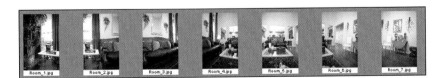

Figure 11.4 You can create 360-degree panoramas and 180-degree panoramas in the same manner.

Although you might shoot and compile images in the same fashion for a full 360-degree panorama as you would with a 180-degree panorama, how you output the final composite makes all the difference. And the size, shape, and orientation of the final panorama will determine how you can apply it to a 3D scene. Figure 11.5 shows the same image from Figure 11.4 but wrapped on a cylindrical object in Luxology's modo 202.

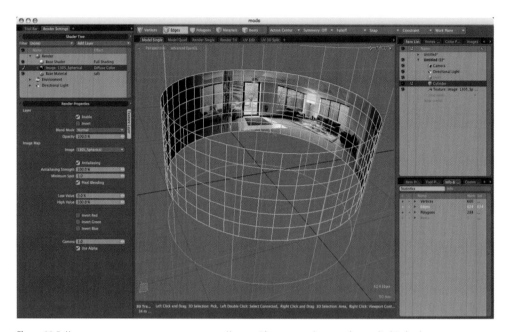

Figure 11.5 How you use your panoramas are up to you. Here, a wide panorama is mapped to a cylindrical polygon.

Quite a few cameras on the market are made specifically for creating panoramic images. Many of these will shoot an entire 360-degree image in one shot! But often, unless you're creating panoramas on a regular basis, the cost of these cameras is hard to justify. Believe it or not, creating panoramas is not as complicated as you might think, and you can use just about any digital camera. As you've seen from the examples, you can use panoramas in different 3D programs with a number of different mapping methods. So, where do you begin? And what's the best way to create a panorama? Well, you first need to plan your shots.

Planning the Shots

Capturing images for panoramas requires that you shoot your images in a row, with each image slightly overlapping the previous, with about 15 to 20 percent of overlap. This goes for simple panoramas of just a few images or a full 180-degree panorama with six or more images. Shooting in a row, in addition to shooting multiple rows, is also required for capturing 360-degree panoramas. You'll learn how to create these panoramas in this chapter using a special panorama tripod rig. But did you know that your simple point-and-shoot camera often works better for some panoramas? (You'll

read about this in the "Creating Panoramas with a Point-and-Shoot Camera" section.) The reason for this has to do with the nodal point of the lens. When you take a photograph with a digital SLR camera, your camera has a decent size body and a lens that extends out. When you turn your body (or tripod) to take each shot, you're pivoting from the back of the camera, not the lens pupil. Figure 11.6 shows an example of a typical tripod-mounted camera.

Figure 11.6
A camera mounted on a tripod is great for longer exposures and steadying your shots, but set up like this, it's not good for panoramic photographs.

Because the camera in Figure 11.6 will shoot from the body, it's not good for shooting panoramas. By mounting a camera on a tripod in a typical fashion, as you rotate the camera to take panoramic shots in a row, the camera's nodal point is at its base. With shots like this, your images will have parallax. *Parallax* is when the angular position is different in each image. You might not think this makes a big difference in the final shot, given that your camera is fixed in one position on a tripod, but in certain situations, it will cause a lot of issues. Generally, long-range outdoor images won't suffer from noticeable parallax as much as indoor shots. When images have parallax, it means your images will not "stitch" together cleanly. Figure 11.7 shows a few shots put together in Stitcher (version 5.1).

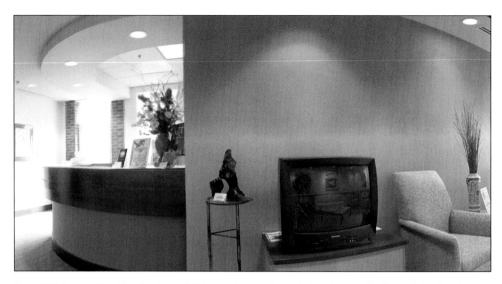

Figure 11.7 Images stitched together from a digital camera improperly mounted can have parallax. The result is a blurred, uneven panorama.

Look at the edges of the walls, the tiles in the ceiling, and the edges of the television. Can you see the blurring? Although the initial shots appeared to be lined up, because the camera was rotated from the back of the lens (or the body of the camera), the stitched images can't line up properly. Perhaps with enough manipulation, masking, and blurring, you could achieve the results you want. But when you bring these final panoramas into your 3D application to create an environment, the last issue you'll want to worry about is parallax.

To avoid parallax, you can use a panoramic tripod mount. A spherical VR head, as it's often called, pulls the camera back from the initial tripod mount, allowing the nodal point to be at the front of the lens. Figure 11.8 shows the setup.

Figure 11.8
To avoid parallax in your panoramic images, you can use a spherical VR head.

Figure 11.8 shows a Canon digital SLR camera mounted to a Manfrotto 202SPH spherical VR head. Figure 11.9 shows the result of shooting with this setup.

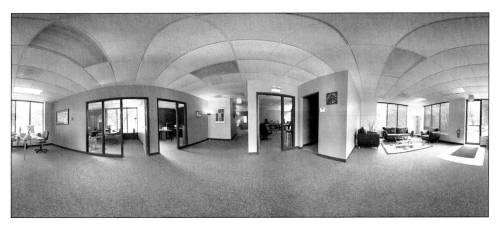

Figure 11.9 Shooting indoors with a spherical VR head eliminates parallax.

Planning your shots is important. Therefore, you'll want to know how you're going to use your final shot. Is it a full 360-degree panorama? Is it just a wide panorama? Will both be used in 3D? How will you map them? Spherically? Cylindrically? From there, will you be shooting indoors in a tight space or outside on a large landscape? This will determine what lens to use and bring with you on the shoot. Planning ahead will make your time shooting more enjoyable. And speaking of shooting, you also have a few exposure issues to address when shooting panoramas.

Setting Exposure for Panoramas

Exposure is, of course, crucial to capturing the right image. But when you're capturing images that are going to be "stitched" together, blended in such a way that the final image appears as one large photograph, exposure is even more important. Additionally, the time of day you shoot your images plays a key role in the exposure of your images. Imagine this: You're creating a panorama of a sunset on a beach. You take your first shot toward the setting sun. Then you rotate your camera about 30 degrees and take the next. As you rotate around your environment, shooting photographs, your exposure changes as the light varies. Many panoramic programs that allow you to stitch together multiple photos want the images to be taken at the same exposure, but in reality, that's not always practical. In some circumstances, your images will be approximately the same exposure, such as the images in Figure 11.10. Here, a 180-degree panorama looking over the Universal Studios lot in Los Angeles on a sunny summer afternoon doesn't require any variation in exposure.

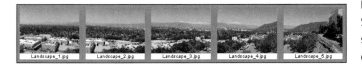

Figure 11.10

Shooting midday outdoors in open space doesn't require variations in exposure.

When a shot like this is mapped to a cylindrical plane in your 3D application, you will have no problem lighting your 3D objects to match the lighting conditions. Exposure is bright and even across the image. But let's say you're shooting indoors, and the light varies greatly around the room. What's the best exposure to use? If you shoot at a medium exposure that is balanced to the average light of the room, some areas will be washed out, and others will be too dark. Figure 11.11 shows an image taken toward a window during late afternoon. The automatic exposure of the camera adjusts to the bright light outdoors, and accordingly, the shot is underexposed.

Figure 11.11
Shooting indoors during the day can result in underexposed shots.

Although this image can still blend into a panorama, it would be better if you shot it later in the evening for two reasons. The first reason is for exposure compensation as you saw in Figure 11.11. By adjusting the exposure to meet the lighting indoors, you'll wash out the windows. On the flip side, by exposing to the light outside, the

indoors becomes too dark. And although you can take two shots of the same location—one exposed for outdoors and one for indoors—you'd still have to merge the two images in Photoshop. The second reason for shooting indoors at night is that light coming through a window during the day tends to create a halo effect, which is difficult to remove, even if you're the best Photoshop artist. And also, why would you want to have to clean up your images? It's better to get the shot accurate from the start. A picture of a window with a halo effect will also cause issues when it comes time to stitch and blend neighboring images.

The shots you take for indoor panoramas can vary in exposure, but it shouldn't be any more than a third of a stop. For example, Figure 11.12 shows seven images, each with varying exposures.

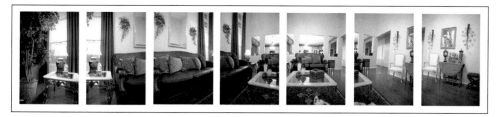

Figure 11.12 Seven images taken indoors all vary in exposure settings but blend together nicely for a final stitched image.

Each image was balanced slightly in Photoshop for color and saturation, but the exposure variance looks natural. That's the goal—to shoot your images so that there is not a strong distinction between shots and so that the end result is seamless. The image on the left was shot with a shutter speed of 1/60 and an aperture of f3.5. The second image was also shot with a shutter speed of 1/60 but with a larger aperture of f2.8. The second-to-last image was shot with f3.2, and the image on the right was also shot with f2.8. As you can see from these images, even at slightly different exposures, none stands out as too dark or too bright.

Correcting with Exposure Compensation

You can correct images that are improperly exposed. This is where the advantage of shooting digitally comes in handy because you can instantly preview the shot after you take it. When shooting, take multiple shots of each location. Take one shot as you normally would, balanced to the average light in the room. In most cases, certain lights will become overexposed. If this happens, take another shot but underexposed by about 1.5 or 2 stops. Then, in Photoshop, you can use layer masks and blend the underexposed image on top of the overexposed shot. Bring the opacity down for the underexposed shot, and your image will look balanced, bringing down the exposure of any hot lights. Figure 11.13 shows a shot taken indoors, exposed to see the blue sky outside the window, but the rest of the image is entirely too dark. Figure 11.14 is the same shot but exposed to compensate for the walls and indoor lighting, making the window area overexposed.

Figure 11.13 A shot taken with an exposure balanced to see the outside

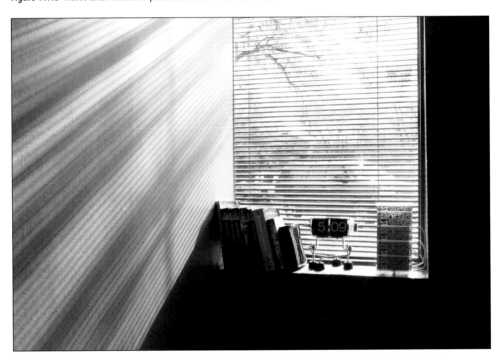

Figure 11.14 The same shot exposed to see the indoor lighting

Follow this technique to blend the two images in Photoshop:

1. Load the two images in question into Photoshop.

2. Make sure the overexposed image is in a layer above the underexposed, as in Figure 11.15.

Figure 11.15 Load both images into Photoshop, and using two layers, place the underexposed image in the top layer.

3. You'll create a mask and paint the areas where you don't want to see the underexposed image. A down-and-dirty way of doing this is to simply erase the underexposed image (the top layer) except for the properly exposed window, revealing the properly exposed walls underneath. However, depending on the image, this might be hard to do accurately. Instead, in the Layers palette, click the Add Layer Mask icon at the bottom (Figure 11.16.)

Figure 11.16
Add a mask to the top layer, the underexposed image.

4. Select the Brush tool, or press B, and then find a midsize brush, perhaps about 600 pixels in size (depending on the size of the images being used). Find a brush with a slightly soft edge, and then paint on the underexposed areas of the image.

Figure 11.17 shows the main wall from the evenly exposed shot mixed with the underexposed shot.

Figure 11.17 Painting on the underexposed image with a mask applied reveals the properly exposed wall in the layer beneath.

5. Continue painting any unwanted, underexposed areas. You can then save this image to be used in your stitched panoramas. Figure 11.18 shows the result.

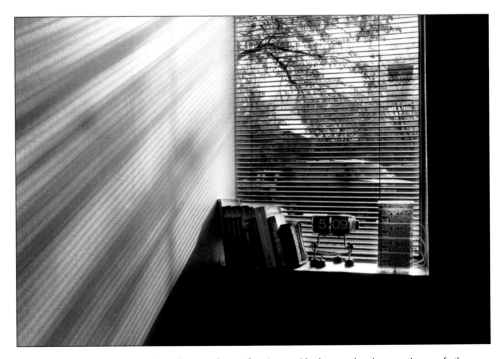

Figure 11.18 Painting out the underexposed areas of one image with a layer mask ends up creating a perfectly exposed image, ready to be stitched into a panorama.

Although this technique is not complex, it does take a little time, and if you need to do this for all your panorama shots, be prepared to spend a good amount of time in front of the computer! But in most cases, even with a large panorama and many images, you'll have only one or two images that need to have their exposures compensated. This process is great for window shots, as you've seen here, but it's also good for night-time shots when the exposure time needs to be longer to compensate for low light. Taking shots at night often ends up creating overexposed light sources such as table lamps or streetlights. This Photoshop technique can correct those shots, but remember, you need to take two shots in order to do it. Finally, you can use the Curves tool to balance the image as needed, and then you can flatten the layers and save the image to be placed in your panorama.

Assembling Panoramas

You can assemble panoramas in a number of ways. You can do it with even the simplest camera and, often, with included software from your camera manufacturer. Many small point-and-shoot cameras offer a panorama mode. To use this mode, reference your user manual, and then start setting up a shot for which you want to create a panorama. Start on the left, and take the first shot. In a moment, your camera's LCD display will show the image you just took as it always does but with a variation. It will show only about a third of the right side of the image but placed left and transparent over whatever your camera is viewing now. Use this transparent portion of the previous image to align the next image. It's quite handy actually—and makes taking panoramas easy. In addition, because your point-and-shoot camera doesn't usually have a long lens and thick body like a digital SLR, you're less prone to seeing parallax in the final images. If your digital camera came with panorama software, go try it! Take some shots, load them up, and push a few buttons to create a stunning wide photograph. If you don't have panorama software with your camera, read on. This project will show you how to quickly and easily assemble a panorama with Photoshop. You can use the final image in a 3D application.

1. Start Photoshop, and load the Landscape images on this book's DVD. There are five images in all, at 3264×2448.

2. Once the images are loaded, create a new Photoshop document. Select File > New, and in the dialog box that opens, set Width to 21840 and Height to 2448. This is an image that is larger than five times the width of one image but is the same height. You'll use this extra space to move images and then crop to the final image.

3. Set the resolution to 72. You need no more than this when working in 3D, but if you're going to print, you'd set it higher, usually 300. Make sure it's an RGB image, not grayscale, and give the new document a name such as LandscapePano. Figure 11.19 shows the panel.

Figure 11.19
Create a new Photoshop document that is five times the width of one image.

Note: If your system does not have enough resources to work with images this large, you can scale down the landscape images to 1024×768 and then use a new image of 5120×768, or five times the width (for five images at 1024).

You might think that this width is excessive, and although you could create a smaller panorama, this large scale will be better for use later in 3D. But also, this will change a bit later. Right now, it's needed to accommodate all five images at their full widths.

4. With the new Photoshop document created, press V to activate the Move tool, and then drag the five images, one at a time, into the new Photoshop document. Try to load the images in order, Landscape_1.jpg as the first image, Landscape_2.jpg as the second, and so on. It doesn't really make any difference except that layer 1 will be the first image on the left, and the other images will follow in order; for example, layer 3 will be image 3, and so on. It's a good way to stay organized. As they load, move image 1 to the left, image 2 next to it, image 3 to the right of image 2, and so on. Figure 11.20 shows the process.

Figure 11.20 Assemble your digital photos in the new Photoshop document from left to right, as they were shot.

5. Once you have loaded the five images into the new document, you should have five layers, visible in the Layers palette (press F7). Figure 11.21 shows the layers.

Figure 11.21

Once you have loaded the five images into the new Photoshop documents, you should have five layers, each containing one image.

6. Save your new document. Now, it's time to start blending the photos together. You can do this with masks like you saw in the previous project, but for these particular images, you have another choice using the Spot Healing brush. Select your first image, which should be layer 1 if you've loaded the images in order. Make sure it's positioned all the way to the left in the Photoshop document. Then, select layer 2, and move it over the first image, making sure they overlap, as shown in Figure 11.22. You'll see common markers in each image, such as buildings or trees. Try to align these.

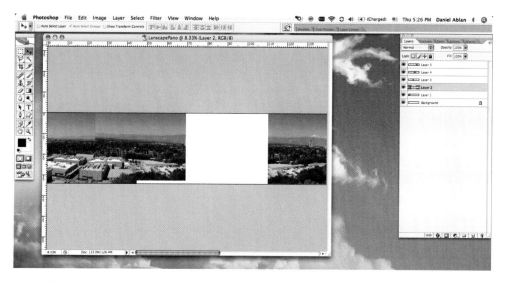

Figure 11.22 Place the second image over the first, aligning the image with any common markers such as buildings.

7. Looking at Figure 11.22, you can see that with the second image aligned based on the buildings, it no longer fits the height of the document. This is because the image was taken at a slightly different rotation. What you're seeing is a form of

parallax, but because of the distance in the image, it will not be an issue. Align image 3 (layer 3) the same way as layer 2, looking for any common spots, such as the corner of a building. Figure 11.23 shows the placement.

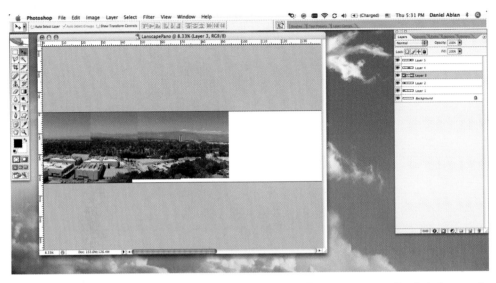

Figure 11.23 Align layer 3 (or image 3) next to layer 2 (or image 2), also using common markings in the images such as buildings.

8. Align images 4 and 5. Now, if you have trouble knowing where to line up an image, or just want an easier time seeing placement, turn the opacity down for that particular layer. You can do this at the top of the Layers palette. Figure 11.24 shows image 5 with its opacity turned down, making it transparent and allowing for easier control of alignment.

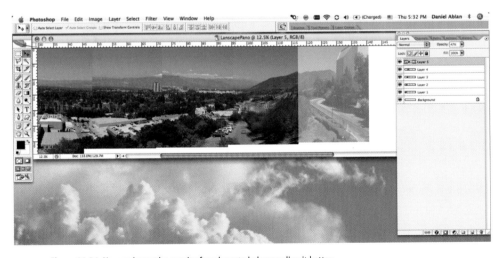

Figure 11.24 You can lower the opacity for a layer to help you align it better.

9. When the last shot is aligned, bring all the opacities back to 100 percent, if you changed them. Save your work. You'll notice that with the images overlapped, the entire image no longer needs to be 21840 in width. Press C to select the Crop tool. Click and drag over the image to isolate just the images, now in place, as in Figure 11.25.

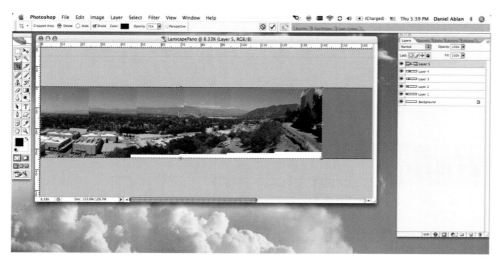

Figure 11.25 Once the images are aligned, you can crop the entire document.

10. With the crop set, you can double-click to accept it or click the check box at the top of the screen. The image will still be pretty big at 10115 width. But it's now half the original because of the overlapping images. Next, it's time to blend the images. Layer 1 is obviously OK, because it's the starting point, so select layer 2.

11. Layer 2 lines up either with buildings or with the mountains, but not both. So, you'll need to warp it a bit. Select Edit > Transform > Skew. You'll see the image outline appear, and when it does, click and drag the top-left corner to pull that portion of the image in, as shown in Figure 11.26.

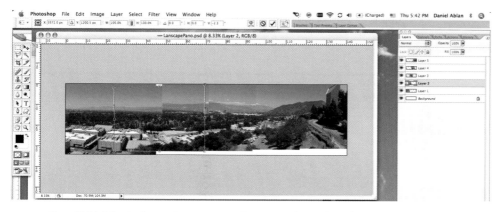

Figure 11.26 Using the Skew tool, you can warp an image to match up with an adjoining image.

12. Drag the top-left corner of the image down until the mountain range aligns. Remember, you can always undo and try it again.

13. Perform the same operation of skewing the top-left corner of the image for the remaining images. Figure 11.27 shows the panorama with all five images now aligned.

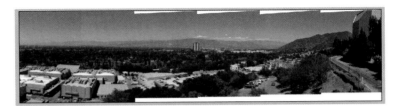

Figure 11.27 Using the Skew tool a bit more, all five images are now aligned.

14. Now that the images are aligned, save your work.

15. Next, you need to blend the images to remove the seams. If you look closely, the images have a slight tonal difference, mostly noticeable in the sky. In a panorama stitching program, you have the ability to "equalize" the images so they are blended a bit better in regard to tone. In Photoshop, you can certainly do that, but it's a bit more of a manual process. Using the levels and saturation controls, you can balance each image. However, before you even think about doing that, get rid of the seams between each image. You'll be surprised how much this changes the overall tone of the panorama. Select layer 2.

16. With layer 2 selected, create a mask for it, as you did earlier, by clicking the Add Layer Mask icon at the bottom of the Layers palette. Then, select a brush by pressing the B key, and use your left and right bracket keys on the keyboard to size the brush, enough to cover the seam between image 1 and image 2, something about 175 pixels. Then, click and drag over the seam. Figure 11.28 shows the result.

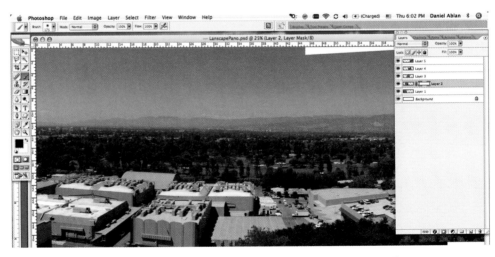

Figure 11.28 Using a brush on layer 2 along with a mask, you can blend the seam into image/layer 1.

17. Continue using the brush with a layer mask to blend the image effectively and remove the seam. Mess around with this for a while, and when you're comfortable, perform the same steps on the other layers. Make a mask, select a brush, and then paint the seam. Note that you can also use a soft-edged brush with the Eraser tool to blend a seam for troublesome areas. Figure 11.29 shows the final blend.

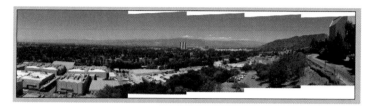

Figure 11.29 After layer masks have been created, the five images are now aligned and blended.

18. Lastly, crop the image to just the area containing images, removing the white background. Figure 11.30 shows the final panorama. Save your work!

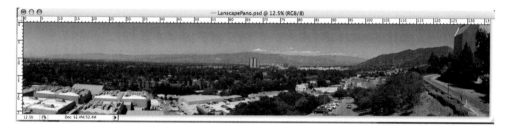

Figure 11.30 Once the images area aligned and blended, it's only matter of cropping the image to reveal the final panorama.

With a little work, it's possible to create panoramic images in Photoshop. Remember that you have tone and color control over each image, and you can also simply paint and touch up the final panorama as you like. From here, after you save your image, you can apply it to a 3D environment.

Using Panoramas in 3D

Most 3D programs take all image formats, such as JPEG, PNG, and TIF. When you save your panorama using Photoshop, be sure to use an image format that "talks" with your 3D application. So, what can you do with a panoramic image in 3D? Lots! You can map the images in a few ways, which the next project will show you.

1. Open your favorite 3D application, such as Cinema 4D, Maya, or NewTek's LightWave. For this project, you'll use the panorama you created in the previous tutorial. It will be mapped cylindrically because of its width.

2. You can create a large flat box and bend it in your 3D program, or you can use a cylinder. For this project, I'm using Maya. Create a polygonal cylinder with a bit more geometry than the default, with the Radius and Height options set to 8 and with Subdivisions Around Axis set to 30. Figure 11.31 shows the setup.

Figure 11.31 Create a cylinder with a little more geometry to help smooth it.

3. Change from a wireframe view to a shaded solid view (in Maya, you can do so by pressing 5).

4. Then, select just the top faces and bottom faces of the cylinder, and delete them, leaving just the sides, as in Figure 11.32.

Figure 11.32 Remove the geometry at the top and bottom of the cylinder so only the sides remain.

5. Right-click the model, choose Assign New Material, and select Lambert, as shown in Figure 11.33.

Figure 11.33 Assign a Lambert material to the cylinder.

Note: For this project I'm using Maya 7, although these settings will work the same in Maya 8.

6. When you select the Lambert shader, the attributes change on the right side of the screen. Change the Lambert name to Landscape, and then click the black-and-white checkerboard icon to the right of the Color attribute. The Create Render Node panel appears, as in Figure 11.34.

Figure 11.34
Assign a new render node to the Color value of the Lambert material.

7. In the Create Render Node panel, you can assign various procedural nodes. Choose As Projection for the 2D texture, and for this project, click the File icon. The panel will close, and you'll see new commands in the attribute panel. For Projection Attributes, set Proj Type to Cylindrical.

8. Click Fit To BBox to automatically size the cylindrical image. Then, for the Image attribute, you'll see a folder icon to the right. Click it to load your panoramic image.

9. Load the image, and you'll see a thumbnail in the panel, as shown in Figure 11.35.

Figure 11.35

Load the panoramic image, and it'll be visible in the thumbnail preview but not in the viewport.

10. You probably can't see the image in the viewport, so press 6 on your keyboard to see textures in OpenGL. Figure 11.36 shows the mapped image, which is repeating.

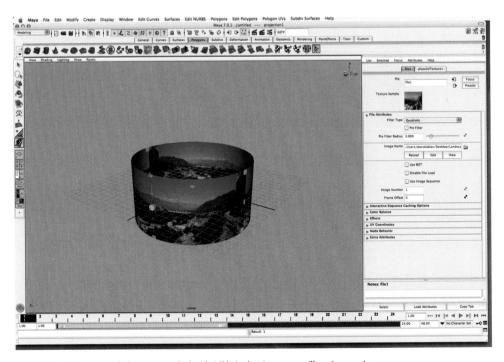

Figure 11.36 With the image applied and visible in the viewport, you'll see it repeating.

11. The repeating texture is fine, but you can disable it by going to the place2d-Texture tab and unchecking Wrap U. This turns off the wrapping feature for the U of the UV coordinates.

12. From here, your environment is ready to go! You can place an object within the cylinder and animate the 3D camera. Figure 11.37 shows a render with a 3D object over three frames.

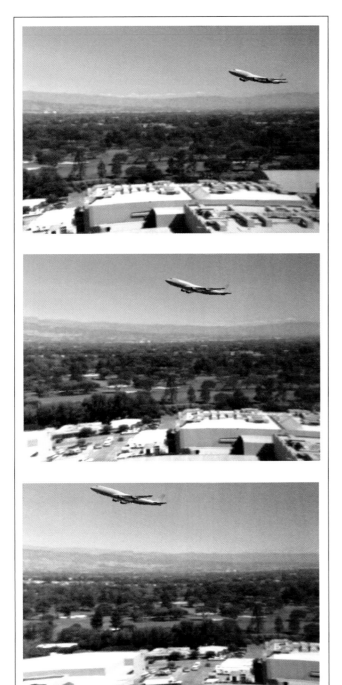

Figure 11.37
Once your image map is in place, you can begin creating animations. Here, a 3D plane is rendered over the cylindrical backdrop.

In Figure 11.37, the 3D aircraft is only slightly moving on the y-axis. Rather than complex camera animations, the cylindrical landscape panorama is rotated around the y-axis to simulate movement. It's sort of a traveling matte. This technique has other benefits as well. Although the composited 3D aircraft is simple, you can go further depending on the type of panorama you've created. Let's say you've photographed a landscape panorama of a large strip mall with a parking lot in front. You can use projection mapping to map the images of the parking lot onto geometry in which you can composite cars or perhaps other building for architectural purposes. The panorama will serve as a backdrop, so no matter where you rotate the camera, you'll see the mall and its surroundings.

Creating 360-Degree Panoramas

Of course, if you were to rotate the camera upward in the previous exercise, you wouldn't see anything, because the panorama is just cylindrical. You can use the same shooting techniques described previously to create full 360-degree panoramas for use in 3D. Follow along with the project in this section to get started creating a 360-degree panorama in Stitcher. You'll finish the project by watching the accompanying video tutorial on the book's DVD.

Using Stitcher, you can create spherical, cylindrical, or even cubic panoramas, as well as others. The process you saw earlier in the chapter using Photoshop to bring together multiple images to create a cylindrical panorama works well in most situations, but not as much with full 360-degree panoramas. Stitcher can create panoramas for landscapes as you've already done, and often it's a matter of clicking a few buttons. Go to www.realviz.com to read more about Stitcher and download a demo. For now, read on to learn how to create a full 360-degree panorama.

1. Start Stitcher, and you'll see a pleasant but blank interface, as shown in Figure 11.38.

Figure 11.38 This is the Stitcher interface upon start-up. It's empty and ready for images.

2. Using Stitcher (version 5.*x*) is easier than you might think. You have advanced feature controls, but Stitcher does such a good job merging your images; you might not need to access the additional tools. At the top left of the interface are five floating icons. Move your pointer over the first one, and you'll see additional ghosted icons appear to the right, as shown in Figure 11.39.

Figure 11.39
To begin loading images, you can click the first icon at the top left of the interface.

3. If you move your pointer over the additional icons that appear, you can see the various options: Open Project, Load Panorama, Save Project, and so on. For now, click the first icon, Load Images. The Load Images panel appears, and you can point to your photograph directory or use the images provided for you on this book's DVD. When you get to the image folder containing your files, click the Select All button at middle of the Load Images panel. This will allow you to bring all the images in at once. Figure 11.40 shows the panel.

Figure 11.40
It's easy to load many images at once by clicking the Select All button in the Load Images panel.

4. Leave all the other settings as they are, and click OK to load the images. The Office images on this book's DVD are quite large, so loading all of them at once might take a moment. Figure 11.41 shows the progress bar as the images load, and you can see the image thumbnails appearing at the bottom of the screen.

Note: If your system can't handle loading all 49 images at this resolution, you can either scale them down before loading or simply load just a few to get the project going. Don't use the Select All feature; instead, Shift+select, say, the first 10 images.

Figure 11.41 A progress bar appears as the images load into Stitcher. You can see each image as a thumbnail at the bottom of the screen.

5. Once the images are loaded, you'll see the thumbnails for all of them across the bottom of the interface. You can size them by dragging the slider at the bottom left, and you can move between them by clicking the arrows on the left and right sides of the images. You can also use the Image Strip in Stitcher, which allows you to arrange your images, move them, and drag them to a different location on the screen. Perhaps you have a large widescreen monitor or a two-monitor setup. Use the Image Strip to place your images aside as you're working, in sort of a "bin" for your loaded images. Access the Image Strip from the Window menu. Figure 11.42 shows the Image Strip.

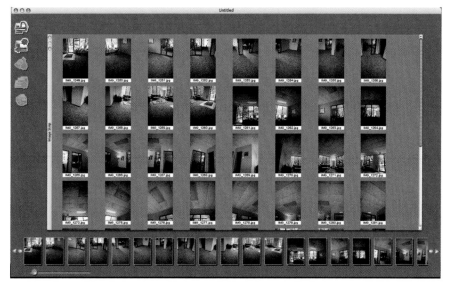

Figure 11.42 The Image Strip can give you a little more control and organization for your loaded images.

Once you have the images loaded, you're ready to stitch them together. And because they were shot with a spherical panoramic head as described earlier in the chapter, they should line up without issue. The second icon at the left of the interface is pretty handy. It's an Automatic Stitch tool. This is great when you have a few images, such as the ones you stitched together manually in Photoshop. This automated tool will look at each loaded image and do its best to place them together. But with a full 360-degree panorama and 49 images, you're better off manually stitching.

6. Earlier, I discussed why it's important to shoot your panoramic images in order. This is especially important now when you have a ton of images to sift through and place. Because the office images were shot in order, from left to right, you can click and drag the first image into the workspace, as shown in Figure 11.43.

Figure 11.43 Click and drag the first image (on the left of the Image Strip) into the workspace.

Note: A quick way to "fit" an image to view is to press the plus (+) key on your keyboard. This will bring the currently selected image to full view.

7. When you drag the image to the workspace, it's outlined in green. This means the image is stitched. Stitched to what? you may ask. Well, nothing really, which is why it automatically showed up with a green border. At the top right of the interface is a small live preview of the panorama. You can enable this by selecting Stitcher > Preferences and then choosing Live Preview from the Preview category.

8. Take the next image, and drag it into the workspace. Now you'll see the border around it as red. This means it's not yet stitched. If you hold the Alt key and then click and drag in the view, you can move the view. Right-click to zoom out a bit to see your two images. Then, click the image on the right to move it, and try your best to align it with the image underneath, as shown in Figure 11.44. The desk and computer should make it pretty easy to line up. You may want to rotate the image as well.

Note: Press Ctrl+Shift, and then click an image to rotate it in the view.

Figure 11.44 Click and drag the second image to the workspace, and move it as close as possible to line up with the previous image.

9. When the image is lined up as close as you can get it, press the Return key. In a moment, Stitcher will stitch the image and adjust the view, while outlining the image in green. If it does this, your image is stitched, and you can add another. Otherwise, you will see a warning pop up that the image wasn't stitched, asking you to *force stitch*, or readjust, as shown in Figure 11.45.

Figure 11.45

If your image isn't properly aligned, Stitcher will ask you to force stitch it.

10. If you get the force stitch message, Stitcher wasn't able to stitch the image. You can of course force stitch if you like, which tells the program to leave the image where you placed it and blend it in. The outline for it will not be green, but rather orange, when force stitched. But you know better and believe in your software. So click the Re-adjust button, and readjust the image slightly. Then press the Return key again to attempt another stitch.

11. Select the third image, drag it into the workspace, press Return, and stitch the image. Continue this process, just as if you were plastering the image to a wall. Figure 11.46 shows all 49 images stitched.

Note: Remember that you can right-click to zoom in and out of your view. In addition, you can hold the Alt key when clicking to rotate around the view as you add images.

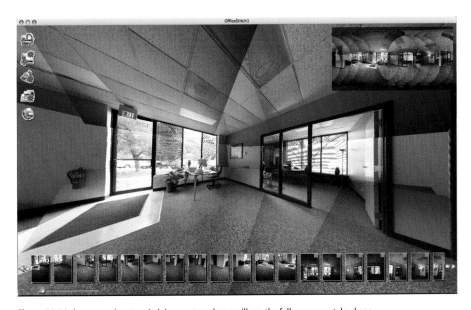

Figure 11.46 As you continue to stitch images together, you'll see the full panorama take shape.

Creating a full 360-degree panorama in the Stitcher program is not hard to do, but it takes a little time. Once your images are all stitched together, you can do anything with them, including rendering them cubically, rendering them spherically, or even creating an interactive Apple QuickTime movie (great for selling houses)!

Creating Panoramas with a Point-and-Shoot Camera

Let's say you don't have a big camera with fancy lenses or a pano-head for your tripod. And let's say you don't even have a tripod—what would you do? Can you still create panoramic images for 3D environments? Absolutely!

Many cameras on the market allow you to take panoramic images. That is to say, they offer the assistance in creating images for a panorama through image playback and viewfinder alignment. From there, you can stitch the images together with the software supplied by the camera's manufacturer. Also, some cameras are specifically designed to shoot panoramas in one shot, but they can be expensive. To spend that much money on a camera that shoots in one particular way is a smart choice only if you're creating panoramas for a specific job or client. The next sections will focus on creating 3D environments with your everyday got-it-from-the-local-electronics-store point-and-shoot camera. You'll learn how to take photos with your digital point-and-shoot camera for panoramas and then stitch them together with a third-party program. You'll then see the final image in a 3D program.

Why a Panorama?

You might be wondering why you'd want to create a panorama with a point-and-shoot camera. Perhaps your 3D environment doesn't need to be a full 360 degrees as described earlier in the chapter. And maybe you just need a high-resolution image to be used in a 3D project, as you saw earlier in the book with the alleyway image. But that's just one image. What if you don't need a full 360-degree image, but you need certainly a lot more than one large photo for your 3D environment? That's where a panorama comes in handy. By stitching together just a few high-resolution photos, you can easily create large, high-quality 3D environments. Here are few good reasons to stitch together photos for 3D environments:

Moving shots You might have an animation that requires a car speeding down a road. By stitching together multiple images, you'll be able to create a large enough background plate behind the car.

Zooming shots Your project might require that you zoom in to your 3D subject, starting from far away and moving in tight. By using many photos stitched together, you can create a large enough environment without blowing up an image and losing quality.

Large rotation shots A 3D project that requires the animated camera to travel around a 3D model will blend better with multiple photos stitched together, rather than using one large image mapped on a curved polygon.

Long dolly shots Even on a simple level, a large wide image can be great to use in 3D. Say you have an animated bird that your 3D camera needs to follow as it flies. A few large photos used together instantly create the environment you need.

Taking the Shots

This project will use a simple point-and-shoot camera to show you how easily you can create the images you need. Figure 11.47 shows the camera being used, a Nikon Coolpix S3. This is a great little camera that is thin enough to fit in your pocket and carry with you every day. Newer models are on the market, but even with a slightly older camera, you can achieve top results.

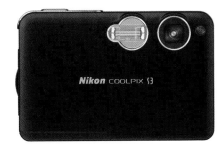

Figure 11.47
A Nikon Coolpix S3 digital point-and-shoot camera works great for creating 3D environments.

Begin by shooting from left to right. The reason for this is that digital images are indexed from left to right. Most panorama-assist modes in digital cameras require you to shoot from left to right as well. When shooting, look for the tallest part of what will be the final image, such as a building or tree. Level that camera so you can fit the tallest subject in view, and then carefully hold that height and pan to the left to take your first shot. Figure 11.48 shows a city shot that begins looking east toward Lake Michigan in Chicago.

Figure 11.48 This is the first shot of a soon-to-be-larger image, taken from left to right.

Now, rotate your body to the right while holding the camera in the same position and at the same height. When you take your first shot, note the details in the right of the image, such as the tall white building on the right. Then, position your camera for the second shot, keeping a bit of the last image's subject in view, such as that same white building. Figure 11.49 shows the shot.

As you take your third shot, repeat the previous process of leaving a portion of the previous shot's subject in view. You can take as many shots as you like, but usually to cover a large expanse, you need only three or four shots. If you're daring, you can take a second row of images above where you took the first to further enlarge your final image.

Figure 11.49 Panning to the right, you can take the second shot, but make sure you leave some of the subject in view from the first image.

Using Simple Software to Stitch Images

Once you've taken the images, open your camera's panorama software. If your digital camera didn't come with panorama software, don't worry. A lot of great tools exist for the Mac and for Windows. Shown in Figure 11.50 is Kekus Digital's Calico, an inexpensive and easy-to-use panorama software for the Mac. You can find out more about this software at www.kekus.com.

Figure 11.50

Using Calico, creating quick and easy panoramas is a no-brainer.

Load your images into Calico from the File menu. You can also do this by clicking the Load button at the bottom of the interface. In a moment, they appear, with the first image highlighted. Figure 11.51 shows the layout.

Figure 11.51
Starting the panorama process in Calico simply requires that you first load the images.

This next part is really tough. Ready? Click the Align button at the bottom of the interface. In a moment, Calico will show you your panoramic image. Phew! That was tough, wasn't it? Figure 11.52 shows the interface.

Note: The latest version of the Stitcher software has features to automatically stitch your loaded images.

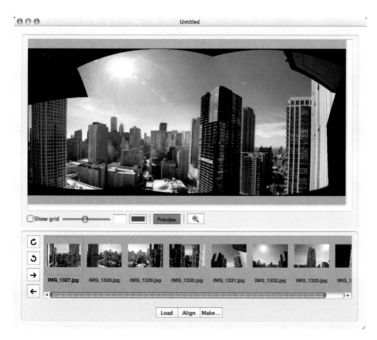

Figure 11.52
Creating the panorama is as easy as clicking the Align button.

When ready, click the Make button. A panel will appear asking you to choose a few settings. All you really need to set is the location to save the image. You can adjust the other settings as you like, but for the purposes here, one large image will work just fine. Figure 11.53 shows the panel.

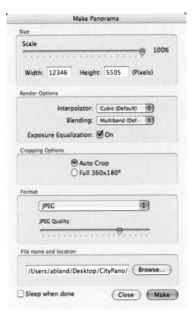

Figure 11.53

By clicking the Make button at the bottom of the panel, Calico will generate your final panoramic image.

After a few minutes, your image will be created for you, ready for 3D. Open your favorite 3D application, and load the image. When the image is loaded, you can apply it to a polygonal shape, such as a curved plane. Figure 11.54 shows the image mapped on a curved plane in Maxon's Cinema 4D.

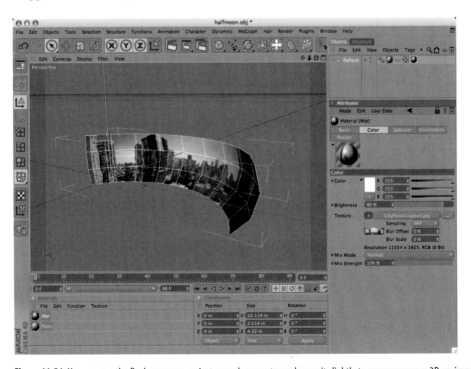

Figure 11.54 You can map the final panorama on just enough geometry and curve it slightly to encompass your 3D environment.

Now that your image is in your 3D environment, you can load 3D objects, animate the camera, and render. You see, by bringing in a large image and mapping it onto a curved polygon, you are essentially extending the range of your camera's view. Be careful how much you animate the camera—you don't want to move or rotate the camera so far that you see the edge of the panorama. And like you saw earlier in the book with the alleyway shot, animating with a large image in the background yields high-quality results no matter where you place the camera. For this city shot (shown in Figure 11.54), you can now add airplanes flying by, birds flying by, multiple 3D buildings to the shot, and so on. Imagine panning the camera from a fixed perspective and, as the camera pans across the large image, 3D buildings grow and come to life. No camera tracking necessary! Why's that? Think about it—the image is flat and not moving. That means you can place your 3D buildings in the shot with (or behind) existing buildings. All that is moving is the camera. Try it!

Note: If you want to place 3D buildings behind buildings in the panorama, make a flat polygon that lines up with the building (from the image) you want to have obscure your 3D building. Then, use a front projection or camera-mapping technique on the flat polygon. Balance the light and luminous values of the new polygon, and you'll now have a mask, matching the digital photo, to block your 3D object.

A Few Tips When Shooting for Panoramas

Here are a few tips for when shooting images that you'll use to create panoramas:

- Shoot left to right, because digital cameras index images in this order.

- Keep exposure consistent. Find a medium exposure to balance dark and light areas of the images. Don't use automatic exposure, because your camera will adjust between images creating unwanted tones in the final panorama.

- Don't use filters, such as a polarizer. A polarizer will create unwanted darkness in blue skies.

- Overlap images by roughly 20 to 25 percent so your stitching software can blend the shots better.

- When shooting indoors in close-range rooms, you should use a pano-head on your tripod to avoid parallax.

Your Next Shot

To get the most out of your 360-degree panoramas or your wide panoramas, you can use a 3D program. On this book's DVD are videos that will show you how to use Stitcher to create a full 360-degree panorama, from adding images as you've seen here to rendering the final output. From there, you'll see that rendered image applied in a 3D program and integrated into an environment. Check out that video, and then turn the page to see how you can use 3D applications to manipulate your existing digital photos.

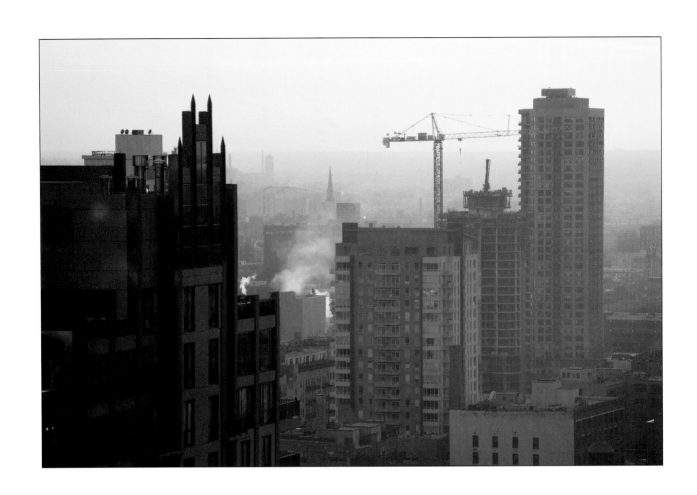

Digital Images: To 3D and Back

Manipulating images in Adobe Photoshop is commonplace to many digital photographers and 3D artists alike. But did you know you can do even more to your photos by using a 3D program? The majority of this book discusses how you can use digital photography in and for 3D applications. This chapter will reverse the idea by showing you how you can use your 3D application for your digital photography.

12

Chapter Contents

Digital Image Manipulation in 3D

One the great benefits of working digitally is the ability to manipulate images (and video) without losing quality. Attempting any type of effect with traditional film means working in the darkroom; in addition, effects beyond the standard dodge and burn techniques are limited to the process of nonsilver photography, which is printing on materials other than photographic paper. You could use the darkroom techniques of blending negatives and double exposures, but for the most part, these techniques are limited.

Enter the digital age. The computer-based tools used today give you the freedom and flexibility to create anything you can imagine. Figure 12.1 shows how you can give images a quick redo when run through a paint filter in Adobe Photoshop.

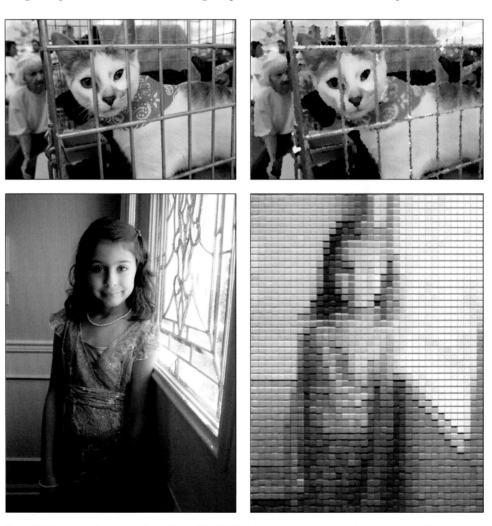

Figure 12.1 You can make a couple of typical, unexciting digital photos more interesting—and perhaps more usable in a particular collage or animation scene or effect—when processed through Photoshop filters.

3D artists generally think of 3D modeling and animation as a creation tool only. And for the most part, it is. But the power incorporated into all 3D applications today make them an excellent choice for enhancing, manipulating, or completely changing your digital photographs. You might not think of this process as an artistic outlet, but as you read on, you'll see that the possibilities are endless using 3D tools. Think about it: in 3D, you have access to reflections, cloning, warping, lighting, dynamics, and various rendering filters. Why not apply those tools to your digital photos?

In the early days of digital photography and 3D, the process of converting a digital photo to 3D and then back out again might not have been easy. Images were difficult to import because many 3D applications did not support their file types, and render times were often too long to make the process worthwhile. Additionally, without OpenGL and quick previews, you couldn't even see what you were doing to the image until it was rendered. Today, it's a different story. 3D applications have advanced OpenGL and texturing previews, with software and processing power becoming increasingly more powerful. Figure 12.2 shows a digital photo manipulated in 3D to create an instant reflection.

Figure 12.2
Using LightWave 3D, you can add a digital photo reflection quickly and easily.

Adding a reflection to an image is not a big deal and is often a simple process in Photoshop for the experienced user. However, it does require quite a few steps, and in most cases, you can create this effect quicker and easier in 3D. In addition, a reflection in 3D is a true reflection, and you have much more control over it than you would in Photoshop. The following project will show you how to create this effect.

Creating 3D Reflections

Reflections in 3D used to be a render killer. That is, turning on this feature would bring computer systems to a halt, with the final outcome not worth the time investment. As mentioned, technology has changed over the years, and it's to your advantage to use these tools. You'll start in your favorite 3D application, such as Autodesk's Maya, NewTek's LightWave, or Maxon's Cinema4D—it really doesn't matter. What does matter is that you have the ability to turn on ray-traced reflections. Most 3D applications support this feature.

1. Open your favorite 3D application, and jump to the modeling portion of the program. In LightWave 3D, open Modeler. In Maya, select the Modeling mode.

2. Create a flat polygon using a Cube primitive. Give it a basic 4×3 ratio to match the digital photo. Build this primitive on the x-axis and y-axis so it's flat on the z-axis, as shown in Figure 12.3.

Figure 12.3 Build a flat cube on the x-axis and y-axis so it's flat on the z-axis.

 Note: Feel free to use any photo you like, including the included royalty-free images on this book's DVD or one of your own.

3. Apply a material to the new flat polygon so that you can apply your photograph to it as an image map or color map. Then, save it.

4. Then, within your 3D application, load the CitySunset.jpg image from the book's DVD (or feel free to use your own). Figure 12.4 shows a shot looking west in downtown Chicago, showing the urban sprawl. It needs to be reflective, don't you think?

Figure 12.4 A digital photo taken at sunset in downtown Chicago will work well for adding a reflection.

You might ask yourself, why add a reflection? Perhaps you want to create a header for a website. Maybe you want to create a digital gallery and give your images a cooler look. Adding a reflection to an image can give it more depth and more interest depending on the image.

5. Hop on over to your application's material- or surface-editing feature, and select the material for the new geometry you've created. Apply a texture (or color) map to it, and attach the digital photo you've loaded. Set the image as planar mapped on the z-axis, as shown in Figure 12.5.

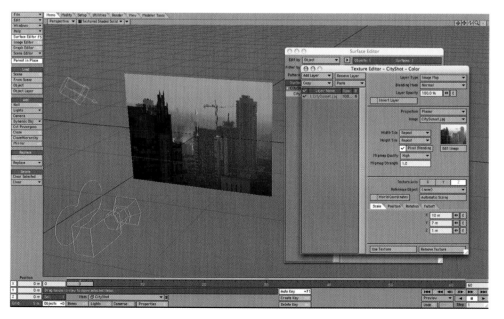

Figure 12.5 A digital photo is mapped as a planar image on the z-axis in LightWave 9.

6. Once the image is mapped, jump back to your 3D modeler. Create a large flat plane on the y-axis to act as a ground plane. This is what will "catch" the reflection. Build it large so it encompasses the entire scene, something like 20m in size for the x-axis and the y-axis. It's flat on the z-axis, as shown in Figure 12.6.

Figure 12.6 Create an additional flat plane to act as a ground or floor to catch the reflection.

7. Once you've created the flat plane, apply a surface material to it, and call it something clever, like Floor or Ground. Then, save it!

8. Place the flat plane underneath the image-mapped city shot so that the picture is resting on the ground, as shown in Figure 12.7.

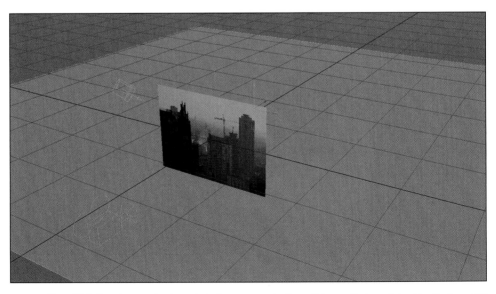

Figure 12.7 Place the ground underneath the image-mapped polygon. Make sure the image is touching the floor so it's not floating in your render.

9. In your surface or material editor, set the color of the new ground plane to black: 0,0,0 RGB. And, set your environment background to black if it already isn't. A reflective floor will reflect not only the image sitting on top of it but the environment as well.

10. Add a reflection to the floor, about 20 percent. Make sure this reflection is set to reflect the environment. Each 3D application handles this process a bit differently; some do it automatically, and some do not. So, check to see whether your render settings have ray-traced reflections enabled.

11. The reflection will appear in the floor beneath the image. So to see it, pull the 3D camera back to reveal the floor area where the reflection will be rendered.

12. You might need to move the camera up slightly on the y-axis and then rotate it down slightly. To avoid any angle change on your image, pull the camera back on the z-axis, and use a longer focal length, effectively "zooming" in on the image. This will minimize distortion. Figure 12.8 shows the setup in LightWave. Figure 12.9 shows what the camera sees.

Figure 12.8 Move the 3D camera back, and zoom it in to avoid angles and distortion in the image.

Figure 12.9 The 3D camera view shows the image straight on, with a long view of the floor in the foreground.

13. When the camera is in place, render a frame. You should see a bit of reflection in the floor. But because the floor is black, it might not show up too well. And, the overall scene is quite flat. Enhance this by adding light. Use a spotlight, and position it in the upper-left corner of the image, as shown in Figure 12.10. Figure 12.11 shows the light view.

Figure 12.10 Place a spotlight in the upper-left corner of the image.

Figure 12.11 This is what the initial spotlight sees in the 3D scene. It focuses on both the image and the floor in front of it to enhance the reflection.

CHAPTER **12**: DIGITAL IMAGES: TO 3D AND BACK

14. Set a soft edge to the light as well so it falls off nicely into the black backdrop. Render another frame. The reflection will show up a little better but perhaps not enough. So, change the reflection value of the floor from 20 percent to 40 percent. Figure 12.12 shows the render.

Figure 12.12 A render of the scene shows a slight reflection, which could be enhanced.

15. Because the reflective floor is reflecting both the image sitting on it and the black background, it's a bit dark. You can add even more reflective value to the floor, but try something else first. For the image-mapped city shot, increase its diffuse value and add luminous values to it, as you would a candle or lightbulb. By making the image brighter, it will enhance the reflection, as shown in Figure 12.13.

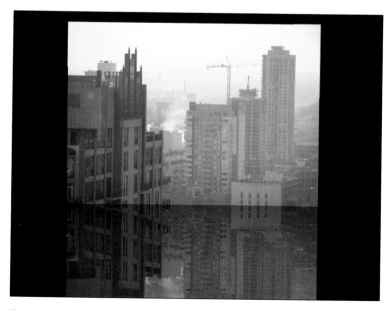

Figure 12.13 Making the image brighter with luminous values enhances the reflection.

As your reflection travels out toward the camera, you might want it to fade a bit. First, make sure your camera can see all of the reflection. This might require a little trial and error by moving the camera back and test rendering the frame. Once the camera is in place to see all of the reflection, then save the scene. Figure 12.14 shows the image and full reflection.

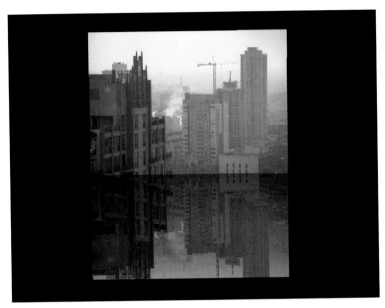

Figure 12.14 By pulling the camera back on the z-axis, you can see the entire reflection in the floor.

Note: You might need to pull the floor object closer to the camera when the camera is pulled back from the image. This will allow the reflection to fill the frame.

17. If you like how the image looks, render a larger format as needed. If you'd like to fade the reflection slightly, read on.

18. Fading a reflection in 3D might sound a bit tricky, but if you have the ability to use masks or gradients, you're in luck. This process will require you to know your 3D software a little bit more in depth, but be assured, it's not a complex operation. Go to your system's material editor, and apply a mask (or gradient) to the reflective surface.

19. Typically, you could use a black-to-white or black-to-nothing mask for the reflection. By doing this, you're telling your 3D program to apply a reflection only where the mask is placed. So if your mask is black, faded to nothing, the black will obscure the reflection, which then gradually fades off revealing it. This is often accomplished with an Incident Angle effect, as shown in Figure 12.15.

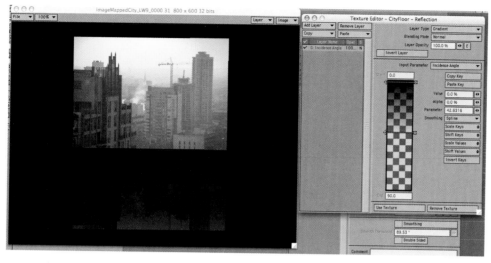

Figure 12.15 An incidence angle can work well for fading a reflection, depending on your application.

20. In Figure 12.15, the LightWave 9 interface shows a faded reflection, but it's faded toward the image, not away. You can reverse the angle of incidence (if your software allows for it) or try another method.

21. Set up your mask or gradient as a distanced-based mask. That is, the input parameter should be set on the Z distance to the object. By doing this, you're telling the mask/gradient to fade based on the distance of the camera to the object. The result is a faded reflection. Note that this is completely adjustable so you can have a small, tight reflection or a long, soft reflection. Figure 12.16 shows a render.

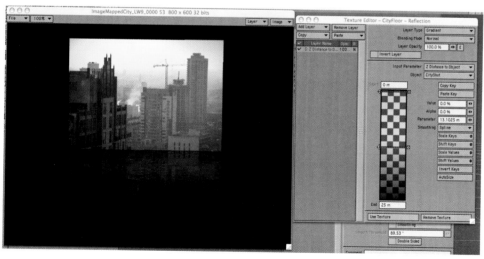

Figure 12.16 Using a Z distance-to-object input parameter for the gradient in LightWave 9, the reflection fades off as it nears the camera .

From here, your scene is set up. Save your surface settings and scene. Render out your image at any resolution you want. Remember, the original image was 4348×2882 in size. You can render the scene that large or slightly larger without losing quality. Now that you've gone through the process of setting this up, all you need to do is replace the image and click Render to create other images with reflections. This is a great way to display your photographs, but there's more you can do, so read on for some additional ideas.

Setting Up 3D Lighting

Imaging programs such as Photoshop are chock-full of third-party plug-ins that can create amazing effects on your digital photos. Often, you might want to have a little more control and step away from the masses—you know, do your own thing. You can use templates for only so long, right? This project will show you a technique for creating lighting effects on your digital photos.

1. Start your favorite 3D application. You can use the WindowShot.png image provided on this book's DVD, or you can use your own image. You'll use 3D lights on the image to create an interesting look.

 Figure 12.17 shows a 3D image set up with an image-mapped photograph. This setup is just like you did in the previous project.

Figure 12.17 This is the image-mapped flat plane, ready to be lit.

2. The camera is pushed in to view only the image. When it renders, you won't see any backdrop like you did in the previous project. Set up a spotlight, and position it to the top left of the image.

3. Make sure the light has a soft edge and its color is off-white. Figure 12.18 shows the view from the light.

Figure 12.18 Viewed from the light view, a spotlight is positioned to the top left of the image.

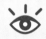

Note: You can position this light anywhere you want. Depending on the photo you choose to use, the light might work better in a different location.

4. With the light streaking down across the image, make sure any ambient light is turned off in the scene. Render a frame of the scene, and what you'll see is a spotlight lighting your image, as in Figure 12.19.

Figure 12.19
This is the 3D render of a digital photo with a spotlight streaked across it.

5. Adjust the light as you like, perhaps changing intensity, position, and so on. When ready, clone the light, and place it opposite of the current light. Tint it with a color, perhaps orange or blue. Render a test to see the results. Figure 12.20 shows the render.

Figure 12.20
Add a second light (tinted orange) to the image.

6. Next, clone the first spotlight one more time. Use the gobo (or cookie) image from Chapter 7, "3D Imaging with Photography." This is the blurred, black-and-white image of tree branches. Place it as a projection image for the spotlight. Figure 12.21 shows the setup through the light view.

Figure 12.21
Apply a black-and-white image as a projection image.

7. When ready, render a frame. Save your work. Figure 12.22 shows the image, now with two lights and a third projection light. Render the image at a larger size, and then save or print it.

Using lights on images is one way to tint and color them for effect and mood. And, like the previous tutorial, once this scene is set up in your 3D program, you can load it again, replace the image, and render to create multiple images with this look. But how about applying filters to your images? Many 3D applications have filters for rendering and typically are used only on 3D scenes. Who is to say you can't use these filters on flat image-mapped objects?

Figure 12.22

Applying a projection image to the scene creates more interest in the final render.

Using 3D Filters on Digital Photos

Depending on your 3D application, you can apply various 3D filters on your images. Using the same image-mapped polygon technique as you used previously, you can apply different filters at render time for different image effects.

Figure 12.23 shows a shot of a fire truck. It's a standard digital photo, with good color, nice sunlight, and so on. But clearly, it's not going to a fire. Or is it?

Figure 12.23

This is a typical digital photograph, which you can manipulate in 3D.

The shot in Figure 12.23 is mapped on a flat plane in 3D. The lighting is general without shadows. Now, what would make this shot more interesting? Using a digital image filter, often found in most 3D programs, you could change the look of the image entirely. Figure 12.24 shows the same image, but with a fractal turbulent noise applied at the rendering process, the fire truck now appears to have a bit of smoke around it.

Figure 12.24

Using procedural noise during the render, fractal patterns are drawn over the image.

On a different level, you can use a negative filter on the image. Figure 12.25 shows the fire truck with the filter applied.

Figure 12.25

Apply a negative filter at render time to reverse the color data within the image.

Of course, you could perform many of these image effects in Photoshop or another imaging program. But in 3D, you can take everything to the next level. For example, you can apply a negative filter as shown in Figure 12.25 and then add a procedural texture, and how about lighting it like you did earlier? Render that, bring it back in, and render it again with a reflection. Remember, with digital, you can continually render this image with different effects and apply more effects on top of it without losing image quality—that is, of course, if you save the image properly. Save your rendered images as high-resolution uncompressed files, such as TIFFs, PICTs, or other formats you commonly use.

Note: Avoid JPEGs if you're going to edit and resave the image more than once. JPEGs are fine for final output, however.

Creating Hairy Images

Have you ever wanted to do something really different with your digital photographs? Maybe you've tried tiling them, blending them, or manipulating them with a digital montage program. But have you ever made a hairy image? That's right, hairy, not scary, although it could be. With the advancements in hair and organic materials in 3D applications, many allow you to use an image to not only drive the length and density of fur but the color as well.

Using Sasquatch from Worley Labs (www.worley.com), you'll see how you can use an image-mapped object to create a furry image.

1. Create a flat plane as you've done before, and give it a surface/material attribute.

2. Load a digital photo, and apply it to the flat plane. Find an image that has a good amount of tonal value, something with bright colors will work fine. Figure 12.26 shows the image being used for this project.

Figure 12.26 To begin creating a furry image, try to find an image that has a lot of tonal values, some colorful, with contrast.

The contrasting image will work well because Sasquatch will use the grayscale value for various fiber settings, as you'll see soon.

3. Next, apply the image as a planar image map. Position the 3D camera on an angle, something like Figure 12.27. The reason for this is to see the fur as it grows out of the image.

Figure 12.27 Position the camera on an angle, which will allow you to see the hair when rendered.

4. Use any type of light you want, such as a spotlight to light the image-mapped plane from the front. Clone that light and perhaps tint it a bit, and then set it off to the back. This will help highlight the fibers when rendered, pulling them away from the backdrop. Figure 12.28 shows the scene from a perspective view.

Figure 12.2 Set up at least two lights one main key light and one backlight, slightly tinted.

5. In LightWave, you need to first assign the Pixel Filter plug-in for Sasquatch. On the Image Processing tab, add the Sasquatch Pixel Filter plug-in, as shown in Figure 12.29. Make sure Preview Mode is checked if you want to see adjustments later in the main Sasquatch window.

Figure 12.29
To use Sasquatch in LightWave, you need to first assign the Pixel Filter plug-in to the scene.

6. Next, select the image-mapped object, and open the Object Properties panel for it. On the Render tab, select the Displacement plug-in Sasquatch. Double-click the Sasquatch plug-in to open it, and for the first setting, Fur/Fibers, you can pretty much leave these at their defaults to start. If you're familiar with the program, make any adjustments as you like. Figure 12.30 shows the panel.

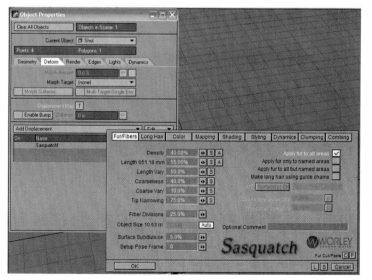

Figure 12.30
In the main Sasquatch panel, you can leave the Fur/Fibers settings at their defaults.

7. Click the Mapping section in Sasquatch, and keep the Color Image Strength setting at 100 percent. For the image, you can select your digital photo. It's planar mapped on the y-axis, so adjust those values as needed. Figure 12.31 shows the setup.

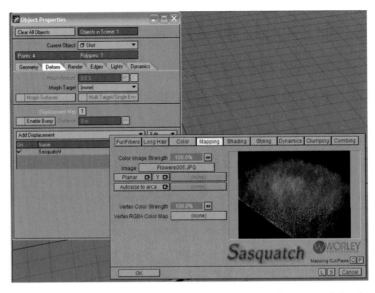

Figure 12.31 By applying the image to the mapping section of Sasquatch, you can apply its color to the fur and fibers.

8. Click OK to close the Sasquatch window, and save the scene. Then, render a test frame to see the results. Make any adjustments as you like back in the Sasquatch panel after the render completes. With the Preview Mode setting selected earlier in the Pixel Filter plug-in, the render you've just done will not be visible in the Mapping section of Sasquatch. Figure 12.32 shows the render.

Figure 12.32 Using just default settings and applying an image to the fur and fibers inherits the color of the image.

Now, what's really cool is that anywhere you see the small *s*, you can use your digital photo for that particular adjustment. For example, use the image in the Fur/Fibers area to generate the density based on the image. Or, try using your digital photo to generate the length of the fibers.

You can use images in 3D for many purposes, such as simple image mapping, textures, and, as you've seen, even fur. Another really cool trick you can do with digital photos in 3D is generate particles. Particles are more common in 3D applications than ever before. Particles will give you the ability to create rain, snow, lava, fluids, smoke, and more. In most 3D programs, an "emitter" is used to generate particles. From there, you adjust the birth rate, telling the system how many particles to create over a set amount of time. You choose how fast they move, how they blend, and so on. But what a lot of people don't realize is that you can generate particles from images. A great program to handle particle generation is Softimage's XSI. Visit www.softimage.com for more information about this powerful system and its particle generator.

CREATING HAIRY IMAGES

Appendices

Choosing a Printer

A When film was all the rage (before digital), printing was a major part of photography. Almost every serious photographer, pro or amateur, understood darkroom techniques for printing their work. The use of film, lenses, and shooting was just half of the equation for the shooter; the other half was all about the developing, the paper, and the processes of printing.

Today, although film has given way to digital and cameras have migrated to new standards and formats, setting apertures, shooting, and developing your eye have virtually remained the same. The darkroom is now a desktop computer, and long gone are the days of chemicals, red lights, and enlargers. Today, the advantages of digital photography go far beyond what anyone could have imagined just a few years ago with traditional techniques. But the art of printing still eludes digital photography technology. With digital, you can enlarge, crop, rotate, colorize, blur, and sharpen your images to enhance your photos more than you ever could with film. But there is still something to be said about the quality of a film to emulsified paper print from a traditional enlarger. So, how can you achieve the same, or close to the same results, with today's digital printers and paper?

You may be the type of person who prints only one or two photos a month. Most of your work might end up only in a digital form, such as being used in a 3D application, used on a website, or burned to DVD for a slide show. But every once in a while, you find that a photo you took would look best printed and framed. What a novel idea! You'll first need to decide what printer to buy.

Buying a printer is easy. Walk into any store that sells electronics, and you'll be bombarded with printers. Some printers are small, some are large, and some do it all. Most printers are ink-jet printers, meaning they have ink cartridges that cost an arm and a leg to replace. Some photo printers, however, use a dye-sublimation cartridge. Dye-sub printers can offer a much higher-quality print (over ink-jet printers) because the ink is not "spit" onto the paper in small dots like with an ink-jet printer. Rather, heat is used to evaporate the ink into the photo paper through a film that contains cyan (blue), magenta, yellow, and black. Many of today's smaller 4×6 one-touch photo printers offer dye-sublimation printing. Choosing which printer is right for you means first deciding what you'll do with it. You may be partial to a specific brand, such as HP or Canon, but for the most part, all digital printers today perform well, and you can focus your decision on a few key features: resolution, paper, compatibility, and size.

Resolution

Resolution is confusing to a lot of digital photographers, especially those working in 3D on a daily basis. When you visit your local office store or warehouse club and look at the featured printers, take a look at their resolutions. What does this exactly mean? you ask. The size of the ink droplets is what determines the resolution in your printer. This means that the spacing of the nozzles and the number of nozzles for each color printhead, per inch, are what eventually becomes the resolution value for that printer. Today, most printers offer at least a 1200 dots per inch (dpi) resolution. Beyond this, it will be hard for you to tell the difference in resolution. Is that to say that a 4800 dpi printer is not worth buying? Not exactly. It all depends on the size of the print you're making and the quality of the initial image. Certain images with a lot of lines and curves will benefit from a high-resolution printer. But most images print well on 1200 dpi printers. That means that even your fax/copy/printer combo can produce some nice results.

Paper

Just as it was back in the darkroom days, choosing the right paper can make or break the final printed photo. Will just any "photo paper" do? Probably, but there are a few features to look for and set up when printing digital photos. Each manufacturer offers its own brand of photo paper for its printer. In the end, it doesn't really matter if you use the HP brand, the Sony brand, or Bob's No-Name brand. What matters is the type of paper you choose.

When looking for a photo paper, you usually can find a glossy type. Photos printed on glossy paper look nice, and this also helps boost contrast. The (often) hard-to-find matte-finish papers are sometimes more ideal for a professional-looking print because they have less glare.

Whether you choose a gloss or matte finish, you also need to consider the weight of the paper. Have you ever just printed a photo on a sheet of ink-jet copy paper? It doesn't look so good, does it? Your first thought might be to ditch that printer and get yourself the newest top-of-the-line photo printer. But just because something has the name *photo* in it doesn't mean it will print any better. You see, simple copy paper is thin and lacks weight, or a *finish*. This means the ink from the printer can't saturate fully, leaving you with a soft, washed-out look. By using a thicker paper designed for photo printing, your expensive ink will be put to good use.

Note: Choosing the weight for your photo paper might also require you to check your specific printer specs. Many everyday printers can't handle certain paper on the market.

Note: Be sure to set your print options to Best when printing a digital photo. Some printers have software that allows you to choose presets such as graphic, text, or photo quality. Look for this in your printer options on your computer.

Compatibility

A simple and obvious decision when looking for a printer is to find one that is compatible with your computer. Not all printers are created equal, you know! Many printers are Windows only, and although your Mac might have a driver and print to it without issue, it is something to consider. Your best bet is to look for a printer that is compatible with your system by looking on the printer box (or at the specs online through the manufacturer) and by reading the system requirements.

Even if the printer you choose is compatible with your operating system, also make sure you have the right connections. Most printers today connect via universal serial bus (USB), but if you have an older computer, it might not have a USB port. Further, older printers have parallel cables, and your newer computer will have USB. If your computer and printer are fairly new—that is, within the last two to three years—you shouldn't have any trouble.

Size

Two common printers are available for digital photography. You can always find a standard ink-jet printer that uses up to 8×10-sized paper. You'll also find a slew of smaller, one-shot simple printers that are designed specifically for digital photo printing. These printers use precut 4×6 paper and can hook to your computer or directly to your camera. These little guys take up little space, they produce excellent-quality images, and they even can print borderless to get that "in-store" printed look.

If you're trying to look professional and you have the money to spend, you can really make your digital prints stand out. Digital printers have evolved to create 11×14, 16×20, and larger prints. Be warned, though; these printers can get pretty expensive, but what's more expensive is the ink. Replacing ink on these bad boys can cost hundreds of dollars. Using large-format printers is not something you'd want to do just for the fun of it (unless you have lots of cash); rather, they're for professional use. You'd use these high-end printers to create prints to sell, to create prints for clients, or to create prints for those special occasions when you get that one perfect shot you just need to print large.

To learn more about printers, sizes, and brands, visit the following sites:

http://www.pcmag.com/article2/0,1895,1645738,00.asp

http://www.steves-digicams.com/printers.html

http://reviews.cnet.com/Printers/2001-3155_7-0.html?tag=cnetfd.dir

Another important issue when discussing size is not just the size of the paper you choose but the size of the print itself.

Digital images are not a continuous tone the way images from film are. Film is analog, and digital is, well, digital! That means you can't simply assume that you can use one image for any size print. It goes back to the "garbage in, garbage out" theory in that if you shoot a low-quality image, you'll print a low-quality image. With film, you can shoot and make just about any size print from one negative. Well, the laws have changed a bit with digital photography, or perhaps it's better to say that the laws are just more complex. Figure A.1 shows a photograph taken with a Canon 5D digital SLR camera. It's a high-quality JPEG photo.

By opening this photo in Adobe Photoshop and then choosing Image > Image Size, you can see that the image is 4368×2912 with a resolution of 72 dpi, as shown in Figure A.2.

Is the resolution really this low? Will it affect the print? The answer is no. You see, your image is digital; it's not a continuous tone, and the image has a lot of data. By unchecking the Resample Image box, you can now adjust the resolution, and the width and height will adjust accordingly. Let's say you're sending this image out for print, rather than doing it yourself. Your print shop requires that all images be 300 dpi. Well, your image shows 72 dpi, just like your 3D rendered image, even though it's more than 4,000 pixels in size! Figure A.3 shows the same image with a 300 dpi adjustment.

Figure A.1 This is a digital photo, shot at high quality with the Fine setting in the Canon 5D camera.

Figure A.2

Looking at the image size in Photoshop shows that the image has a large width and height but a low resolution.

Figure A.3

Setting the resolution to 300 dpi changes the width and height to 14×9.

By changing the dpi to 300, the image width and height are now roughly 14×9. If your own digital printer is making an image at 8×10, you have more than enough information to print a high-quality image. You can even print larger. But what if you need to print larger than 14×9, perhaps 20×30 or more? Photoshop allows you to resample the image. Checking the Resample Image box allows you to manually set a width and height, such as 20×30, while also setting a different resolution. Figure A.4 shows the dialog box.

Figure A.4
Resampling the image results in a separate width, height, and resolution.

You might think changing the resolution and size would destroy the image quality, and if you are not careful, it can. But in most cases, such as the example shown here, you can increase the resolution of the image a good bit before seeing any noticeable image loss.

Note: If you're planning to increase the resolution of an image for a very large print, try working with Photoshop's sharpening tools to adjust the sharpness of the image as you increase its size. Remember though, your best defense against poor image prints is to shoot at higher resolution. Only use "up-res" techniques for last resort or at least in small amounts.

Reference Materials

B

There is always more to learn about photography and 3D. For that reason, this appendix will guide you to a few resources that can further enhance your photography and 3D experiences.

Reading References

Computer technology is great, but sometimes you just want to get away from the computer and do something different—you know, like read about computers! These references are just a few books that can help open your eyes to someone else's ideas:

Aaland, Mikkel. *Shooting Digital: Pro Tips for Taking Great Pictures with Your Digital Camera, Second Edition.* Sybex, 2006.

Anon, Ellen, and Tim Grey. *Photoshop for Nature Photographers: A Workshop in a Book.* Sybex, 2005.

Birn, Jeremy. *Digital Lighting & Rendering. Second Edition.* New Riders, 2006.

Culhane, Shamus. *Animation: From Script to Screen.* St. Martin's Griffin, 1990.

Kerlow, Isaac V. *The Art of 3-D: Computer Animation and Imaging, Third Edition.* John Wiley & Sons, 2003.

King, Julie Adair. *Digital Photography Before & After Makeovers.* John Wiley & Sons, 2006.

Lord, Peter. *Creating 3D Animation.* Harry N. Abrams, 1998.

Thomas, Frank, and Ollie Johnson. *The Illusion of Life: Disney Animation.* Hyperion Press, 1995.

White, Tony. *The Animator's Workbook.* Watson-Guptill, 1988.

These are just a few books of interest, and more are being published every day. Browse online, read reviews, and check around to see who has read a book in which you're interested. Get feedback, and see whether it's right for you. Often, one simple tip or idea is worth the price of the book, especially during a project! What's better, head on down to your local bookseller, and browse the shelves. Often getting your hands on a book before you buy it gives you the opportunity to review it and see whether it contains the information you need.

Other References

Sometimes you just need to see some great photography, or 3D, to be inspired. Maybe you need to read some unbiased reviews. Here are a few links to show you what other people are doing:

Photo.net www.photo.net

CG Channel www.cgchannel.com

Digital Photography Review www.dpreview.com

Fred Miranda www.fredmiranda.com

Photographysites.com www.photographysites.com

Rob Galbraith DPI www.robgalbraith.com

Complete Digital Photography www.completedigitalphotography.com

DPI www.dpi-digitalphoto.com

Index

Note to the Reader: Throughout this index **boldfaced** page numbers indicate primary discussions of a topic. *Italicized* page numbers indicate illustrations.

C

calibrating images, **216–222**, *216–221*

Calico program, **266–268**, *266–268*

cameras

 animating, 137

 calibrating, **216–222**, *216–221*

 handling, **55–56**

 for HDR images, 201

 for light-probe images, 192–193, *194*, 197

 operation principles, 2

 for panoramas, 238–239, *239*, **264–269**, *265–268*

 with particle generators, 140

 selecting, **52–55**, *52–53*

 shaking, **56–57**, *57*

 viewfinders in, *57*

Canon cameras

 for image-based modeling, 214

 for panoramas, 241

Canon 5D camera, 3

 city image, 16, *17*

 city street image, 16, *16*

 for light-probe images, 194

 settings, 296, *297*

Canon 20D camera, city night image, 55, *56*

Canon 30D camera

 aperture control in, 19

 steady shots with, 57

Canon lenses

 patio image, 20, *21*

 tennis player image, 21, *21*

Canon Rebel camera, 17

cement texture, 42–46, *43–47*

CG Channel site, 300

chairs pattern image, 67, *67*

channels

 for bump maps, 102–103, *102*

 color, 83

chemical process, 2

chess board image, 22, *22*

Chicago

 downtown image, 274, *275*

 O'Hare airport image, 52, *52*

 traffic light image, 5–6, *5–6*

chrome sphere. *See* light-probe images

Cinema 4D program, 268–269, *268*

city images, 16, *17*

 Chicago downtown, 274, *275*

 night, 55, *56*

 panoramas for, 265, *265–266*

 street, 6–7, *7*, 16, *16*

CitySunset.jpg image, 274, *275*

Clone Stamp tool, 202, *202*

cloth effect

 applying, 135

 wind effectors with, 142–144, *143*

Cloud_Bkd.png image, 151, 153–154, 157, 179–180

clouds, animating, **181–184**, *181–184*

CMYK (cyan, magenta, yellow, and black) color, **78–80**, *79*

color, **78**

 for 3D shapes, 115

 bit depth, **83**

 hue and saturation, **80**, *80–82*

 RGB vs. CMYK, **78–80**, *79*

color channels, 83

Color Image Strength setting, 290

Color Key effect, 161, *161*

Color Range key, 166, *166–167*